The Art of LEGO® Design

The Art of
LEGO®
Design

Creative Ways to Build Amazing Models

Jordan Schwartz

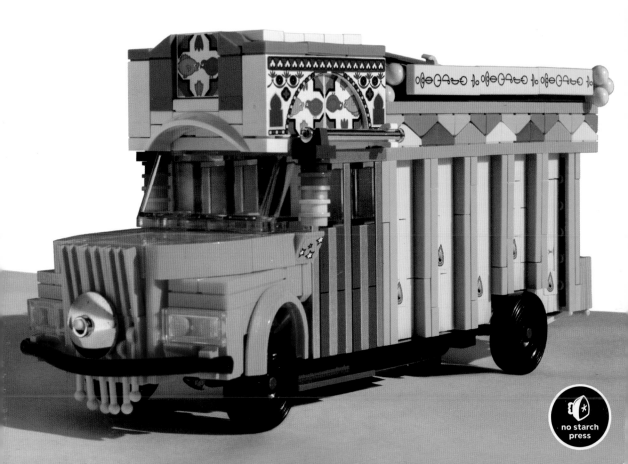

no starch press

The Art of LEGO Design. Copyright © 2014 by Jordan Schwartz.

Printed in China
First Printing

18 17 16 15 14 1 2 3 4 5 6 7 8 9

ISBN-10: 1-59327-553-6
ISBN-13: 978-1-59327-553-2

Publisher: William Pollock
Production Editor: Laurel Chun
Cover Design: Ryan Byarlay
Developmental Editor: Jennifer Griffith-Delgado
Copyeditor: Pamela Hunt
Compositor: Serena Yang
Proofreaders: Lisa Devoto Farrell and Alison Law
Indexer: BIM Indexing & Proofreading Services

For information on distribution, translations, or bulk sales please contact No Starch Press, Inc. directly:
No Starch Press, Inc.
245 8th Street, San Francisco, CA 94103
phone: 415.863.9900; fax: 415.863.9950; info@nostarch.com; www.nostarch.com/

Library of Congress Cataloging-in-Publication Data
Schwartz, Jordan.
 The art of lego design: creative ways to building amazing models / Jordan Schwartz.
 pages cm
 Summary: "The Art of LEGO Design explores LEGO as an artistic medium, revealing rarely-known and creative ways to build impressive models with LEGO"-- Provided by publisher.
 ISBN-13: 978-1-59327-553-2 (pbk.)
 ISBN-10: 1-59327-553-6 ()
 1. LEGO toys. 2. LEGO toys--Design and construction. I. Title.
 TS2301.T7S38 2014
 688.7'2--dc23

 2013048974

To my family, especially my grand-parents, Linda and Mike, for spoiling me with LEGO sets at every major holiday for nearly 20 years. I've learned that there is, in fact, such a thing as "too much LEGO."

Contents

Acknowledgments

Creating this book has merged two of my passions—model building and writing—and I'm very happy that I had the opportunity to write it. I'm especially thankful to have published it with No Starch Press; the staff have been nothing but supportive during this, at times, tedious process, and I am grateful to have had access to their expertise.

This book also wouldn't have been possible without its contributors. These builders are among the best, and their work supplements my writing and models beautifully. I know their models will inspire countless LEGO fans around the world, and I am so grateful for their contributions.

One last special thanks goes to my twin brother, Alex, for putting up with late-night readings of my manuscript and for letting me steal his LEGO elements and minifigures for this book without too much fighting.

Preface

It's 1949. Billund is a tiny hamlet located in the southern part of Denmark, in the middle of nowhere. Its only notable feature is that it's located in the part of Denmark that gets the most annual rainfall. But in this small Danish town, carpenter Ole Kirk Christiansen is about to create something that will be cherished by millions of people worldwide—something so respected that it will make his family one of the wealthiest in Denmark for three generations. Christiansen is about to begin manufacturing plastic "automatic binding bricks." He will call them "LEGO" bricks after the Danish *leg godt*, or *play well*.

Though originally conceived as a children's toy, Christiansen's bricks appealed to other age groups as well because constructions could be as simple or as complex as the builder desired. Even in the product's infancy, commercials portrayed LEGO sets as fun for the whole family; they showed the children, mother, father, and grandfather all building with LEGO together. The idea that LEGO can be fun for both children and adults is alive and well today.

The LEGO Group expanded its product line over time. In the 1970s, it released LEGO Technic sets, which featured a new horizontal building style. A decade later, Model Team sets—the most detailed models yet—hit the shelves. MINDSTORMS kits with tiny computers and motors followed, attracting more teenagers and adults than ever. Jump forward a few decades, and the Architecture line, Ultimate Collector Series, and modular buildings join the list. Each year, the number of adult-marketed products seems to grow.

Thanks in part to the increasing appeal to adult builders, we have LEGO fan communities. LUGNET, created in 1999, was one of the first online LEGO user communities for sharing news, information, and models. Other communities that focused on specific building techniques, themes, or geographical regions followed. Today, thousands of LEGO models are posted online monthly; but before builders were able to share their work online with fellow hobbyists, the best creations were the LEGO sets themselves and the models at the LEGOLAND theme parks (at least as far as hardcore builders were concerned). The Internet has made it possible for hobbyists to develop their LEGO building skills to match and even surpass those of the LEGO Group's master builders. Online photo galleries offer stunning, inspirational models, and websites like eBay and BrickLink make it easier than ever to find parts for your collection.

The Internet has also made it possible for some of the most innovative builders to attain celebrity status. Famous builders have elements, techniques, and styles named after them, with their work held as the standard. These builders become well known because they to strive to build the most creative models possible—models that don't look like they've been built from LEGO parts. Builders who can create models that make you question whether they're really made of LEGO have done something great. And that's just what this book aims to show you: how you, too, can build models that break out of the blocky LEGO aesthetic.

The LEGO Group's motto: *Only the best is good enough.*

If you ever visit the Idea House—the LEGO employee–only historical museum in the center of Billund—you'll see a modest, hand-carved wooden sign with the company's founding motto. It reads *Det bedste er ikke for godt*. It's a motto to take to heart when building: *Only the best is good enough.*

Introduction

The progression of quality in LEGO models from the 1950s to today is remarkable. Compared with models from the 1950s, the modern creations in this book look truly futuristic.

But that doesn't mean you can instantly build models like the ones in this book without practice. We all have to start at the beginning, and learning from existing models can help you develop your skills. Every model is different, but the basic steps for building similar subjects are the same. Remember these basic concepts as you browse the models in this book and elsewhere.

Information and Inspiration

Within these pages, you'll find practical information and analyses of the featured models, which you can apply to nearly any model you build. For example, where should you start when you're building an automobile? What's the best way to build a chassis? Builders ask these questions when they design a model, and this book will help you address them when you build your own models.

While step-by-step instructions can show you how to re-create specific models, they fail to explain how and why the original builder made certain design choices. This book reveals those thought processes. When you reach a certain skill level, step-by-step instructions won't be as satisfying, and that's when the information in this book will be most valuable to you.

But even if you're not at that point yet, this book has a second purpose. It is also meant to inspire, serving as both a guidebook and a look book. The models in it are among the best pieces from some of the most creative builders in the LEGO community.

Overview

Let's get building! A minifigure version of me with some 1960s Modulex bricks

When you read this book, keep your mind open to every possible building opportunity. This book isn't an exhaustive collection of all the best LEGO models and how to build them. Instead, I'll show you some key techniques and methods—and the theories behind those methods—both in general and in the context of specific model categories, like buildings and spacecraft.

We'll start with some things you should know and do before you begin building, and then we'll explore specific LEGO elements, like minifigures, bricks, and slopes. Next, we'll dig into more general concepts, like creating textures, adding lights, and sculpting organically. We'll wrap up with design techniques based on subject matter, including animals, people, automobiles, and so on.

You'll also find interviews with top-notch LEGO builders scattered throughout this book. The interviews reveal how those builders design the models they're best known for. You can use their insights to learn new techniques and improve your models.

There's a lot of ground to cover, so let's get to work!

Inspiration

1

&

Preparation

For every artist, the most important step in the creative process is the first one: inspiration. Inspiration is what electrifies and excites us enough to spend days, weeks, months, and even years creating.

Inspiration for LEGO builders can come in an infinite number of forms. Perhaps it's the climactic scene in the year's most action-packed blockbuster or the lyrics of a great new song from your favorite musician. Or maybe it's a trinket at a local antique store that leads you to imagine a scenario that you feel compelled to construct.

No matter what inspires you, certain processes can help you get the most from your inspiration so that you can build the best model possible. I'll describe how to look at the world and visualize your final model, help you set up your work environment, show you some basic building tools, and discuss the most useful LEGO elements to gather before you build.

The Plastic Perspective

The first step in the LEGO creative process is one that develops over time: learning to look at everything with "LEGO eyes"—that is, looking at the world with LEGO elements and colors in mind and visualizing how a certain subject might look if it were built from LEGO elements. After a while, the real world begins to look blockier. I call this the *plastic perspective*. Developing and perfecting your plastic perspective is fundamental to the model-building process. Once you've reached the stage where you can look at something and know which elements you would use to build it, you know you've got the plastic perspective.

When sculpting with clay or metal or building models from wood or foam, you have the option to strive for accuracy and verisimilitude. This isn't the case when modeling with LEGO pieces— to some degree, your builds will always have a slightly blocky aesthetic. By developing your LEGO eyes and seeing with the plastic perspective, you learn to predict the extent of that blocky aesthetic.

Say you decide to construct a chrome gold spaceship you saw in an old science fiction comic book. Let your imagination run wild. How would the ship fly? What powers it? Who's inside? Ultimately, you can build anything out of LEGO elements, but not always at every scale, in every color combination, or with the best techniques. One major challenge of model building is that you have to be practical; your tools and resources are limited. When building the chrome gold spaceship, the most obvious limiting factor is the lack of chrome gold elements. You won't even find enough in the aftermarket. Unless you're willing to wait decades to compile the best chrome gold brick collection in the world, you'll have to forget the color that originally inspired you. But you can still focus on building that spaceship in a way that evokes the original. You'll need to make the same sort of compromises with other components as you consider the size, shape, and scale of your model. By determining which colors, shapes, and scales will work with your subject before you snap the first pieces together, you'll have a strong foundation on which to proceed.

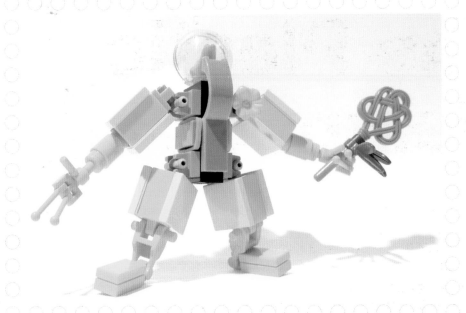

Colors

Pay close attention to the colors of your subject. Search for LEGO elements by color with online databases such as Peeron (*http://www.peeron.com/*) or BrickLink (*http://www.bricklink.com/*). If you find the ones you have visualized in the correct colors, you should be in good shape to move forward.

As you work on your projects, you'll learn more about LEGO elements and the colors they come in. In general, the more basic the color, the more elements available in that color. A light yellow model will be more difficult to construct compared with a standard yellow one, because fewer light yellow parts are available. But that doesn't mean it can't be done. If you do choose to build in a scarce shade, your model will be more impressive.

This small mech, piloted by a LEGO frog, is affectionately named *Buttered Toads*. This odd little model boasts an equally odd color scheme, made up of yellow, light yellow, medium green, and medium blue. The unusual color combination of several rare shades makes this model bright and visually striking.

If you can't find the right elements, don't resort to painting bricks to get the color you need. In the LEGO community, painting elements is like cheating because it eliminates a major building challenge—collecting the right pieces. But more important, by painting pieces you diminish the artistic impact of models that use unusual or rare shades of bricks. If people become accustomed to seeing painted elements, when they see a truly impressive use of a rare color, they won't care or simply won't believe it.

Shapes

When considering a subject for your build, look at its angles, lines, and curves to identify which LEGO elements could be used to replicate them accurately. Try to visualize your subject as if it were made out of giant LEGO elements (maybe even imagine yourself as a minifigure at its scale). Can you identify slopes, wedges, or other elements in your subject? You can match LEGO elements to your subject in two ways. First, you can look for elements that match its shapes exactly. For example, when choosing a windshield for an automobile, just choose the best-matching prefabricated one. Second, you can find simple assemblies that match sections of your model: If one wedge won't create the correct shape, maybe two connected in a certain way will.

Size and Scale

The larger your planned model, the easier it will be to shape; the smaller it is, the trickier and more puzzle-like the building process will be. Try to imagine the size of your model when translated to your chosen scale. Sometimes, you'll find that you can't build a subject at one scale but you can build it at another. If your first choice of scale seems unrealistic, try a different one.

There are a few main scales to consider when building. The most common is *minifigure scale*, where a minifigure represents the height of an average human (for the sake of convenience, usually about 6ft).

Two other scales to consider are *Miniland scale*, which is used in the Miniland displays at the LEGOLAND theme parks, and *microscale*, shown on the opposite page. Miniland scale uses figures around 10 bricks high, 3 bricks wide, and 2 bricks deep as the scaling standard. Microscale, on the other hand, describes anything smaller than minifigure scale.

Don't be limited by these standard scales. If none of them suits your needs, make up your own!

Five Stud Kingdom by Sean and Steph Mayo takes microscale to a whole new level. Notice that they use a **LEGO** Technic spacer as a turret, brushes for trees, and flowers for clouds! Even builders with small or limited collections can build amazing, grand models at microscale.

Reference and Research

Whether you're a novice builder or a long-time enthusiast, search for existing models of your subject to use for inspiration and reference. With so many models showcased on the Internet, chances are good that you'll find one similar to your idea. Try sites like Brickshelf (*http://www.brickshelf.com/*; a dedicated LEGO gallery), MOCpages (*http://www.mocpages.com/*; another LEGO gallery with significant user interactivity), and Flickr (*http://www.flickr.com/*; a photography website that's become the main haven for the online LEGO community).

Many novices think they can build their models to look exactly like their real-life counterparts, but that's usually unrealistic, especially when building at minifigure scale. Not even elite builders can build a completely accurate model because LEGO elements have inherent limitations. Compromises will always have to be made on a model's design, whether that's forgoing functional doors on a DeLorean or skipping the cargo bay on a spaceship. That's why already-constructed models of your subject make the best references—they'll help you determine where you may have to make compromises in your own model.

In addition to studying already-built models, look for actual blueprints and other real-life references, including photographs, diagrams, and drawings. The more research you do, the better acquainted you'll be with your inspiration and the better your end product will be.

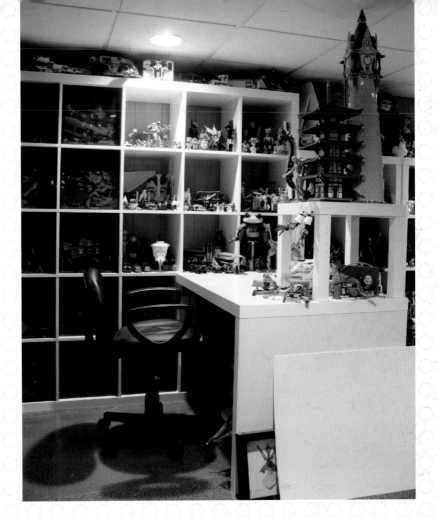

My basement work area. Notice the large white desk, ample light, and numerous shelves for displaying models.

Your Work Environment

There's really no stereotypical LEGO building area. Some folks build on the floor, some on the bed, and others on the kitchen table. Most people don't think too hard about their work areas, but an unsuitable work environment can affect your finished model. Consider factors like your work surface, lighting, and nearby distractions before settling down to build. Here are some ideas for setting up your work area.

Your Building Desk

Dedicate a desk to building models—the bigger, the better! I make a huge mess when I build, and a larger desk makes it easier to sort through my elements.

Your desk is like your canvas, so give yourself plenty of space. A white desk is great because the contrast between the white of the desk and the colors of the parts makes it easier to locate them. Inexpensive desks make the most sense, especially if you're buying one just for LEGO building. Despite their small size, LEGO elements can damage surfaces, so why not use a cheap desk from a flea market rather than a family heirloom?

Make sure your desk is well lit. You don't want to dig around for a missing part in near darkness. Put your desk near a window, if possible, and place a good lamp on the desk for extra light or for nighttime building.

Indispensable Building Tools

A typical palette knife

Different people like different tools when working with LEGO pieces, but certain tools are indispensable, so you should always keep them handy.

Palette Knife

A palette knife has a thin, flexible blade and is usually used for mixing artist's paints. I find that it's often more useful than the brick separator, because it can be used to remove any element the brick separator can, and then some. But it can also easily damage parts, so it shouldn't be used with rare elements.

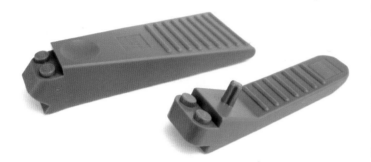

Brick Separator

There are two kinds of brick separators. The early version is bulky and only good for removing bricks or plates from each other, whereas the newer one is slim, sleek, and much more versatile. In addition to its brick- and plate-removing abilities, the newer separator has a small axle at one end that you can use to push pins and similar items out of Technic holes; the other end tapers to a thin lip for removing tiles. The brick separator is a great little device that often comes free with expensive sets.

Drawing Tools

Gather some pencils, a pencil sharpener, an eraser, and a notebook. Sketching your subjects will help you visualize them so you'll better understand their shapes and how to bring them into three dimensions with LEGO elements.

Tape Measure

A small, flexible tape measure will also come in handy, especially when the size of your model is a concern (either for moving or display reasons). If you build massive or life-size models, however, a heavy-duty tape measure is a better option.

Fighting Builder's Block

Sometimes we just draw blanks when building LEGO models—that's builder's block, which is similar to writer's block. That's when I find websites like Brickshelf, MOCpages, and Flickr useful for inspiration. When visiting these sites, try browsing randomly. You may be pleasantly surprised by what you find. Some sites let you select "favorite" images, which will be accessible later if you want to view them again. I find that browsing through my favorites is the best way to overcome builder's block. Apply this same idea in a more real-world way by going through your book or film collection to see if anything stands out. Odds are good that something in your collection will inspire a build.

A more practical cure for builder's block is to join an online building contest. Several are usually running at any given time, and many offer prizes. The subject isn't always the inspiration as much as the prizes or awards offered. After all, who doesn't like to win free stuff?

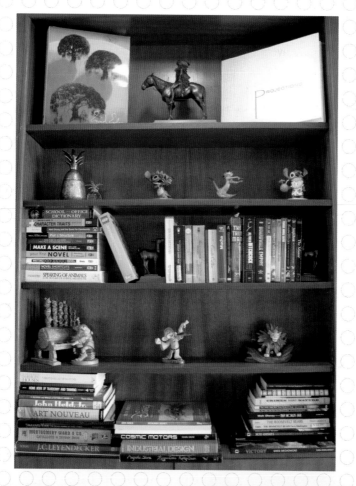

My bookshelf could yield a million ideas for models—I can find inspiration in art and design books, novels, films, or even the statues that decorate the shelf.

Essential Elements

Personal building styles are developed through continual building. As with most art forms, a person doesn't set out to choose a style; it forms naturally. In the case of LEGO modeling, a significant factor that defines your style is the elements you use often. If you have favorite elements, you probably treat them like gold. When you dig through your LEGO collection and find one, you put it aside. Maybe you keep a secret stash of them somewhere. (We all do.)

Be proactive. Buy lots of your favorite elements so that you'll have them as your stock dwindles. If you know you will be using 50 half pins in your next model, why not have them ready to go? You should stockpile certain other elements in addition to your favorites, as I'll discuss in the following sections. Though these elements may not always solve your building problems, you'll find them useful due to the connection points they make possible as well as their size and distinctiveness.

You'll notice bulky bricks are not on the list. The elements I've listed are small, so they'll fit in more places than larger elements. You can do amazing things with large specialty elements, like Galidor parts (a LEGO science fiction theme from 2002), but most bulky pieces spend time collecting dust. It's the little ones that are most useful, so collect a bunch.

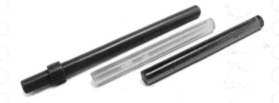

A 6L bar and two 4L bars

318 Bars

A 318 is a bar or shaft (anything a minifigure hand can grip). Many of us remember the first release of the straight shaft used as a lightsaber blade in the first Star Wars sets—a favorite element among many builders. They're available in a variety of colors and sizes. Bars are measured by length in studs (L), so a 4L bar is 4 studs long, a 6L bar is 6 studs long, and so on.

Travis Bricks

The travis brick is a bona fide powerhouse of connections. This modified brick first debuted in 1985 and, unlike many other elements, has remained unchanged.

The hollow studs in the travis brick allow for multiple connection points. Not only can you place bricks and other stud-based elements on its sides and top, you can also place 318 bars inside the studs. The travis brick comes in several colors, and you'll even find unreleased versions — leaked from LEGO HQ—in unusual colors in the aftermarket.

Pneumatic Ts

The pneumatic T is a functional element used for connecting pneumatic tubing. This unique bar has a tiny hole that runs through it, allowing for the passage of air. This element is basically a T-shaped 318 bar that can be used for detailing.

Two versions have been released since 1984. The current version features a subtle slope on each of the element's three ends so that the pneumatic tubing can be slipped on easily. A popular technique uses the element as a hinge by adding two 1×1 clips to the top and slipping the short end through a travis brick.

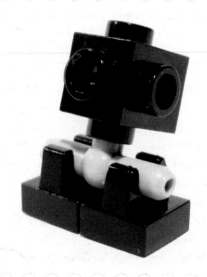

(TOP) **The current style of the pneumatic T** (BOTTOM) **The pneumatic T can be used as a versatile hinge assembly. The T allows for articulation in the grip of the clips and around the stud of the travis brick through which the T is attached.**

Finger Hinges

The finger hinge is two elements in one; it's the single most useful hinge ever produced. Unfortunately, these hinges are no longer in production and have been replaced by the click hinge system due to strength issues. But fret not: Because they were one of the only hinges produced for such a long time, they're reasonably common and cheap in the aftermarket.

Although click hinges are much stronger than finger hinges, they're not nearly as versatile. Click hinges are usable only in the click hinge system, with a male or female click hinge element that fits with its counterpart. Finger hinges work with a diverse group of elements; any element having the width of the hinges' fingers can be placed between them. More important, finger hinges can be placed at any angle, and they come in a variety of colors (including the standard black, white, and grey).

(TOP) **A blue finger hinge** (BOTTOM) **This assembly demonstrates that other elements can fit between the hinges' fingers; in this case, a lever and a flag are easily wedged in between.**

Flexible Hoses

By flexible hoses I don't mean pneumatic or stiff hoses, both of which are still produced. The flexible hose is as wide as the 318 shaft but rubbery and bendable. It was produced in lengths of 5, 7, 9, and 12 studs and in brown, yellow, and black until 2003. Because it's out of production, it's scarce and pricey nowadays. However, this part can make for some very interesting connections and detailing. Flexible hoses work best with minifigure-scale details (like furniture) because they can bend into very small and specific shapes—a rare type of control that most elements do not offer. Although they can be hard to find, most LEGO aftermarkets will have some available for purchase.

(LEFT) **A yellow flexible hose with a minifigure hand stuck in one end** (RIGHT) **This build by Michael Jasper uses flexible hoses to create a charming rocking chair with round armrests and legs.**

Minifigure Hands

Anything LEGO produces can be used as an element, including the minifigure hand. Still, many enthusiasts won't take minifigures apart, even though their parts can make great elements for detailing. Minifigure hands are useful because you can clip them to other pieces; you can also slip flexible hoses over their wrist stumps, creating a valuable combination of a flexible hose with a clip on the end (as shown on the previous page). For detail work, minifigure hands can give your builds a wonderful barbed or spikey effect.

Although your minifigures may disagree, hands make phenomenal building elements.

1×1 Clips

The 1×1 clip is a tried-and-true classic. It takes up a 1×1 stud footprint in the LEGO grid and can hold any 318 shaft or attached clips on each of its two pincers. The clip comes in a huge variety of colors and is very common, so you should be able to get it in the color you need at a reasonable price. This element has been around since 1989 and was unchanged until 2011, when a newer version featuring a tiny slit between the two pincers was released. Don't worry, though; the change doesn't affect the piece's functionality.

Cheese Slopes

The 1×1 slope is affectionately known as the *cheese slope* because of the yellow version's resemblance to a small wedge of cheese. Like the 1×1 clip, the slope is very common and comes in numerous colors. Its slope is at a 30-degree angle, and it has a tiny footprint, which means it can fit in more places than any other slope.

Perhaps the most important thing about this element is that the slope itself has no stud, which makes it very adaptable. A downside to this element is that the inclines will not line up without building a complicated assembly to match the tiny raised edges at the bottom of the slopes' inclines.

A black 1×1 clip and a yellow cheese slope

Pistols

Bang bang! Here's a strange selection that may surprise you: the pistol. This element is often used as a hinge or joint. This element demonstrates one of the most important rules of LEGO building: Look at everything as a building element. The pistol is more than a minifigure accessory; it's an angled 318 that can be used for details and hinges. To make a subtly angled hinge, you can add a clip on one end and place the handle through a travis brick. You can spin the handle end in the travis brick hole and move the clip around the barrel of the pistol.

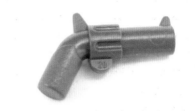

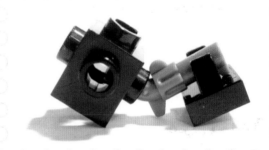

(TOP) **A dark grey minifigure pistol** (ABOVE) **This unusual assembly is built with pistols and 1×1 clips. It shows some of the angles that the pistol allows.** (LEFT) **A hinge assembly made using a pistol**

Half Pins

Finally, the half pin—probably a builder's most used element. The half pin, created in 1980, comes in light grey, white, or blue. It adds a hollow stud to any Technic hole or tube, and it works beautifully as a detail element: an upside down white one makes a convincing candle. It also comes as an extra element in LEGO sets, making it abundant and inexpensive.

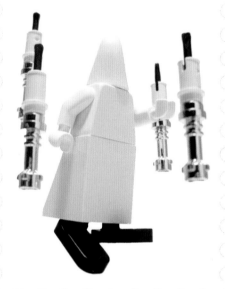

(TOP) **A light grey half pin** (BOTTOM) **A spooky phantom levitating with four candles made of screwdrivers and white half pins**

Minifigure 2 & Company

Let's meet the minifigure (or minifig, as it's often known). If you've played with LEGO at all, chances are you have already met. Not only has the minifigure been a staple of the LEGO experience for decades, it's become a pop culture icon across the globe.

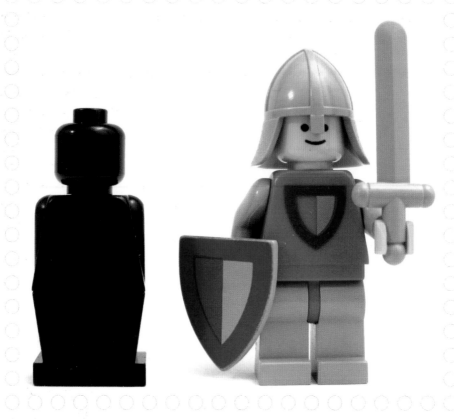

The minifigure was born in 1975. The original resembled the modern minifig, minus the arms, articulation, and charm. Some early figures sported headgear, like flat caps and cowboy hats, but the figures themselves weren't very interesting. Their lack of arms and moveable legs didn't help. The version we know today was released in 1978 and gave LEGO models a new level of personality.

(LEFT) **The original minifigure form has legs made of one solid piece, is all one color, and has no arms.** (RIGHT) **A castle minifigure from the 1970s. When compared with the castle minifigure, it's clear why the first form just didn't cut it.**

Along with the new minifig's articulated body came the classic smiley face. This head was the only one available for a decade, and it became a company trademark. But as successful as the new minifigure was, its design was stagnant. To add variety, in 1989 the LEGO Group introduced rogues with mustaches in the first Pirate line. Since then, the list of minifigures has become even more diverse, including famous characters like Darth Vader, Buzz Lightyear, The Joker, Indiana Jones, and more. Now, that's variety. Whatever you're into, chances are good that there's a figure relevant to you, especially with the introduction of product lines like the Collectible Minifigures series.

Besides being simply fun, minifigures add a human component to LEGO models. They convey emotion, action, and scale, which makes them important, popular, and collectible. Without the minifigure, we'd have only bricks, plates, and slopes: cold chunks of interlocking plastic. The minifigure transforms those pieces of plastic into a chair to sit on, a house to live in, or a car to drive. For many builders, constructing minifigures is the most fun aspect of designing a model, because building a minifigure is a bit like playing God, especially when combining figure parts in outlandish ways. Minifigures can be anything we want them to be: just snap together a head, torso, and legs, and the minifig instantly comes to life.

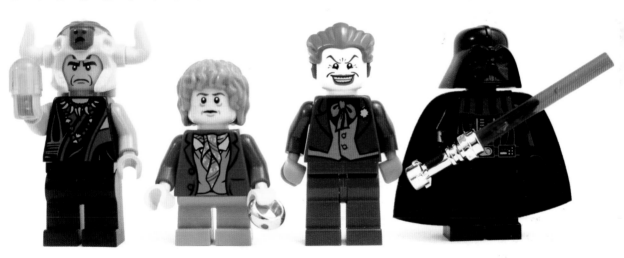

A small selection of licensed minifigures from various sets

Anatomy of a Minifigure

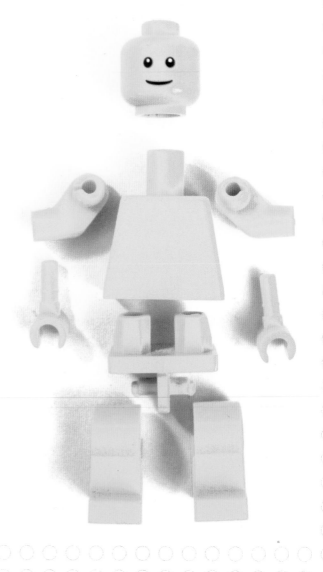

The minifigure is made of nine different elements.

The minifigure is made of three basic parts: head, torso, and legs. The torso and legs are made up of individual parts themselves. The torso is five separate pieces: the torso itself, a left arm, a right arm, and two hands. The legs are three parts: the hips, a left leg, and a right leg.

Basic minifigure parts have come in many variations, like Redbeard's peg leg and hook hand from the original Pirate line or the spring-loaded feet and one-piece molded hands that hold mini-fig-size basketballs from the NBA-licensed line in the early 2000s. Tall legs and unarticulated short legs are also available, as are robotic arms, rock-monster arms, giant crab claws, boxing gloves, and mermaid tails.

A selection of minifigure limb variations, including bat-wing arms, a genie tail, a peg leg, a hook hand, and a mermaid tail

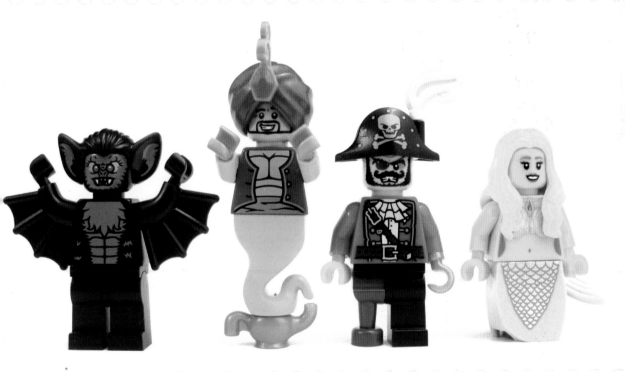

Skin Tones

What's the best skin tone to use? Is it flesh or yellow? Everyone has an opinion on the topic. This debate, started over a decade ago, will probably never be settled.

For years, the LEGO Group used only the generic yellow skin tone, but everything changed in 2003 with the release of the "fleshies" in a wave of *Spiderman 2* and NBA-licensed sets. According to the LEGO Group, flesh tones are used only when a minifigure is meant to represent a real-life human character. And as you can see in the image to the right, multiple shades of flesh have been produced.

Every builder has a preference. Some builders use only yellow for skin tones, while others use one of the flesh tones. And, of course, some people use a combination.

When your goal is to build realistic models, flesh-toned figures are usually the best option. They simply look better in detailed models because they are designed to represent real people.

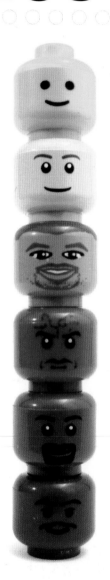

Six flesh tones make up the LEGO spectrum.

Strike a Pose

One important way to add realism to your minifigures is by posing them. Minifigures are small and subtle, but just as small and subtle detailing is important to the realism of a building's façade, so too is the detail in your minifigures' poses.

Although the minifigure isn't an anatomically correct representation of the human body, we can still draw parallels between the two. The swivel of the head is easy to get right—just don't turn it around too much! The legs are also easy to pose because, like the head, each leg only has one point of articulation.

The hands and arms, however, present a bit of a challenge, and it's common to find them posed in odd ways. Look closely at the hand, and you can see that it's bilaterally symmetrical but horizontally asymmetrical. The "bottom" of the hand tapers.

When you think of the vertical half of the hand closest to the torso as the thumb and the outside half as the remaining four fingers, you'll find it easier to create many poses. Turn the hand horizontally either way, and you have a fist. Turn the top of the hand inward towards the torso and keep it at the waist—your minifigure has its hand on its hip, striking a feisty pose. Turn the top of the hand horizontally outward away from the torso and place it at shoulder level, and your minifigure is hitchhiking.

The Haunted Mansion's hitch-hiking spooks, Phineas, Ezra, and Gus

Be patient and experiment. You'll surely find a pose suitable for whatever your figure happens to be doing in the context of your model.

Of course, you can also use nonfigure parts to achieve poses that the standard parts don't permit. For example, stick a cow horn into a minifigure's torso arm socket. It fits in there snugly, and you'll be able to pop it back out through the bottom of the torso. This gives you a 318 bar sticking out from your torso, and you can attach a wide variety of elements to it. Or insert a flexible hose into the shoulder sockets, and run it through to the other side to create a figure with its arms sticking out.

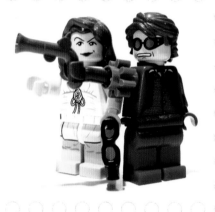

You could also replace the left leg with a right leg with the outer side facing forward (or vice versa). Now your figure is posing with its leg outward, as if it's modeling. Better yet, remove the hip joint, and replace it with two 1×2 plates. Put both legs in the two studs in front of the figure to create a sitting or curled-up pose. Do this with only one leg to make your figure kneel.

(TOP) **A cow horn inserted into a minifigure's arm socket. You can connect hundreds of different elements to the exposed 318 bar.** (MIDDLE) **This steampunk minifigure has a flexible hose running through his torso to replace the standard right arm.** (BOTTOM) **A sitting minifigure, curled up**

When posing figures wearing helmets, hats, or masks that cover their entire head, try replacing the head with a Technic ball. The ball allows you to pose the helmet looking up, down, or cocked to the side. Because the helmet conceals the ball underneath it, it will look like your figure's head is looking in whichever direction the helmet faces.

A Technic ball concealed under a helmet allows for dynamic head posing.

You'll have to remove minifig limbs for many of these poses. Whenever you are disassembling minifigs, be warned: swapping out hands won't damage the hands or wrists, but removing the arms will loosen the shoulder joints and make them brittle over time. Eventually, the socket could become too loose to support an arm that's holding an accessory, especially with older minifigures that haven't been posed in a long time.

The Extended Family

Since the late 1970s, the LEGO-sphere has seen other figures, such as FABULAND figures and Belville figures. These figures are compatible with the LEGO system, and many of their parts are interchangeable with those of standard minifigures, so you can use them in models. Although many of these figures are obscure, they have useful elements you can use to build better models.

FABULAND Figures

The FABULAND figure, produced from 1979 through 1989, was one of the first major variations on the minifigure. The FABULAND theme starred adorable animal characters. As a building system it fell somewhere between DUPLO and the full-fledged LEGO system and was envisioned as a transitional product between the two. The figures featured the same articulation as the minifigure except that they lacked a removable hand and had a ball-socket neck.

A preschool version of *The Birds* (1963)

Unlike the minifigure, FABULAND figures weren't meant to be taken apart during play, but they can come apart. Although their legs are snugly fixed to the torso, if you pop out the red bar through the hole that fixes the legs to the torso, you'll free the legs.

The arms come out a bit more easily. Look closely, and you'll see that the peg on the FABULAND and minifigure arms is identical. You can give a FABULAND figure minifigure arms or vice versa without having to do any extreme modification. In the photo below, a FABULAND monkey sports red minifigure arms, while a minifigure gorilla has black FABULAND arms. Using FABULAND arms on a minifigure creates an "arms by your side" pose.

The heads of the FABULAND figures are also easy to remove, because they're attached to a ball-socket joint. You can remove the grey ball head of the later figures from the base of the head. (But don't try that with earlier figures—if you try to remove their heads this way, you'll break them off.)

Once you've removed the ball, you'll be able to stick the FABULAND head on a minifigure neck stump. There are many silly combinations to be had here, such as creating mascot-costume figures like the alligator-headed minifigure shown below.

A FABULAND monkey with minifigure arms, and a minifigure gorilla with FABULAND arms

Go Gators! Here's an alligator minifigure with a FABULAND head. These combos make great mascot-costume minifigs.

Belville Figures

The Belville figure is wonderfully articulated and significantly taller than the standard minifigure. Several types of Belville figures are available. The most recent ones lack bendable elbows and knees (which makes them useless for posing and building with), but earlier ones, including the adult male and female body types and the standard child figure, can be very useful.

You'll probably find the child figures most useful because they're closer in size to the minifigure. They have ball-socket necks and posable shoulders, elbows, hands, hips, knees, and feet. I like to put FABULAND heads on Belville bodies. Other popular combinations include sticking a Belville figure arm into the end of a standard minifigure arm, a technique often used to create tall minifigures or mythical hybrid minifigure creatures, such as centaurs.

A lion king—if only he were king of the forest.

A standard Belville figure

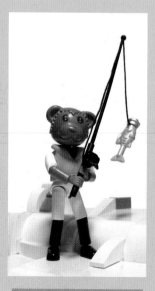

A bear fishing. He prefers a fishing rod to his own paws.

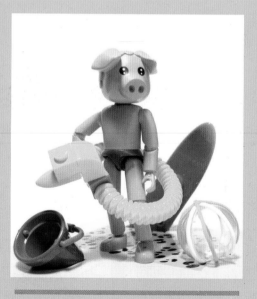

A pig enjoying some warm weather. He always hogs the best spots on the beach.

Technic Figures

The Technic figure is uncommon and not very customizable. While highly articulated, most people find it difficult to build with.

The arms and legs are the most useful elements of these figures, but even if you come up with some creative ways to use them, you'll probably find that there aren't many ways to reliably attach them to your build. The legs are slightly easier to use because they have Technic pinholes in their sides, while the arms have no usable connection points.

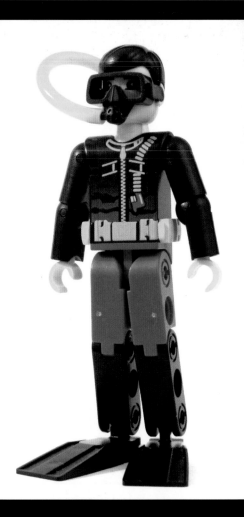

(RIGHT) **A Technic figure decked out in scuba gear** (BELOW) **A Technic figure leg and foot: the foot is 1×2; the leg contains two usable pinholes.**

A Minifigure Rogues Gallery

One of the most fun things to do is to try to build instantly recognizable minifigures of real people or popular fictional characters. You can make anyone into a LEGO minifigure, and it's especially exciting to build minifigure versions of subjects that LEGO would never release officially. Here are some examples!

From left to right: Rocky, Dr. Frank-N-Furter, Brad Majors, and Janet Weiss from *The Rocky Horror Picture Show* **(1975)**

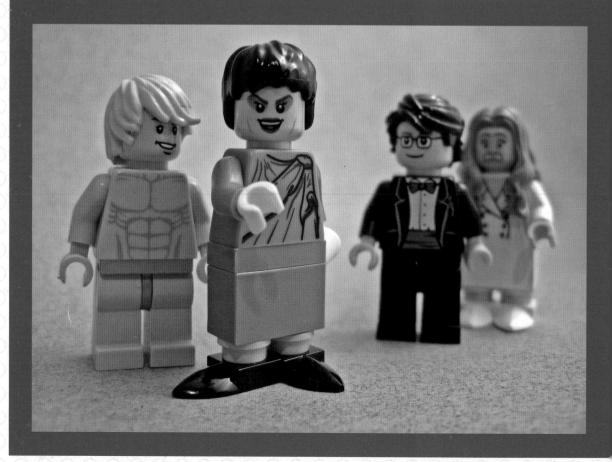

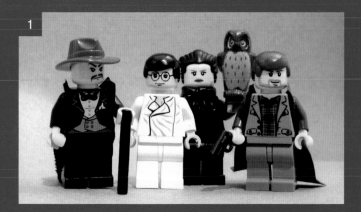

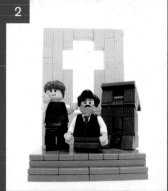

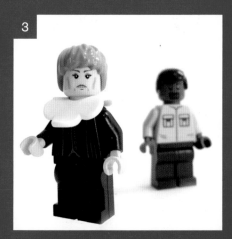

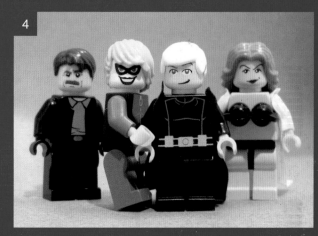

(1) **From left to right: Gaff, Tyrell, Rachael, and Deckard from** *Blade Runner* **(1982)** (2) **Eli Sunday baptizes Daniel Plainview in this vignette based on** *There Will Be Blood* **(2007).** (3) **Judge Judith Sheindlin and bailiff Byrd from the American television program** *Judge Judy* (4) **From left to right: Leon, Pris, Roy, and Zhora from** *Blade Runner* **(1982). Zhora's torso features a popular technique—two lever bases and an elastic band—to make it more anatomically accurate. The trench coats are standard minifigure capes, with the neck holes attached to each arms' shoulder socket.** (5) **A lanky Ichabod Crane from "The Legend of Sleepy Hollow." This figure features 4L 318 bars for legs. Attached to the torso with minifigure hands, these bars give the figure height and an interesting style.**

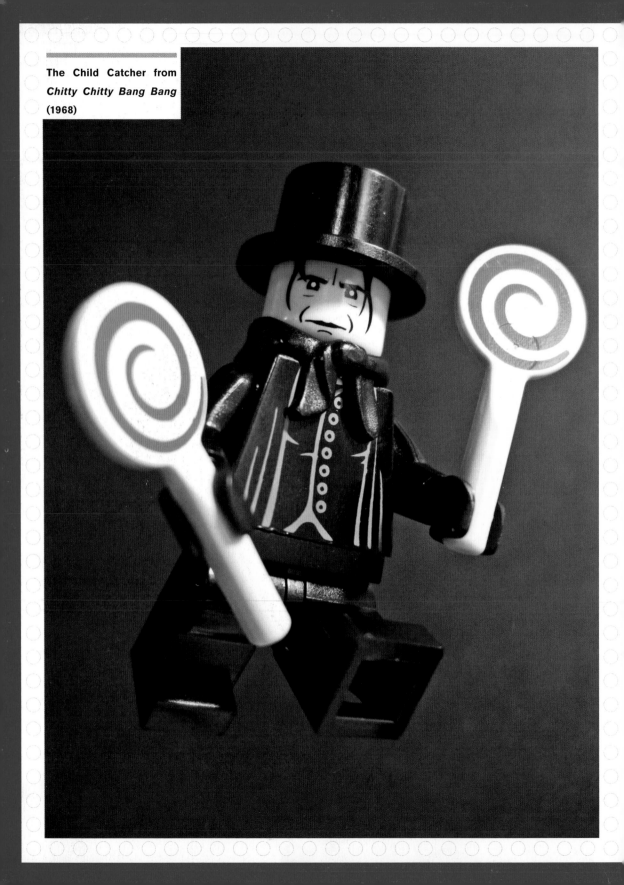

The Child Catcher from
Chitty Chitty Bang Bang
(1968)

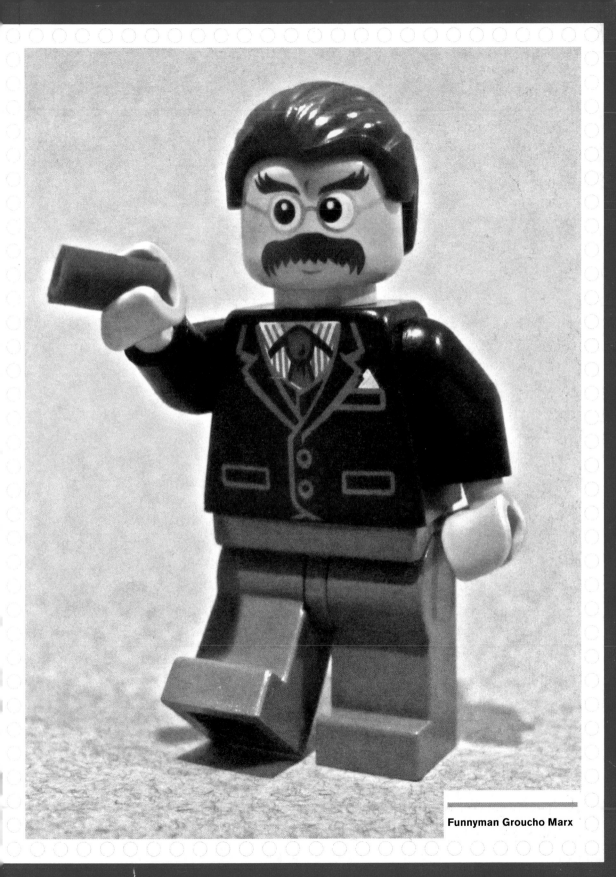

Funnyman Groucho Marx

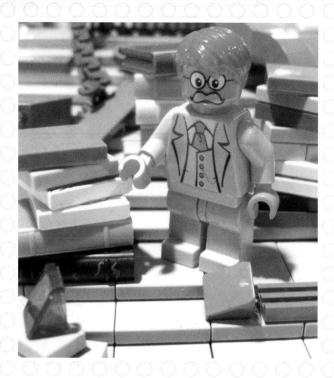

Henry Bemis from *The Twilight Zone* ("Time Enough at Last," 1959)

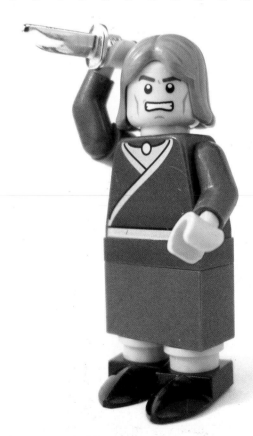

Norman Bates as "Mother" from *Psycho* (1960)

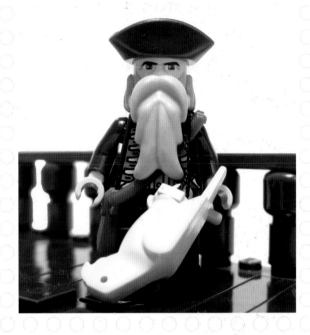

Hannibal Lecter from *The Silence of the Lambs* (1991). His straightjacket is made of a 1×2 white tile with white elastic bands wrapped around it.

The unfortunate sailor with an albatross hanging around his neck from "The Rime of the Ancient Mariner"

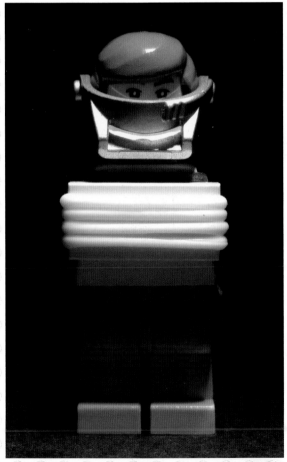

(NEXT PAGE) **From top-left, clockwise to middle: Michael Myers (*Halloween*, 1978), Buffalo Bill (*The Silence of the Lambs*, 1991), Reverend Kane (*Poltergeist II*, 1986), Patrick Bateman (*American Psycho*, 2000), Herbert West (*Re-Animator*, 1985), Hannibal Lecter (*The Silence of the Lambs*, 1991), Jack Torrance (*The Shining*, 1980), Life Form (*The Thing*, 1982), Fr. Jon McGruder (*Braindead*, 1992)**

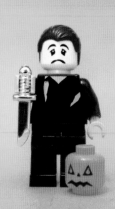
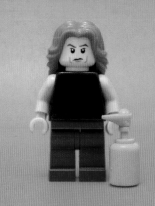
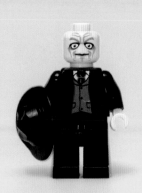
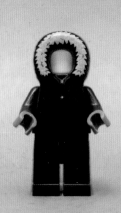
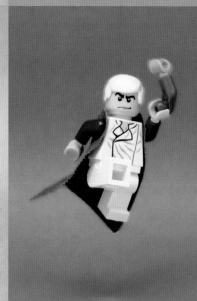
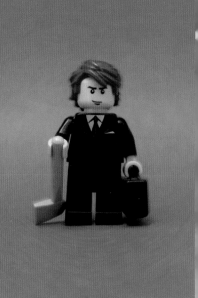
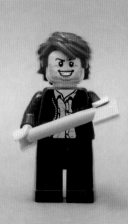
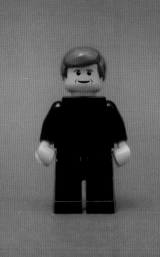
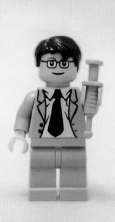

3

Bricks, Slopes, & Studs

The most basic LEGO elements are bricks and slopes. Although you can use these elements in countless ways, you must first master a few rudimentary techniques. We'll begin with bricks, move on to slopes, and finish with what they have in common: studs.

Bricks

The LEGO brick may be the single most iconic piece of plastic ever manufactured. It's over 50 years old and still going strong. Its patented tube-and-coupling system has been the cornerstone of every LEGO element that's been produced. Now that the patent has expired, competitors can manufacture copycat LEGO pieces, but the quality of these fakes doesn't even come close to the real ones, and it's doubtful that it ever will.

Whereas other companies make a variety of toys, the LEGO Group focuses on its building system. This allows the company to meet its high quality standards and means that LEGO bricks are the best to build with. Even if your collection spans generations, all of your bricks are compatible because the LEGO Group has maintained the same quality control specifications over the years.

A chrome gold brick, perhaps the best metaphor for the quality of LEGO products

A sampling of some special bricks

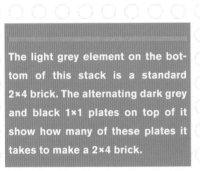

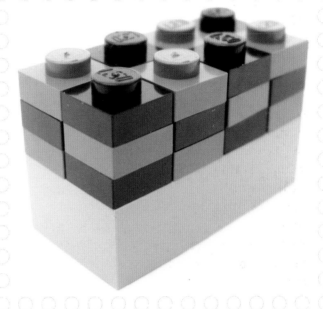

The light grey element on the bottom of this stack is a standard 2×4 brick. The alternating dark grey and black 1×1 plates on top of it show how many of these plates it takes to make a 2×4 brick.

LEGO bricks come in a huge variety of sizes and colors. In addition to the basics, you'll find modified bricks, like Erlings (headlight bricks), anti-Erlings (headlights, minus the lip), bricks with clips, bricks with Technic pins, and so on.

Even with so many types of bricks to choose from, innovative LEGO builders tend to build models out of everything *except* bricks. Some builders even compete online to see who can use the most obscure elements in the most interesting ways.

I use fewer bricks than any other element because bricks take up valuable real estate in models. For example, the classic 2×4 brick takes up the space of 8 1×1 bricks. That's the equivalent of 24 1×1 plates! That's a lot of space in a small model for which you must carefully plan every cubic brick. When building models, you can't just put 2×4 bricks everywhere; to achieve optimal detail, it's important to build using small elements.

Plates

A plate is one-third the height of a brick. In addition to standard plates, you can use modified plates, like tiles, jumpers, plates with clips, and so on. These special elements allow connections and brick assemblies that yesterday's builders never dreamed of.

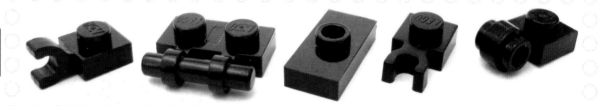

A sampling of some special plates

SNOT

SNOT (studs not on top) is a building style that flips a LEGO brick or plate on its side or upside down. There is not just one specific SNOT technique; SNOT encompasses any assembly in which the LEGO elements aren't oriented studs-up. You can find SNOT techniques used in official sets, such as the text-based signs in the modular buildings line.

A TASTE OF INDIA by Ralph Savelsberg, features one of the more complex uses of SNOT techniques—lettering. The bottom image reveals the reverse side of the sign, showing the complexity of such a structure.

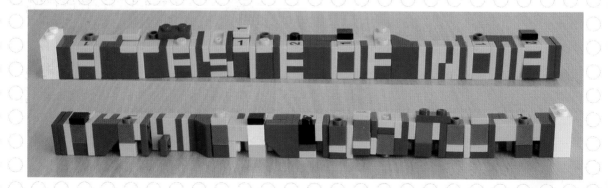

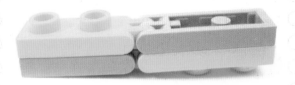

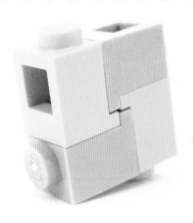

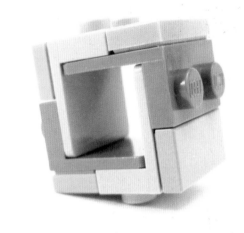

Once you've mastered SNOT, you'll find that a whole new world of building will open up to you. For example, the top-left assembly has elements facing up, down, left, and right. It is constructed of two black lamp holders, two 1×2 transparent tiles, two 1×1 tan tiles, and a 1×1 yellow plate. The black lamp holders lie on their sides and bear the two transparent 1×2 tiles facing up and down.

(TOP LEFT) **The black elements, lamp holders, lend themselves well to SNOT techniques because they bear three studs, all facing in different directions.** (TOP RIGHT) **By interlocking each half in the opposite direction of its counterpart, we end up with a 5×1×2 plate with four studs, two facing up and two facing down.** (BOTTOM RIGHT) **Four brackets connected in a square provide you with two studs facing up, down, left, and right.** (BOTTOM LEFT) **This is a classic example of SNOT—four headlight bricks attached in a square.**

This aircraft wing, also by Ralph Savelsberg, shows SNOT techniques employed to create a smooth slope. Look closely at this assembly to see just how complex it is.

Here is an extreme example of SNOT: an aircraft wing by Ralph Savelsberg. This builder used SNOT techniques to remove the steps that the cheese slopes at the edge of the wing would normally create. You can employ this level of SNOT work when it's essential that your model be as accurate as possible. For instance, the only way to achieve the correct angle for this airplane wing was to engineer the assembly so that the cheese slopes would line up smoothly.

The important takeaway: Just because one side of a brick or plate has studs does not necessarily mean that side is the top and the tubed side is the bottom. Think like you're building in a vacuum: There is no up or down, and everything is simply floating.

Expansive Structures

Bricks are particularly useful when building very large, plain structures, such as castle walls or sweeping landscapes. Depending on your style of wall, you may choose to build it using only bricks. Although many castle walls were aesthetically plain, when building them it's important to choose and blend your colors wisely to give the wall texture. And don't use too many bricks, even for seemingly plain subjects. Even though it's more parts-intensive, consider building large assemblies (like walls) from small elements: Using only bricks won't give you enough detail. Use bricks in moderation, and be sure to break up large walls with details like windows and doors.

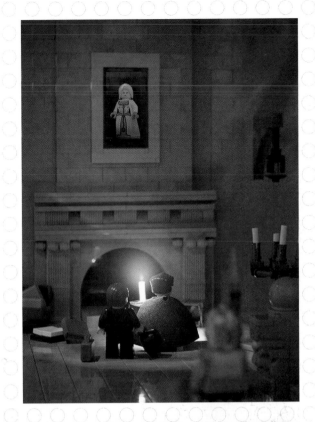

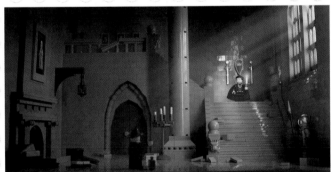

This remarkable model by Mark Kelso, *Dracula's Castle*, is a good example of how simple brick stacking can look very sharp. Notice that the walls are made predominantly from interlaced 1×2 bricks, which provide subtle texture. Details like the gothic door, fireplace, and window break up the expansive walls and make the model more interesting. This model is a beautiful example of "less is more."

Scattering Bricks

Bricks often look good when scattered loosely around a model. For example, you can use lots of blue bricks or plates to create water. Randomly sprinkled white bricks can also be used to mirror the choppy and ever-changing surface of the sea. You could also turn grey or earth-colored bricks on their sides to form rocky ground or a cobblestone surface.

This model, *Robin Hood Rescuing Will Stutly*, by Tyler Clites, uses grey bricks and slopes turned on their sides to create a cobblestone effect, complete with weeds sprouting from between the stones.

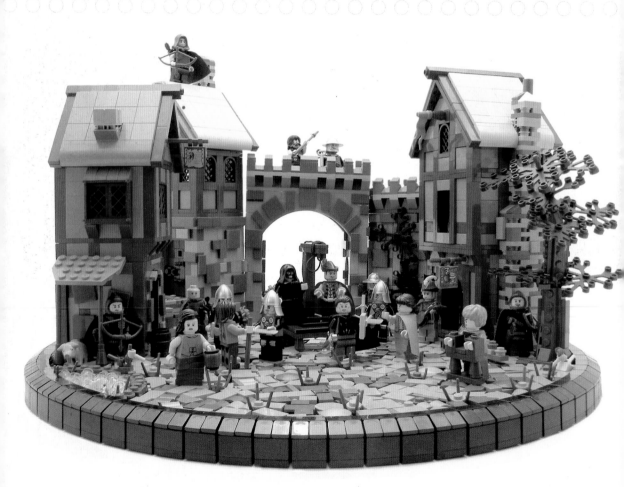

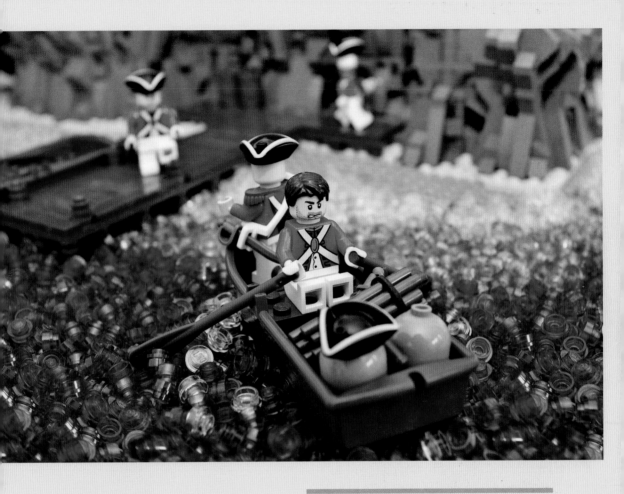

This close-up of *Colonial Outpost* by THE BRICK TIME Team (Sven Pätzold and Björn Pätzold) shows lots of transparent blue 1×1 plates used to make water. Notice how the lighter blue and transparent ones closer to the shore are used to suggest depth.

Slopes

Slopes were first produced in 1957, and although some shapes and textures have changed over the years, they remain an important basic piece. Before slopes were available, every incline in a set had to be built with bricks, resulting in a pyramid effect. When slopes were first introduced as roofing and shaping elements on vehicles, they added a very different aesthetic quality to models: realism.

Three basic types of slopes are produced today: *regular*, *inverted*, and *bows* (sometimes referred to as *curved slopes*). Regular slopes come in angles of 18, 33, 45, 55, 65, and 75 degrees and widths ranging from 1 to 8 studs. Convex and corner slopes are more limited in size and quantity, and they exist to complement their 33- and 45-degree brethren. Then there are inverted slopes, which also exist for angles of 33 and 45 degrees. Bows, the most recent slope variety, come in a reasonable range of sizes and shapes; the two most common sizes are 1×3 and 1×4.

A range of slopes, showing the curve they create when stacked in succession

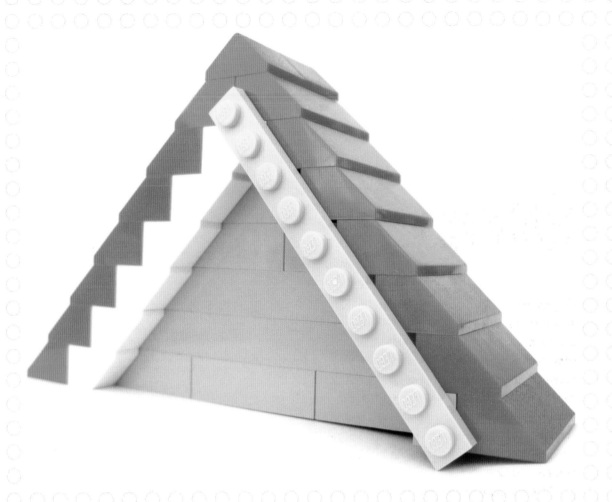

Roofing

Roofing is the most common use for slopes. But simply stacking slopes to create a roof won't conceal the steps on the edges. Any overhang at the edges of your building will give you enough space to add the appropriate inverted slopes to the underside of the blocky edges. You could also hide the stepped edges of a roof with plates or tiles facing outward.

Stacking slopes creates jagged steps on the edges. On the left side of this assembly, white inverted slopes fill in the red slopes' steps; on the right side, a tan plate hides them instead.

There are other ways you can create roofs aside from simply stacking slopes. One of the nicest methods uses the *cheese slope*. Cheese slopes are the best element to use for roofing in minifigure-scale buildings because they closely match the size of roofing tiles. In grey, this method makes especially wonderful slate roofs.

Instead of just making an incline with cheese slopes, use jumper plates to offset each row of slopes by half a plate, as shown below.

But no matter how you use slopes for your roofs, don't forget to mix in the odd accent color or two for a slightly worn and weathered look.

The Benbow Inn by **THE BRICK TIME Team (Sven Pätzold and Björn Pätzold) features a wonderful roof.**

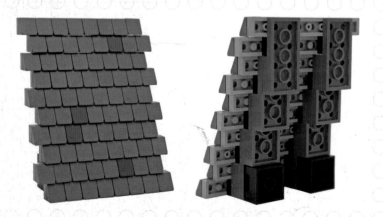

(LEFT) **A close-up of the cheese slope roof technique. Notice the brown cheese slopes added for a weathered effect.** (RIGHT) **A back view of the cheese slope technique. Black jumper plates offset each cheese slope row by half a plate.**

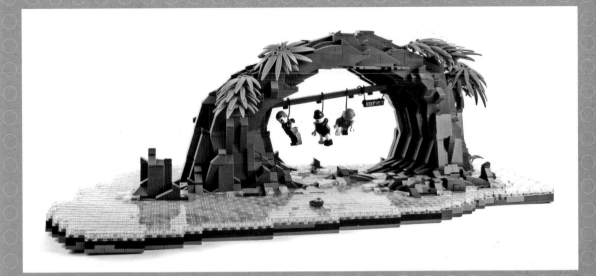

Rockwork

Another common use for slopes is in *rockwork*, which includes everything from small rocks peppering your landscape to grand mountains towering over your model. Given the seemingly random nature of actual rockscapes, it's sometimes difficult to create realistic representations.

When preparing to tackle the rockwork in your projects, look at some pictures of real rock formations to get a feel for them. To give your rockwork a natural look, avoid placing slopes randomly in your model, even if you think that the texture of real rocks seems random. And be sure to use lots of different types of slopes, not just 1×2 and 1×3 slopes.

This *Pirates, Ye Be Warned* model, inspired by the first *Pirates of the Caribbean* (2003), uses interesting rockwork, especially around the inside of the arch. It's built entirely from studs-up slopes.

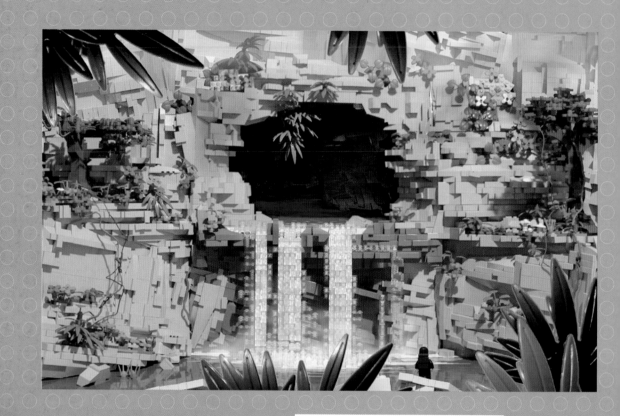

Apocalypsis: Journey Inward by Mark Kelso shows some dramatic rockwork using angled panels of rocks. Notice the dark grey pieces used for rocks around the waterfall, which make those rocks look wet from the waterfall and its mist.

Studs

The brick might be the iconic LEGO element, but studs are what make it so identifiable. Not sure if something is a LEGO element? Just check the studs—if they're branded with the word "LEGO," they're genuine LEGO pieces.

When I worked on the LEGO Creator line, I often needed to add studs deliberately because my style is about as different from Creator's as it can be. As with most LEGO lines, Creator encourages studs, but most models I built were completely studless. As a compromise between the two styles, I would place studs only in places where my subject had pro-tuberances in real life.

Studs make it obvious that a model is built with LEGO elements, so hiding them (as I do) departs from the LEGO aesthetic. If you want to hide the studs, the easiest way is to use tiles, which are just studless plates. Covering up the studded areas in your model with tiles is quick and clean.

From top to bottom: standard studs, hollow studs (jumper plates), tiles

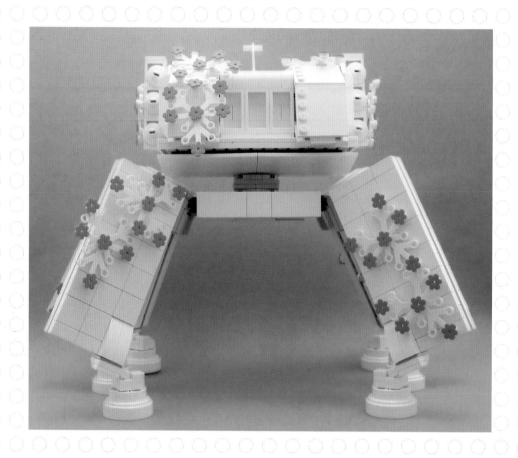

In some cases, however, placing studs strategically can help your model look even *more* realistic. The keyword here is *strategically*. For example, studs work flawlessly as bolts on the side of a robot or ship, as shown above. They can also add texture to natural, sprawling landscapes. Keep experimenting to decide where studs might work in your model, and eventually you'll find a nice balance.

This cherry blossom–camouflaged mech features a fine balance of studs and tiles. Strips of solid studs on either side of the mech's head run all the way to the back of the model. As some of the only studs on the entire creation, they look like exposed bolts. Meanwhile, large grids of white 2×2 tiles cover the mech's six paneled legs for a cold, mechanical, and futuristic aesthetic.

4 Patterns & Motifs

Making two-dimensional designs from LEGO elements is a fun but tricky way to add realism to LEGO creations. Katie Walker was one of the first builders to take LEGO mosaics to the next level. By using small plates, tiles, and cheese slopes in nontraditional ways, she creates patterns that are difficult to build with bigger elements.

First, let's take a look at how Katie achieves these amazing patterns. All of the photographs in this chapter show her innovative creations.

Introducing Cheese-Slope Mosaics

You can arrange 1×1 cheese slopes along with other small plates and tiles to create patterns, motifs, text, or other images. These cheese-slope mosaics can be stand-alone displays or components of larger models. For example, this technique is useful for building stained-glass windows, tiled floors, fancy carpets, and even lettered signs.

But how do these mosaics stay together? The pieces aren't usually attached to each other, but are instead pushed together tightly within a frame so they can't pop out. Because of the tension created when these elements are squeezed together, you can even tip the mosaic upside down without the pieces falling out.

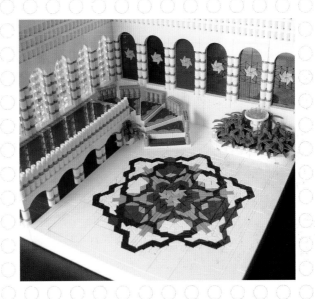

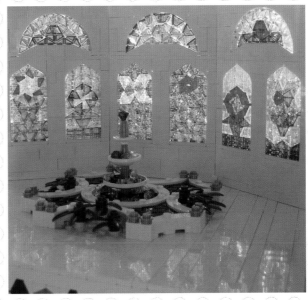

(TOP) **An elaborate floor tile decoration** (BOTTOM) **These stained-glass mosaics; the flowers really pop when light shines through the back.**

Measurements and Shapes

Before you get started, it's important to know the dimensions of your mosaic and the pieces you want to use. We'll discuss measurements in terms of *half-plates*—that is, half the height of a standard plate. For example, a 1×1 plate is five half-plates long and two half-plates high. Because three plates stacked on top of each other are the height of a brick, a 1×1 brick is five half-plates long and six half-plates high.

When you use cheese slopes in a mosaic, place them on their sides. The length along the bottom of a cheese slope is five half-plates, and the height is four half-plates.

Unfortunately, cheese slopes are not perfect 30-60-90-degree triangles, which makes them more difficult to arrange. The corner with the 30-degree angle has a blunt tip, approximately 1.2 half-plates in height. If cheese slopes were perfect triangles, it would be possible to create seamless patterns, but the blunt ends inevitably create gaps.

Arranging two cheese slopes together to make a perfect square is also impossible because of these wonky measurements. As I already mentioned, the blunt tip on a cheese slope is approximately 1.2 half-plates tall, so two sides of the rectangle will be 4 half-plates plus 1.2 half-plates, for 5.2 half-plates in total. Though this slight difference isn't noticeable over small sections in a mosaic, it adds up over larger areas, and you'll have to compensate for that in your patterns.

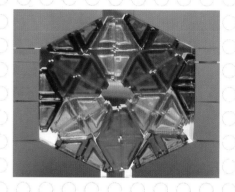

Notice the gap in the middle of this mosaic, created by the blunt ends of the cheese slopes joining in the middle.

2

5

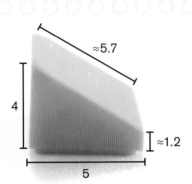

≈5.7

4

≈1.2

5

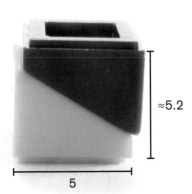

≈5.2

5

(TOP) **A 1×1 plate is five half-plates long and two half-plates high.** (MIDDLE) **A cheese slope is five half-plates long by four half-plates high.** (BOTTOM) **There's no such thing as a perfect cheese-slope square.**

Arranging Cheese Slopes

As you create a mosaic, you need to approximate shapes and slowly fill in the gaps until you have a pattern you like. It's rare that all of the elements will fit together perfectly in a frame, so simply try your best to build with as few gaps as possible.

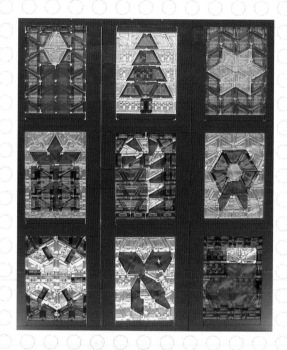

You can create a variety of shapes and images using only cheese slopes.

Squares

One of the easiest ways to arrange cheese slopes is to line up rows of slope "squares" and use different colors to create an image or pattern. You can orient cheese-slope squares in four different ways.

Occasionally problems can arise with this method because the shapes aren't really squares but rectangles. Gaps are not a major issue when arranging cheese slopes into squares, but the unequal heights and widths can add up in a large pattern containing multiple squares.

Other Shapes

Squares aren't the only place to start an interesting pattern. You can use cheese slopes to make trapezoids, rhombuses (and other parallelograms), triangles, rectangles, and hexagons.

Try tessellating these shapes and other variations with careful attention to color to create many fascinating designs. For example, this complex design is made from triangles (fourth row, second shape) that are in turn made out of trapezoids (top row, third shape).

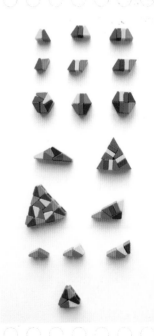

More Complicated Mosaics

Some mosaic designs just can't be built by arranging cheese slopes in an orderly fashion. If that's the case for your mosaic, first try to create the image you have in mind with cheese slopes and 1×1 tiles (or plates and bricks), and then fill in the gaps with other slopes and tiles.

In her spider mosaic shown below, Katie first arranged white slopes and tiles into the shape of a spider's body. After some experimentation with different shapes and angles, she filled in the negative space with black elements. The filled shapes included rectangles, triangles, trapezoids, and hexagons. A few small gaps remained when the mosaic was finished, but black is a forgiving color, so the small gaps aren't obvious.

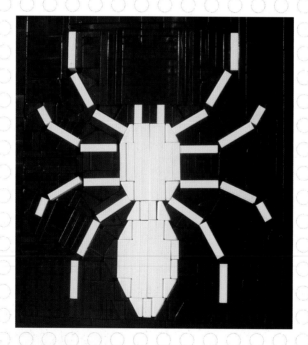

Your mosaics don't all have to be simple patterns. With this style of building, you can even craft pictures like this spider.

A mosaic with lots of cracks and gaps isn't nearly as attractive as a well-filled one, so you'll want to eliminate as many gaps as possible. Sometimes filling them in will be as easy as sliding in an extra tile or two. Other times, you'll have to substitute shapes in the mosaic with similar shapes of a slightly different size, with careful consideration for the colors you're using. Depending on the design, some substitutions might not work because they would change the image too much. Here are a few substitutions tricks to keep in mind when you have gaps to fill.

Rectangles come in many different lengths. If you use just bricks, plates, and tiles, your rectangles will all have lengths that are multiples of two. If you add a cheese-slope square, you can approximate odd-numbered lengths as well. If you have a section of a mosaic with rectangles that are either too tight or too loose, try using a slightly larger or smaller rectangle. This usually means pulling out or adding in a cheese-slope square so that the change in area will be as small as possible.

These substitutions apply to many different shapes. If you look at the bottom-right figure on page 59, you'll see that a lot of those polygons are quite similar and easily adjusted. For trapezoids and parallelograms, just add or remove some of the plates or tiles between the cheese slopes to make them bigger or smaller. You can make a hexagon out of two trapezoids or three rhombuses. If you're using two trapezoids, change the number of plates and tiles in the trapezoids. Hexagons made up of three rhombuses are harder to adjust. Switching to a hexagon made up of two trapezoids will probably help, as long as it doesn't mess up the colors of your design.

Try not to fill the gaps so tightly that the tension in the mosaic causes the frame to bend and snap. Avoiding this situation is tricky because the frame can snap even when there are still obvious gaps in the mosaic. Also, as you tighten some areas, other parts might start getting pushed out of alignment, which can actually create more gaps. Take a moment to examine the mosaic carefully, see which pieces are pushing others out of alignment, and try removing some to see if that solves your problem.

	2×5
	4×5
	$\approx 5.2 \times 5$
	6×5
	$\approx 7.2 \times 5$
	8×5
	$\approx 9.2 \times 5$
	10×5
	$\approx 10.4 \times 5$

A chart of rectangle measurements, all numbered in half-plates

Planning a Mosaic

It can be fun to jump right in and make your mosaic, but sometimes it helps to have a plan. When you do want to think ahead, here are some useful tips to remember.

First, spend some time experimenting with cheese slopes. You can document the different patterns and arrangements you like until you have a library of potential designs for future projects. Then, whenever you want to create a mosaic, you can check your library for ideas. Make sure to take clear photos of patterns you discover.

It's also helpful to see what others have built; the Internet is a great resource for finding ideas. You can adapt a design to suit your own needs by varying a few shapes, changing a few colors, modifying the size, and so on.

Planning a design on paper can be prudent as well. If you want to make a mosaic from tessellated cheese-slope squares, draw the design on graph paper with a diagonal line to split each square into two cheese slopes. You can also download and print hexagonal graph paper to sketch on. This type of paper is good for planning patterns made primarily of rhombuses, trapezoids, and hexagons.

If graph paper doesn't work for the design you have in mind, start by building an interesting configuration from only white pieces. Then, take a picture of it and print several copies of the design. Test different patterns by coloring in the pieces on the printed copies. Once you have a pattern you like, all you have to do is build the colored parts of the mosaic.

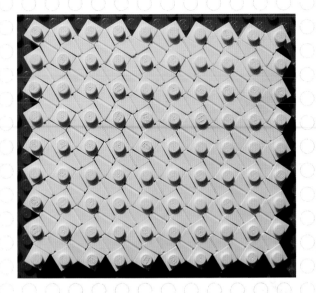

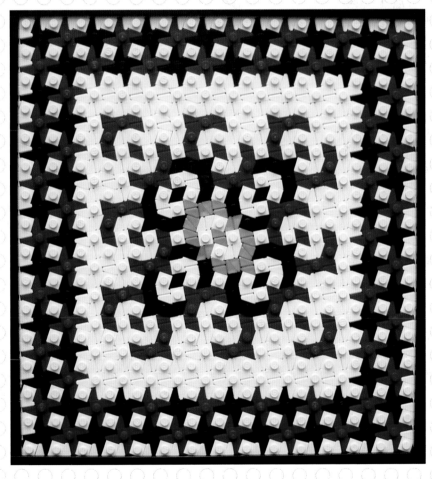

(OPPOSITE) A **finished mosiac, based on a graph-paper sketch** (LEFT) When you've arranged your white pieces in a pattern you like, take a photo. This design consists of 1×1 bricks attached to a baseplate at an angle, with cheese-slope rhombuses to fill in the gaps. (BELOW) **The final mosaic built to the pattern developed in the previous figure**

Framing a Mosaic

You can build frames in different ways, depending on how you plan to use the mosaic, but you should consider a few points before beginning.

Orientation

For mosaics that will be displayed vertically, such as on a wall or in a window, build the frame on a plate two studs thick, at whatever length you need. Build up a back wall and two sides, and then top it off with another plate. For stained-glass windows, use transparent bricks for the back wall so that light can pass through them.

(TOP) **A vertical mosaic frame without the top. The transparent back is useful if your mosaic is made of transparent cheese slopes.** (BOTTOM) **The completed mosaic frame**

If your mosaic will lie horizontally, such as for a floor decoration, you can build it on tiles attached to the top of a layer of bricks or plates, as in the partially filled-in example.

With this simple setup, however, the mosaic won't sit evenly with the surrounding floor—it will be one or more half-plates higher or lower, depending on how high you build the frame. Sometimes that's a good thing, especially if you are making a rug, which would normally sit slightly higher than the surrounding floor. In the top-right figure, the back wall is made with green tiles on top of a single layer of yellow bricks, and those tiles are one half-plate higher than the mosaic. The other two sides are made with a layer of two plates, topped with lime tiles. The mosaic is elevated one half-plate over those sections.

It is possible to make the mosaic level with the frame, however. For example, you could insert a level of bricks lying sideways between the tiles and the pieces of the mosaic. The frame would be thicker, but the mosaic would be flush with the surrounding floor.

Looking at the bottom-right example, the base of the frame is tan, and there's a layer of red tiles on top of that. Next, you can see a stack of yellow bricks lying sideways. The mosaic is built on top of those yellow bricks and is perfectly even with a frame two bricks high (black and grey in this example). For a studless finish, replace the top grey bricks of the frame with a layer of two plates, and then top it off with tiles.

(TOP) **A frame like this is useful if your mosaic will be a rug or floor pattern.** (BOTTOM) **Another floor-oriented frame**

Shape

The rectangle is the most common frame shape for mosaics, but it's not the only one; you can use crescents, hexagons, and more. With other shapes, however, you may find it takes more trial and error to fill in the frame with as few gaps as possible.

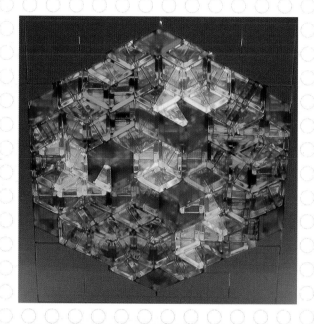

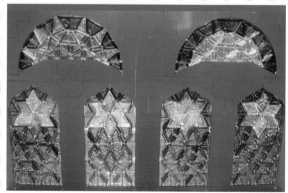

(TOP) **This beautiful hexagonal frame is filled in with transparent cheese slopes.** (BOTTOM) **Here are some ornate windows with more unorthodox frame shapes.**

Special Frames

You can make some really eye-catching frames from pieces you might not expect. Macaroni bricks can provide curved edges, while panels and panel corner pieces give you a thinner frame.

A lot of patterns made with headlight bricks and other pieces have gaps that you can fill in with cheese slopes. For example, you can use headlight bricks and slopes to create a gap in the shape of an eight-pointed star.

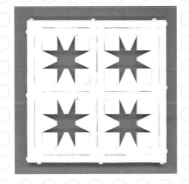

(TOP) **An eight-pointed star pattern made from the negative space of 1×3 slopes** (MIDDLE) **A flower frame built from macaroni bricks** (BOTTOM) **A more colorful macaroni-frame mosaic**

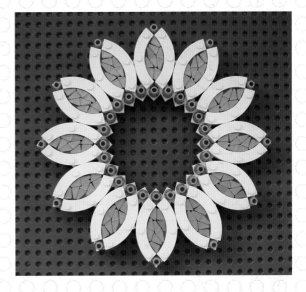

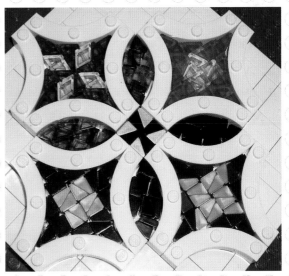

Mosaic or Frame First?

Whether you start with the mosaic or the frame depends on what you're making. Perhaps you've built a church and need a stained-glass window to fit in a specific space. In that case, you would build the frame first and create a mosaic to match it. This can turn the mosaic-building process into a puzzle as you try to fill in the predetermined space.

Other times, you might have an idea for a mosaic but not know how large the finished product will be, or perhaps you want to experiment with designs until you find one you like. You would then need to measure your mosaic so you could make a frame big enough to hold it. After transferring the mosaic to the frame, you'd probably have some extra space to fill in, too.

The disadvantage of building "mosaic first" is that you'll construct your mosaic twice, once in the design stage and once again to fit it into the frame. But you can avoid this repetition with a bit of planning. For example, if you start with an extra-large frame, you'll know that you'll be able to fit your mosaic into it. With this technique, however, you'll usually have to fill in a lot of extra space. You could also carefully adjust the size of the frame while the mosaic is still in it. This method is tricky, and you'll probably mess up part of the mosaic, but it might still be quicker than redoing the whole thing in a brand-new, correctly sized frame.

Other Helpful Hints

Building cheese-slope mosaics can be tricky, but you can do a few practical things to make the process a bit easier.

- Use tweezers or toothpicks to nudge cheese slopes and tiles into place. These little pieces tend to fall over as you move them, so it's helpful to have something to pull them out with.
- If you're serious about mosaics, buy cheese slopes in bulk, either from the Pick-a-Brick walls at LEGO-brand retail stores or at BrickLink (*http://www.bricklink.com/*). It's hard to get enough cheese slopes in one color from sets alone.
- It's okay to use printed tiles in a mosaic, as long as the printing won't show. In fact, for some sizes and colors, printed tiles might be the only kind readily available.
- Transparent cheese slopes and some slopes from the Pick-a-Brick bins can be slightly larger than other cheese slopes. Mosaic measurements tend to be very precise, but you can readjust your mosaic if problems come up.

Finally, don't give up, and don't be afraid to experiment! Try things that seem impossible: They might be simpler than you think, and you'll probably get other good ideas during the attempt. Working with cheese-slope mosaics is difficult, but it does get easier with practice.

Katie Walker on Mosaics

How did you start creating the slope patterns you are known for?

The first thing I figured out was how to make squares from four headlight bricks. At first, I just pressed squares together and used colored bricks to make patterns. Later, I varied the patterns by adding other elements between the headlight bricks. A lot of these designs used slopes and arches that made interesting shapes, but they also left empty spaces in the patterns (such as in the space under an arch).

When I posted pictures of these designs online, friends said they were neat, but it was unfortunate that the gaps were so large. If the patterns were solid, they could be used for tiled floors in larger models. After that, I focused on filling in the gaps that appeared in my patterns. At first, I tried to make sure that all the elements in a pattern were connected to each other. Eventually, though, I found some gaps that could be filled only with loose cheese slopes. I felt guilty about it— as if I wasn't following the "rules"—but it worked well enough, and it set a new precedent.

One particular black-and-white pattern had a lot of large, empty squares to fill, and cheese slopes were the best way to do that. As I filled those squares, I thought that the arrangement of slopes inside of the squares would look neat tessellated out to larger sizes. I tried it, and I really liked the results. From there, I developed larger and larger designs out of cheese slopes and the occasional 1×1 tile. These designs were completely unconnected, and they held in place only because I squeezed them into perfectly sized frames.

I also tried arranging cheese slopes into starlike shapes. The blunt tip of the cheese slope created gaps in those patterns, but eventually I realized that I could arrange two slopes into rhombuses and use the 60-degree angle for gap-free, starlike designs. At that point, I felt comfortable experimenting with cheese slopes, with very few limitations. It didn't matter if they were connected to anything, if they were all perfectly lined up at 90 degrees, or even if they were completely gap-free. I just wanted to see everything that cheese slopes could do.

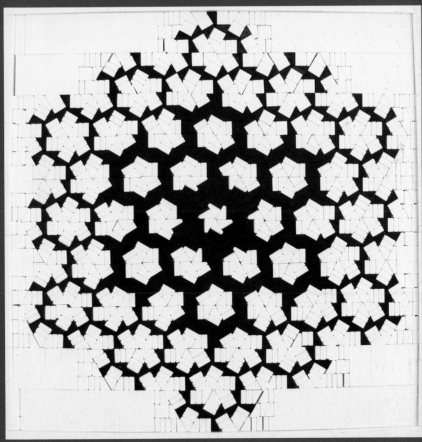

(LEFT) **Spiral triangle**
(BELOW) **Black and white parquet deformation**

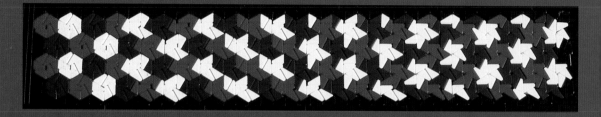

A particularly beautiful parquet deformation. The pattern changes slowly, with hexagons on the left transforming into stars on the right.

How do you create your patterns? Is there a lot of math and geometry involved, or do you tinker until they're just right?

I mostly just tinker around to see what works well and looks interesting. I love symmetry, so I tend to get a few pieces into an intriguing formation and then tessellate them. The hardest part is getting all of the pieces to fit together without gaps so they can be used for floor designs. Then I start using a lot more math and geometry. I know the dimensions of the different pieces, and I know what substitutions I can make to change the sizes of certain shapes. I will measure the size of the area that needs to be filled, figure out what ought to work, try it out, and then adjust as needed.

Are there any real-life inspirations you reference when you set out to make a new pattern?

Most of my patterns have been developed without any real-life inspiration. Instead, the shapes of my materials tend to dictate how the patterns turn out. For example, because the cheese slope has a blunt tip, a lot of possibilities are eliminated. I started working with the rhombus shape a lot because tessellating it doesn't create as many gaps. After I find something that works, I will methodically try out every possible variation I can think of. Many of those variations will give me ideas for a whole new type of pattern.

A friend did give me one book to use for inspiration—*The Grammar of Ornament*, which is a collection of ornamental designs from several different civilizations. I spent time reproducing several of the patterns in that book. Those gave me new ideas, which in turn led to new patterns and techniques.

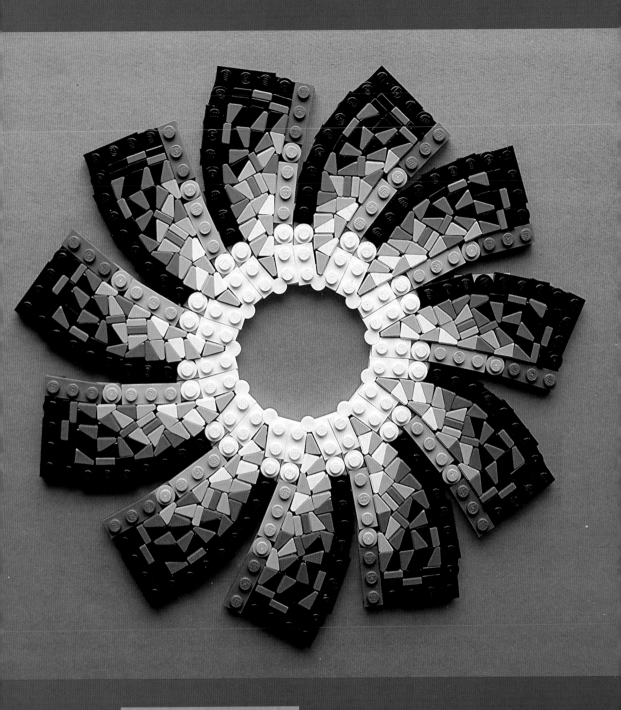

A starburst pattern, with a gradient
changing from white in the middle
to black on the outer edges

How do you like to use these patterns in your models?

Patterns (made from cheese slopes or otherwise) are great for use as tiled floors in all sorts of different models. They can also be used to decorate walls, and transparent pieces make great stained-glass windows.

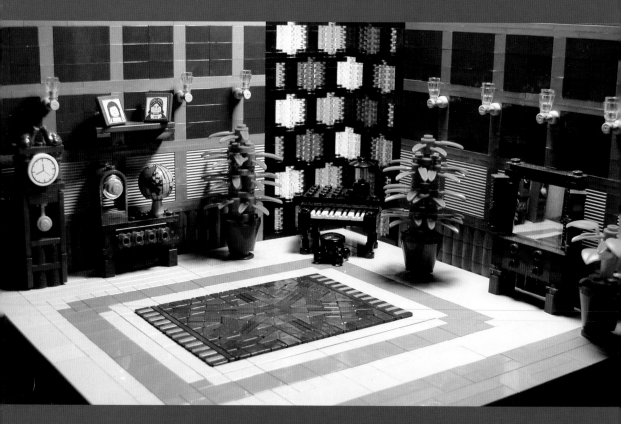

The Blue Room at Mayo Manor

5 Texture

Though Ole Kirk Christiansen made the first LEGO bricks out of plastic, the miracle material of his time, the LEGO Group has produced many nonplastic pieces over the years. Because these elements break up the glossy surfaces of plastic pieces, you can use them to add realism to your models. Adding another texture can help your models look fresh and interesting. In this chapter, we'll first explore building with textiles and rubber, and then we'll see how to create textures with the plastic elements themselves.

Fabric Elements

The LEGO Group first used cloth elements as ship sails in the 1989 Pirate line, and until the mid-1990s, fabric was used only for sails and flags. Fabrics have since been used in many other ways, both aesthetic and functional.

From 1997 to 2001, textiles were a major part of the Scala line, which featured cloth pillows and blankets for its large dolls. The dolls also had an extensive but not particularly attractive wardrobe, including electric blue sport coats and neon green shorts. Belville sets, which debuted in 1994, also included wearable clothing, although not to the same extent as Scala. Prominent pieces in the Belville wardrobe included skirts, dresses, and capes. Even standard minifigures have their share of cloth elements! You'll find all kinds of minifigure clothing, like capes, skirts, and collars.

Many sets also contain practical cloth elements. For example, string (which is usually considered a cloth element) is often used to hoist objects with winches or to make nets for sports goals.

LEGO has made these elements from a range of fabrics. Originally, sails were made of a woven fabric—kind of like linen—that had a nice weight and feel, but it frayed easily. Flags in the Castle lines and teepees in the Western line were made with the same fabric. But in the mid-2000s, a significantly thinner fabric replaced it. While lighter in weight and cheaper in feel, it withstands the rigors of play better over time.

(OPPOSITE TOP) **The top textile is an older, frayed pirate sail; the bottom is a newer one, which is in much better shape.** (OPPOSITE BOTTOM) **A minifigure version of Ming the Merciless from the 1936 *Flash Gordon* serial. His collar is made from a few pieces of cloth minifigure neckwear.**

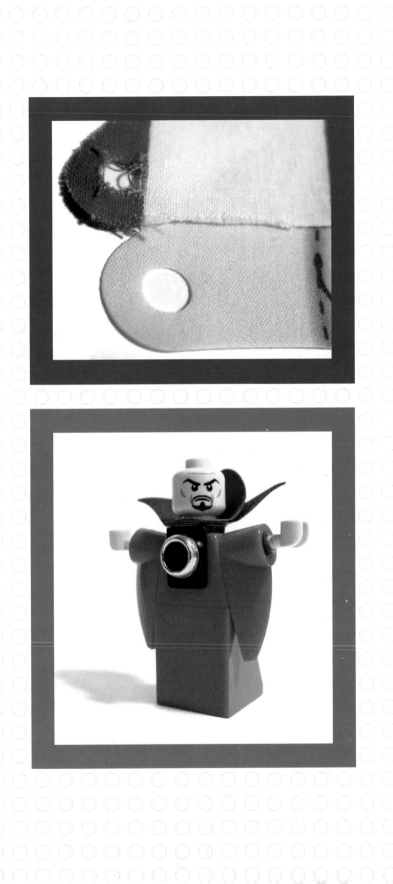

You'll find the widest range of fabrics in obscure lines like Scala, Belville, and DUPLO. These minimalist lines share little DNA with the main LEGO brand, so when designers needed to create fabric elements, they had more creative freedom. My favorite is the bear-shaped rug from the prehistoric DUPLO theme. Use this fuzzy brown element over cavemen figures to mimic the hide of some massive beast. Minifigure-based lines would never include such strange, literally textured elements because they don't fit with the aesthetic of the standard system. But that doesn't mean you can't use them with minifigures, anyway!

Scala and Belville garments introduced other unusual materials, like cotton, felt, and spandex. It's hard to believe they're actually LEGO parts!

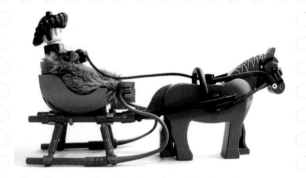

(ABOVE) **A minifigure-scale sleigh with a cozy bear wrap** (BELOW) **Various textile elements, including a sail, flag, bear rug, minifigure cape, and Scala garments**

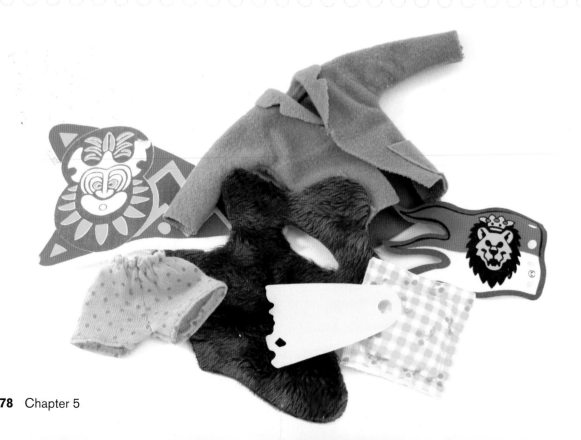

Building with Fabric Elements

This raggedy old rope bridge uses a range of textiles. The 1×4 tile planks are attached to folded nets, and highly detailed string hand rails zigzag across the bridge. The nets, attached to plates on either side, are what hold up the bridge.

How are textiles and other nonplastic parts useful in our models? Remember, as LEGO builders, we never take a LEGO element at face value. Why not turn a pair of pants into a funky flag? Minifigure capes into dragon wings? Textiles bring a real texture to your models that plastic elements can't.

Creating Texture with Fabric Elements

As the builder, if you wish to achieve realism in your models, add detail. A flag flapping in the breeze, wind-filled sails propelling a ship, a flowing cape on a superhero—all of these details add a lifelike quality to your models.

Even if you aren't building a realistic model, a soft cloth will attract a viewer's attention when used alongside hard, plastic elements. Any builder, regardless of the subject or style of model, can use cloth to his or her advantage.

For example, look at my *Tanuki Samurai*. For this large, 1/6-scale figure, I used various textiles to make him look softer and more organic. The furry DUPLO bear rugs over his shoulders and calves help to make him look like a warrior. His pants are made from large, folded capes that feel warm and woolly. His paddy hat even uses a hidden string for structure; the rubbery triangular panels that make up the hat are held together with string, which runs between the cheese slopes around its edges. Only string could allow for such a flexible construction.

Notice the string in the samurai's paddy hat. It winds between the edges and is finally tied off in the middle.

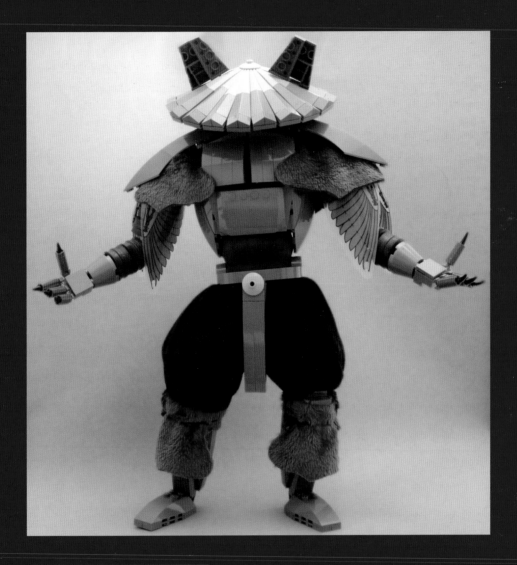

This *Tanuki Samurai* has DUPLO bear rugs on his legs and shoulders and large black capes as trousers.

Sculpting with Fabric Elements

Besides adding texture to models, fabric can offer versatile solutions to unique problems. You can fold it and fit it into gaps in a model where no plastic element could ever go. But working with fabric is not without challenges, especially when you try to sculpt with it. Sculpting with fabric elements is tricky because, unlike most standard elements, fabric has no built-in connection points. Consider the minifigure cape: Its closest connection points are its neck holes. But you still need an element on each side of the hole to attach the cape to the rest of your model, which could add unwanted bulk.

When you can't find an easy way to connect the fabric to a part of your model, the best solution is to wedge it between two elements. For example, my owlet uses four minifigure capes for its face. The two capes on the sides of the face are wedged behind the owlet's eyes. The two capes in the middle are held in place with a cheese slope and the tan banana that serves as its beak. The neck holes on the capes are lined up, which curves them and shapes the owlet's face. This model also has fabric wings, originally from an Ewok glider, with a wavy edge that mirrors a real bird's feathers.

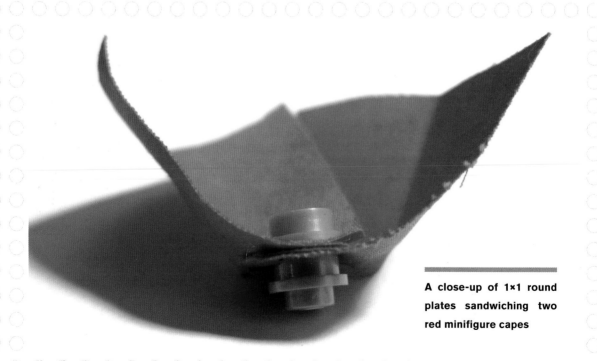

A close-up of 1×1 round plates sandwiching two red minifigure capes

(LEFT) *Owlet in Flight*. Fabric elements are as prominent in this model as the standard plastic elements. They make this owl look softer and more lifelike. (BELOW) The owlet's head, deconstructed to show how the front of its face incorporates minifigure capes

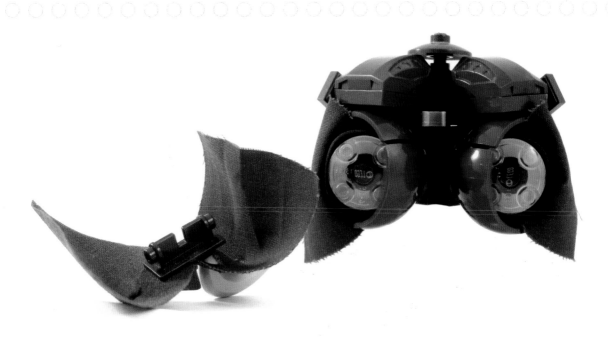

Rubber Elements

Although rubber elements aren't quite as versatile as fabric elements, they're just as important for innovative building.

The most common rubber element, the tire, has been available since the early 1960s. At first, LEGO released only two different tire sizes, but to date over 80 sizes have been produced. The standard tire color is black, but grey and white tires are also available. The smallest tire can fit around a 1×1 round brick; the largest, a balloon tire from set #8457 (released in 2000), fits around a 7×7 round structure. Other types of rubber LEGO elements include tank treads, masks from the BIONICLE line (a mythological sci-fi line that ran from 2001 to 2010), Galidor elements, and rubber bands. Though rubber bands are used in sets as functional pieces, often allowing for some sort of shooting mechanism, they're also great for adding aesthetic detail. They come in a variety of sizes and colors, including white, red, yellow, blue, green, and black.

A selection of rubber elements, including tires and rubber bands

Building with Rubber Tires

You don't have to just slip a tire over a wheel and call it a day. Tires are a lot more versatile than you may think. Some LEGO tires don't have treads that are minifigure scale. To fix this, you can flip those tires inside out, which hides the tread and gives your vehicle's tires a smooth texture to better match the minifigure. (I've never built a realistic minifigure-scale automobile that didn't feature inside-out tires.)

This motorcar's rubber tires, including the spare, are flipped inside out.

Flipping balloon tires inside out creates an unusually textured and shaped element. The smooth round shape that results works beautifully for creature models because it's so organic. For example, in my octopus, the main section of the body is made from a large, inside-out balloon tire and the eyes from smaller balloon tires. The tentacles are made from hard rubber DUPLO monkey tails. The tires shape the body accurately and provide an elastic texture similar to a real octopus.

An octopus made from inside-out balloon tires. The rubber's texture seems almost lifelike.

Building with Rubber Bands

Rubber bands are valuable because they can be used aesthetically and functionally. When you want to add colorful accent lines to a model, you can wrap rubber bands around just about any small assembly. For example, have a look at the black bands detailing *The Mask*'s zoot suit hat or the red and blue ones used as blood vessels in my anatomical model.

From a practical perspective, rubber bands can hold pieces together, allowing you to attach elements that couldn't otherwise be attached. Many purists believe that a LEGO element must be snapped to another piece, which makes using rubber bands controversial. But LEGO rubber bands are still LEGO elements and are therefore fair game in my opinion.

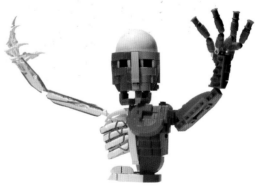

(TOP) **Notice the black rubber bands around the brim and crown of *The Mask*'s hat.** (BOTTOM) **Red and blue rubber bands make up the blood vessels in this anatomical model.**

Creating Texture with Plastic Elements

Cloth and rubber elements aren't the only means of adding texture to your models; with a bit of finesse, you can build just about any texture imaginable from plastic elements.

As with most features of a model, the best way to design a texture from plastic is to experiment and test various elements. You can usually achieve the same effect in multiple ways, so never assume the first method you choose is the best. Try different methods, and if you haven't quite figured out how to approach a certain part of your model, build small sections of it out of context as subassemblies. This way, you can be sure that you're building your model with the best techniques possible.

Warehouse District Shootout is a highly textured Depression-era model. It depicts a run-down tenement building nestled uncomfortably in an unnamed city's industrial warehouse district. Let's take a detailed look at some texturing techniques used in this model.

Warehouse District Shootout depicts a shootout in an early 1930s tenement building between two rival gangs over the control of liquor distribution in their city.

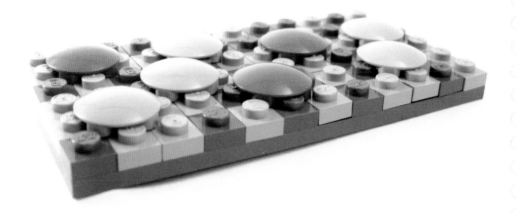

Starting from the ground level, notice how the street looks like cobblestone. This cobblestone is made from 1×1 plates and upside-down boat studs in light and dark grey. The random placement of the boat studs and the underlying 1×1 plates makes the cobblestone look natural.

Moving up to the building itself, you can see a classic brick wall made from tiles and sideways headlight bricks, which are stacked vertically in strips, with four plates between each level.

(ABOVE) **Cobblestone made from upside-down boat studs** (BELOW) **A classic brick wall made from headlight bricks and 1×2 tiles**

Finally, there are some details that you might not even notice at first, but they are critical to the storyline of the model. The Coca-Cola crates are built from several small, brown plates, instead of one or two large bricks, which makes them look as if they're built from many wooden planks. The stickers are from official promotional polybagged sets from Japan; they're not custom! Although these crates are hardly visible in the main photo of the model, every little detail counts.

The world around us is a hodge-podge of countless textures and surfaces. While it's impossible to replicate every texture in a model at minifigure scale, you can definitely capture the texture of the most important details.

6 Dynamic Sculpting

LEGO elements tend to be blocky, which makes building organic or stylized models tough. After all, how can you build something round using rectangular bricks? In this chapter, we'll explore some techniques that make this possible.

We'll start with *organic models*. These are basically anything with curves—biodynamic vehicles, animals, and so on—and making them believable can be difficult. After organics, we'll shift to *stylized models*, which are more about capturing certain aesthetics (from a particular time period or type of art, for example) than realism. The techniques for building both types of models are fundamentally similar, as you'll soon see.

Organic Models

Building with LEGO elements is like putting together a puzzle. Most elements have a flat side or right angle, and like two-dimensional puzzles, if the pieces don't fit properly, then the final image won't look right. If you want to create a realistic model, the elements you choose should fit together seamlessly. Otherwise, it'll be obvious that your model is made from LEGO elements.

Organic models are the hardest type to build by far. There are many ways to build organically, and the most difficult approaches rely entirely on plastic elements. Although using the textile and rubber elements discussed in Chapter 4 is a surefire way to create organic shapes, these elements can look sloppy if the textures don't match the rest of your model properly. Therefore, organic building with plastic elements is often the best way to achieve your desired look. Major methods for organic building include using bows, slopes, and wedges; building with flexible elements; and sculpting using the SNOT method.

Bows, Slopes, and Wedges

The difference between a bow and a slope lies in the incline: Slopes have a flat incline, while bows have a curved incline. Generally, you'll use more bows than slopes when building organic models. The most common bows measure 1×3 and 1×4 and come in a wide palette of colors.

Slopes, bows, and wedges are critical for building organic assemblies because they provide angular and rounded edges. Unfortunately, it's still incredibly difficult to build a completely accurate model with them; you can't just expect to stack these elements studs-up and achieve the shape you need. That's why it's important to build organic models as though you're in a space with no up or down. This makes it easier to experiment with the orientation of your LEGO elements by turning them on their sides and placing them at strange angles.

Ryan Rubino's *Battle of the Leviathans* is a great example of a model that employs lots of bows. Notice the section in front of the whale's eyes. The bows, all placed on their sides, are stepped in a way to make the whale's snout appear thinner than the rest of its body. Ryan knew he couldn't achieve that shape using regular bricks, so he built his whale using white bows facing outward in several directions.

Battle of the Leviathans by Ryan Rubino. The sperm whale is built from many bows oriented in different directions to create its long, rounded form.

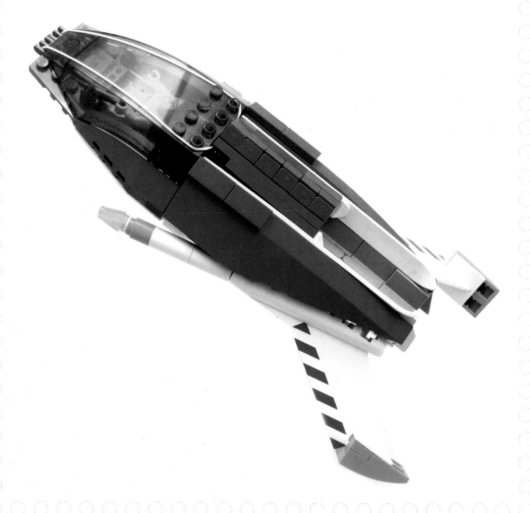

One of the best ways to use these elements, particularly wedges, is to line them up at unorthodox angles. The Buzz Lightyear–themed spaceship I built shows this technique in action.

Matching up the inclines of the forward-facing and backward-facing wedges in this ship creates a swooping shape that looks very aerodynamic.

The cockpit is constructed with a transparent windshield bookended by two blue wedges, and directly behind these wedges are two larger ones. The wedges have 33-degree inclines, but the incline of the flat backside of the cockpit is 45 degrees, making it impossible to line up the large wedges with the cockpit studs-up. We can, however, disregard the wedges' inclines and line up their flat surfaces with the cockpit's 45-degree angle. This way, the wedges match up with the cockpit and create a striking, tapering curve that looks cool and suggests speed.

A deconstructed view of the ship's innards

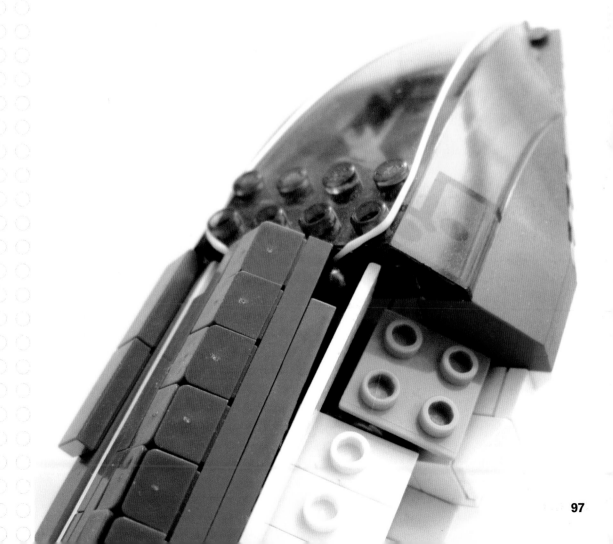

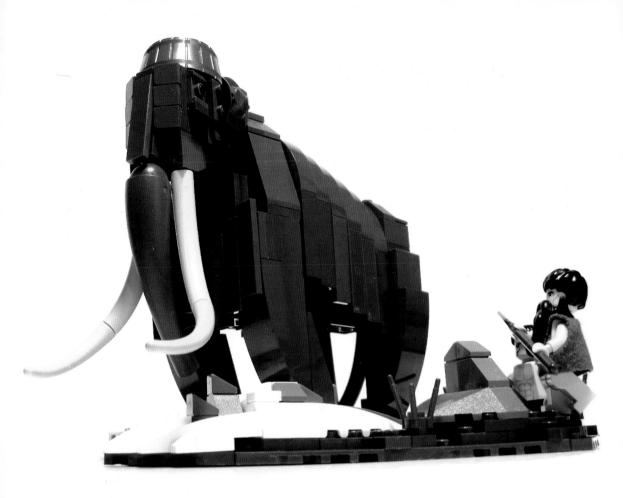

Notice the similar methods used to build this woolly mammoth. In this model, the creature's back is made primarily of large, curved bows that are draped to look like the mammoth's signature woolly hair. These bows are stepped as they move down the mammoth's back, but the steps are subtle enough that the back looks rounded rather than jagged. This shapes and texturizes the bulk of the animal.

Woolly mammoth, with a woolly back made from bows draped sideways

Flexible Elements

Using flexible elements is probably the most fun of the three organic building methods because you can *literally* stretch the elements beyond their textbook shapes. Which flexible elements am I talking about? The hose—any hose. If it's a tubular, flexible 318, it's your friend.

Hoses are key to building with the spine technique. To use this technique, add a specific series of unconnected assemblies along the length of a hose. Because the assemblies aren't attached to each other, the hose will still bend. Imagine the hose as a spinal cord. Then picture those unattached assemblies as individual vertebrae. The spinal column is able to bend because it's made of lots of smaller bones.

(LEFT) **A cross section of the spine technique, showing the hoses and lamp holders** (RIGHT) **The spine technique on a large scale, done in pink and purple. Notice how it bends backward and forward, and from side to side.**

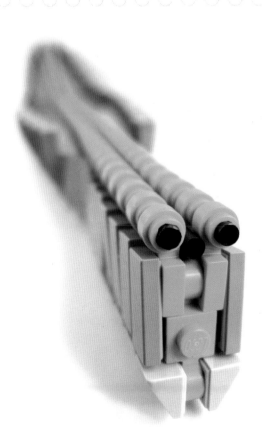

The real kicker of this technique is not its texture but its flexibility. The spine you create should bend not only backward and forward but also from side to side. The only downside to this technique is that there is no good way to cover the backside of the assembly; its back is, unfortunately, open and hollow. This isn't so bad when you build something small like my wyvern, which also has wings to cover up its back. But on a larger model, like the purple and pink one pictured on the previous page, the gaping back is a problem. This is where textile elements may come in handy to fill in the gaps.

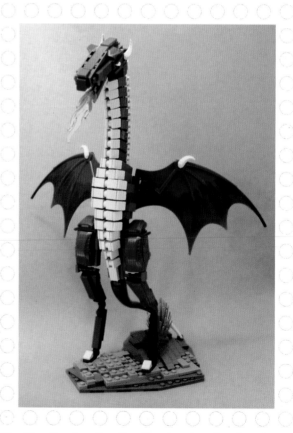

A wyvern with a flexible hose for its spinal column. The hose runs through assemblies of lamp holders, bricks, and slopes, which shape the body. The gaps between each assembly create the great reptile's signature scaly breast.

Bruce Lowell on the Lowell Sphere

While bows and slopes are already curved, it's also possible to create your rounded surfaces through sculpting, as shown in this cute little model of Totoro.

You can sculpt with LEGO elements in many different ways, but I don't recommend studs-up brick sculpting. This type of construction works only in large models built by LEGO-certified professionals and at the LEGOLAND theme parks. Those models are so massive that the steps and studs of the bricks blend into each other and disappear, which wouldn't happen in your average-size creation.

However, there's one good sculpting method that I do encourage you to employ in models of all sizes: the *Lowell sphere*. Named after LEGO fan Bruce Lowell, this groundbreaking sphere quickly became a classic building method. It features plates and jumpers constructed in a studs-out configuration. Judging by the models on the following pages, it's clear you can create almost any shape imaginable—spheres, creatures, trees, clouds—with the versatile Lowell sphere technique. I would go so far as to call it one of the most important LEGO design standards ever developed.

My model of Totoro has a big, cheesy grin made of cheese slopes.

What is the Lowell sphere?

It's a SNOT LEGO sphere design that consists of six identical curved panels built onto a cubic frame. The original sphere uses a 4×4×4 stud core with an outside diameter of 6.8 studs, but the Lowell sphere can be expanded to any core and outside diameter size imaginable.

How did you come up with the design?

In 2002, I designed the hemispherical engine nacelles of a *Star Wars* starfighter *MOC (My Own Creation)* using a rough precursor to the sphere design. The next year, at my first LEGO convention, I noticed multiples of the elements I used to create the nacelle in a large pile of play bricks. I played around with the design and created a full sphere. The reaction at the convention was overwhelmingly positive; at the time, the LEGO community had not seen such a small, detailed SNOT sphere. A few months later, I posted it on my original website as a "6.8-Stud-Diameter Sphere," and it received the same positive reaction from the online LEGO community.

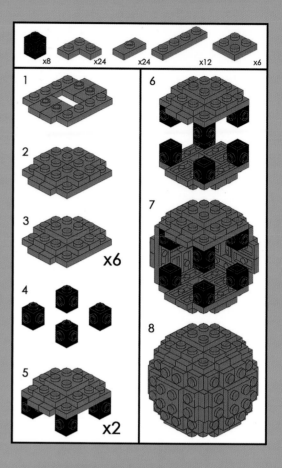

(TOP) **Instructions for the basic Lowell sphere** (BOTTOM) *Doughnut*

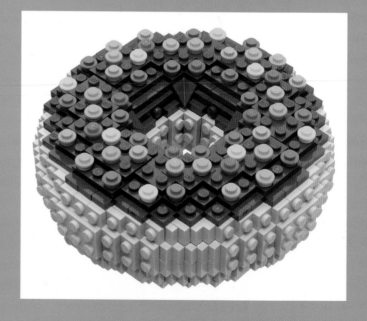

What kind of models did you build with it?

I didn't really incorporate the sphere into many MOCs at first, although I had a lot of ideas. But builders around the world started using it, even at LEGO and in LEGOLAND parks. Bram Lambrecht also created a sphere-generator program based off the idea, and the design took on the "Lowell sphere" name. In 2010, I decided to revisit the sphere, but not just as a sphere; I wanted to expand upon the original idea and create new shapes using the 6.8-stud diameter.

To start, I extended the largest diameter of the sphere (6.8 studs) into a cylinder and added a soft curve to it by elevating "slices" of the cylinder. An example of both the cylinder and soft curve can be seen in my *Oscar Mayer Wienermobile*. Next, I designed a T-intersection and a 90-degree curve, which are both visible in my cactus. I then used four 90-degree curves to make a torus (doughnut) shape, which naturally became a confectionery doughnut! I've continued to build other MOCs using the original sphere as well as the shapes based on it.

(TOP) **Cactus** (BOTTOM) **The Oscar Mayer Wienermobile**

Stylized Models

Meega nala kweesta! A stylized model of Stitch (*Lilo & Stitch*, 2002)

Style is forever. You can't acquire or implement it easily, not by a long shot. I'm not referring to your personal style as a builder here. That type of style usually isn't implemented consciously; it comes naturally when you use particular elements, techniques, or even colors.

The style we'll discuss in this section is about aesthetics. If you choose a particular look for your model, then that style should be present and consistent throughout the entire work. Otherwise, viewers will notice that something is off, even if they can't figure out what. Style defines your model as being part of a particular era, place, culture, and so on.

Think of this kind of style as the difference between a Max Fleischer and a Walt Disney cartoon. Though both cartoonists used comparable illustration techniques at around the same time, their signature characters (Betty Boop and Mickey Mouse, respectively) have very different aesthetics. If you tried to emulate the style of either cartoonist in a LEGO model, you'd be building a stylized project.

Though it might seem like being restricted to LEGO elements limits your artistic freedom, LEGO builders actually have significantly *more* freedom because people won't expect every single detail to be correct. You can't build, for example, a human head from LEGO pieces as realistically as you could illustrate one on paper or sculpt one from clay. That's actually an advantage to building highly stylized models or models based on two-dimensional works. You need to include enough details so that viewers can identify your model properly but not to the same extent as you would in most other media.

If this sounds confusing, consider my model of Stitch (from *Lilo & Stitch*). You can tell it is Stitch because of his proportions, paws, blue color, and large ears. But if you look closely, this version of the blue alien lacks other defining characteristics, including his eyebrows, the ridge over his nose, and the tuft of fur on his head. This works for a LEGO model, but imagine an illustration or non-LEGO sculpture of Stitch without those features. I guarantee that it would look strange.

As with all LEGO building concepts, your stylized model will be easier to design at a larger scale. Think of your model as a digital photograph and LEGO elements as pixels. Up close, all you can see are individual pixels, but from afar, you can see that a picture is formed by the many carefully aligned pixels. The more elements you use, the better defined your model will be. This is important to remember when constructing something stylized.

But perhaps the most important aspect of constructing a stylized model is using your shaping elements. A busy, overly complex, and parts-intensive model is no good. Challenge yourself to use as few elements as possible, and you'll build models that look cleaner and have greater panache. Think about our cartoon example—two-dimensional characters are designed carefully and precisely. Examine line art of your favorite animated character. The only lines you should see are the ones that are absolutely necessary. That's how you need to build your stylized model: Use every necessary element and nothing else.

Looking at my tree man, affectionately named *Stumpy*, the first things you'll probably notice are his lanky limbs. Starting at his legs, we can see they are much wider at the base, like tree trunks. Going up, his legs are built almost exclusively from 2×4 round bricks. Notice how smooth the legs are. That's because in a stylized model, it's more important to get the shapes right than it is to focus on unnecessary detailing. Though actual trees are highly textured (with peeling bark and moss caked to their sides), that's worth forgoing to achieve a good shape. Just a handful of round bricks and a few inverted bows are enough to suggest treelike legs.

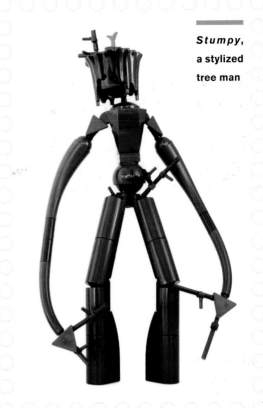

Stumpy,
a stylized
tree man

The tree man's arms are another instance of simplistic design in action. Rather than building them with the same methods used in his legs (something you should avoid with a figure like this, unless you want the arms to look like legs and vice versa), I've used the cylindrical "tentacle" elements. You can see these elements along his arm, starting at the shoulder and ending at the hand. The arms are smooth to match the legs, and they have a great organic shape that looks stylized, even outside the context of the model.

The minimal detailing I did add includes the little twigs growing from the ends of Stumpy's arms, which are made from flexible hosing and minifigure hands. These are the most intricate details on the model, but they're necessary to the figure's design. Like the girth at his legs, these twigs convey Stumpy's treelike nature, even without a barky texture.

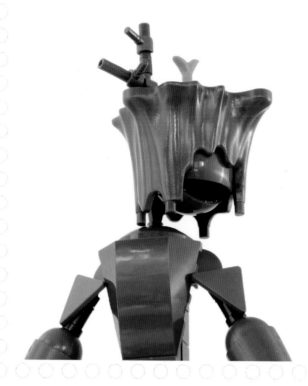

Stumpy's head, made using a prefabricated stump—simple, but full of character

His head, like his limbs, also contains only a handful of elements, but each is extremely important, and all feature prominently in the figure. Specifically, the stump and the ball-and-socket joint for Stumpy's mouth give him a tremendous amount of character in only a few pieces.

Remember, on a figure like this, the head is always the most important part: It's where the viewer's eyes are immediately drawn. The fun part about creating a stylized figure head is using simple and commonplace building elements in a way that makes them go from something bland and lifeless to something alive and full of character. As the icing on the cake for Stumpy, I added a cute little plant stem sprouting from the top of his head.

Tyler Clites on Creating a Style

Tyler "Legohaulic" Clites can build just about anything well, but his stylized models in particular always dazzle. From bowlegged cowboys to terrified ghosts, his distinctive models are full of personality.

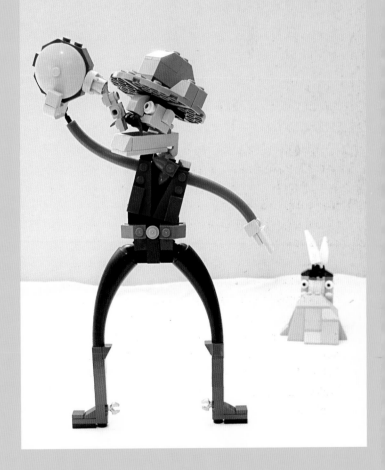

Mind If I Wet My Whistle?

Your models always have a playful style to them, especially the expressive, borderline-cartoony character models. Is there any specific inspiration behind your style?

My cartoony characters reflect who I am. I enjoy finding humor in mundane or ordinary things, so creating it in LEGO seems only natural. I have experience in theater and tend to "act out" and take on different characters in ordinary conversation. I think a little bit of that bleeds over into my LEGO characters and their funny situations.

Some of your characters are downright fantastical. Do you plan out these models before you build them, or do you start building and see where the elements take you?

I don't really do any heavy planning, but I do get a general idea in my head of what I want a character to look like or what sort of pose I want the character to be in. Sometimes it's as simple as grabbing a few random pieces in the appropriate color to see if they work, and sometimes I do end up with little unplanned parts in my models.

You seem to come up with simple assemblies that are highly detailed in the context of your models, like the heads of your _Interstellar Criminal Investigator_ and your _Atlantean Warrior_. How do you design these assemblies?

I often come up with the techniques for things like the heads on these two characters using trial and error. While I have a general idea in my head of how I'd like the character to look, I do a lot of tinkering before I find something that suits it. As a result, I sometimes get things that work out much better than I was planning.

Can you explain your building process? Are there certain procedures you always carry out when working on a model, or is it different every time?

My process varies depending on the model. For most of my characters, I start with the head and face since those elements primarily define the character. From there, I'll work on a pose that suits the character and what he's doing. After that, I might decide to create some sort of environment or scenery to give the character a location instead of just standing in a white or black expanse of nothingness.

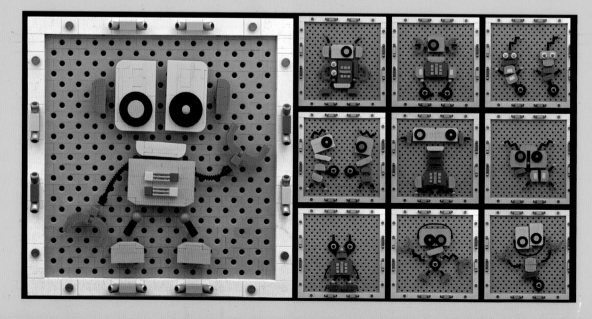

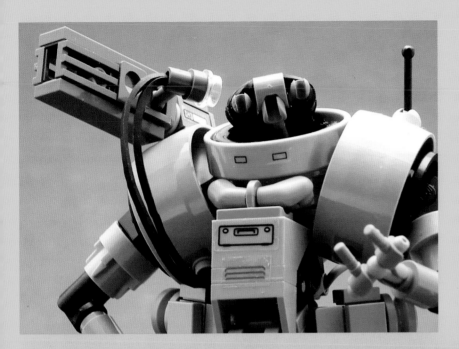

(OPPOSITE) **Build-A-Bot** is a modular build that lets you create many different stylized robot characters. (LEFT) *Interstellar Criminal Investigator* (with a great stylized head and pair of hands) (BELOW) *Atlantean Warrior*

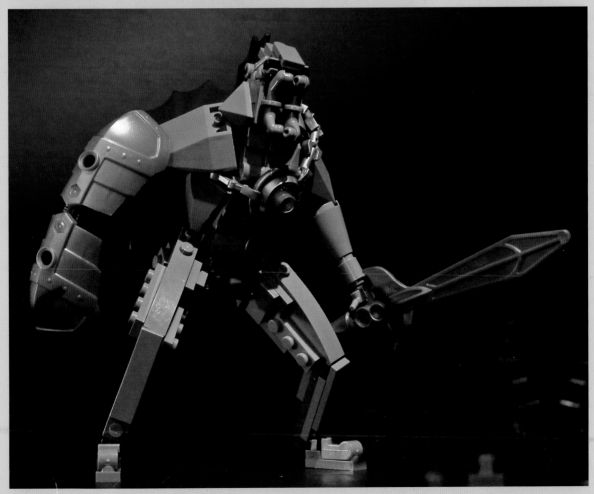

Do you have any tips or hints for building stylized models?

Look at concept art or cartoons. Concept art can be helpful because it is heavily based on design and style, and it can be very inspirational in creating your own characters. Cartoons can give you a good sense of how to exaggerate proportions or expressions to create a certain look or pose.

(ABOVE) *Sometimes It Sucks to Be a Ghost* (RIGHT) *Alice in LEGOLAND*

7

Composition

Composition is the arrangement of elements within a piece of art. Good composition is an easy way to transform your models from playthings into art.

In a two-dimensional medium, like a painting, the artist can easily direct the viewer's attention using lighting, perspective, and the illusion of action (like speed lines around comic book heroes to indicate running or jumping).

These techniques are harder to implement with LEGO. Unfortunately, the individual components of large, complex, and action-filled models tend to blend together. In this chapter, I'll show you how to use composition to your advantage, starting with how to light a model and what light bricks are available, moving on to perspective, and ending with how to use colors in innovative ways.

Lighting

Lights are less common in LEGO models than you might expect. Perhaps it's the lack of versatile bulbs, an inability to hide bulky battery boxes, or maybe even the opinion that lighting is unnecessary for a static model. Whatever the reason, well-lit models are few and far between, which means you can use lights to make your own models stand out.

(BELOW) **On the left is a 9V 1×2 light brick, identifiable by its protruding bulb and metal-wrapped studs; on the right is the current self-contained 2×3 light brick.** (OPPOSITE) **HAL 9000, built with a modern 2×3 light brick**

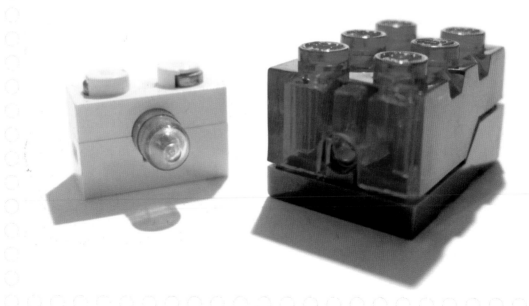

LEGO lights have been around since 1957. The first light element was a primitive—and by today's standards, dangerous—combination of a hollow, transparent 2×4 brick and a little glass bulb. The next light elements became available in the late 1960s, but even then they didn't take off. Finally, the 1980s brought a surge of light bricks, and by the 1990s, eight or so different light bricks were available. The two most versatile types were the nine-volt (9V) 1×2 brick with one bulb and the 9V 1×4 brick with two bulbs, one on each end.

Today's 2×3 light bricks and Power Functions lights are even more versatile than their predecessors. The 2×3 light brick is especially useful because it contains an internal battery, so it doesn't need a battery box. Power Functions lights do require a battery box, but they're compatible within the Power Functions system of motors and therefore can work well in large models with other battery-powered features. If you want to add lighting to your models, these and the two 9V light bricks are the easiest to use. Most other light elements are difficult to build with.

But where should you use light bricks in your models? Try to light only those sections that would be lit in real life. Glowing fireplaces—like the one in my *Hunchback of Notre Dame* diorama—are a perfect example. Lit street lamps are classy. Illuminated fireballs being shot from a carnivorous dragon's mouth—now we're talking! I wouldn't suggest adding lights to a model simply for the novelty of having them. Unnecessary lights can distract from your model, even if the model is well built. You want viewers to admire the construction methods you've used in the creation, not the superfluous lights on top of it.

It's also not practical to light your entire model. You'll need to carefully decide which parts to light and which to leave in the dark. The lights will draw viewers' attention over everything else, so light only the most important components.

I had to be selective about lighting when I worked on the second alternate model to Creator set #7347 Highway Pickup. The main model truck has flashing lights on its roof, and the first alternate, a roadster, features the light bricks as part of a turbo exhaust system. Light bricks are expensive, so it was important to use them in both alternate builds. I thought the two light bricks would be perfect for functioning headlights. I also knew the vehicle had to be large because the 2×3 light bricks are bulky. Ultimately, I built a 1970s-style flat-nosed truck with a 2×4 plate behind the cab that triggered the lights when pressed.

What lesson can you pull away from this example? You should always decide if your model will have lights in it before you start building because lights usually take up a lot of space, especially in minifigure-scale models. For my model, I planned the function for the light bricks before I even decided what type of vehicle I would create. Engineer your creation around the lights, and you won't have to jam them in where they won't fit later.

(OPPOSITE) **Judge Claude Frollo from Disney's *The Hunchback of Notre Dame* (1996) in front of a large gothic fireplace. The glowing flames set a sinister tone in this small but cinematic diorama.**

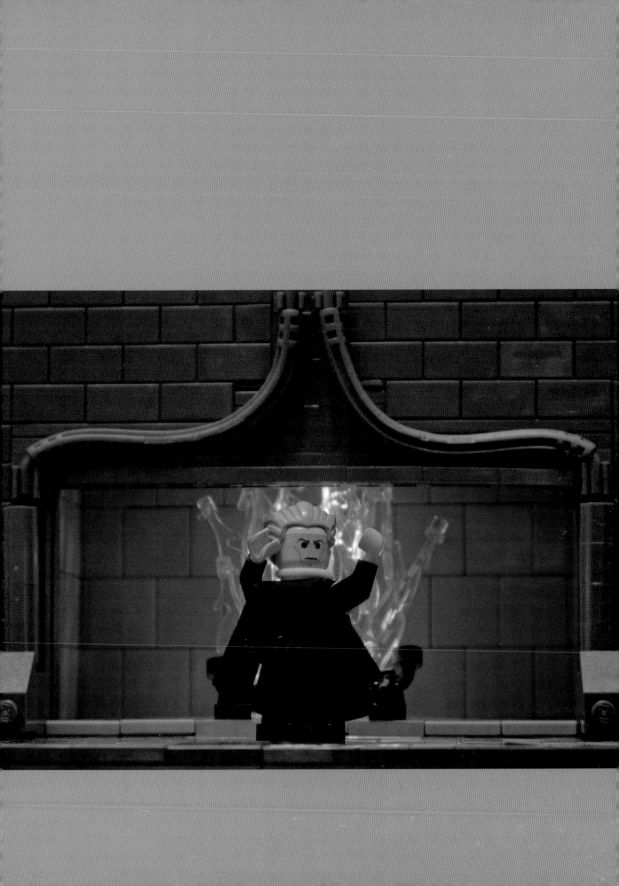

Hiding the Battery Box

Battery boxes are big and heavy, which can deter builders from using lights in their models. The smallest option is a 9V battery box, and even that has a massive footprint of 8×4×3. Because battery boxes are so large, you'll need to incorporate them carefully into your creation.

This task is reasonably simple if you're building large models, such as buildings, castles, or bulky spacecraft. However, when you work with small models—especially vehicles—it's almost impossible to find room for the light bricks, their wires, and the battery box. You need to carefully work out where they can fit—but again, don't wait until the bulk of the model is assembled to do that.

If your model is small, you probably won't be able to incorporate the battery box into the model itself. That means you'll need to cleverly integrate it into the overall presentation. You could build it into a base and place the model on top, or you might even build it into the scenery, if you can design a small diorama to go with your model.

One example that uses lights successfully is my minifigure-scale *Spinner*, a model of the Syd Mead–designed hover car from Ridley Scott's *Blade Runner* (1982). The Spinner has several special features: It has wheels that shift, it shoots pillars of exhaust as it takes off, and it has blinking police sirens on the roof. At minifigure scale, how was I going to build this unique and dynamic car *and* hide a battery box?

The *Spinner* from *Blade Runner* (1982), with func-tioning blinking lights

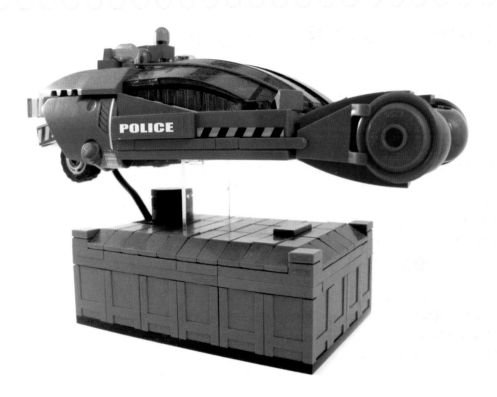

I managed to do so by building the battery box into a base that the *Spinner* could hover over—a base that resembles the futuristic Los Angeles high-rise rooftops in the movie. The next challenge was the vehicle itself. I used two 1×4 light bricks, for a total of four blinking lights. I began designing the model from the cockpit and worked my way back, making sure the lights fit in properly. I placed transparent red and blue bulb covers over the lights to tint them signature police colors. With no more space to add extra functioning lights, I sandwiched the working lights with nonblinking bulbs. When the working lights flicker, the light reflects off the bookended bulbs, and it looks like there are six functional lights when there are only four.

The *Spinner* appears to hover over its base through the use of transparent elements. The lights turn on when you press the raised 1×2 on the top of the base, which holds the battery box. The 2×2 black "smokestack" in the back is actually a sound brick that produces a police siren when the lights are triggered.

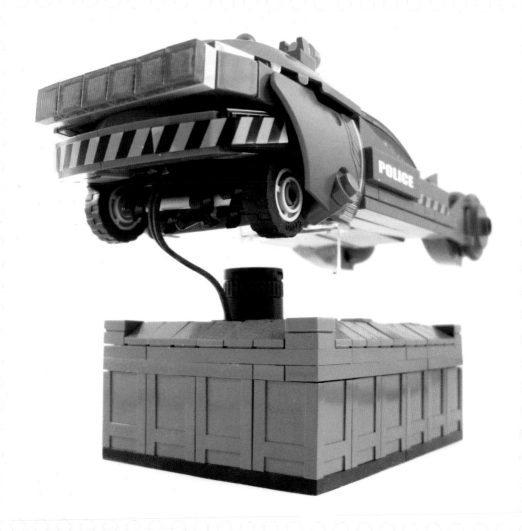

Back view of the *Spinner*. You can see the wire from the battery box weaving into the model. More of the wire is coiled up inside the back of the vehicle.

Unofficial Lighting Solutions

I'm a strict LEGO purist 99 percent of the time (meaning I don't use custom, clone, or non-LEGO parts in my models), but for that other 1 percent, I will cave to something that genuinely enhances the medium and fits in seamlessly. One of those rare products is a custom lighting solution called *LifeLites*. Developed in 2006 by LEGO enthusiast Rob Hendrix, LifeLites feature tiny LED bulbs implanted neatly inside half pins. The lights fit snugly into places official LEGO lights simply cannot go.

LifeLites are even more dynamic than official light bricks because the LED pins don't connect directly to the battery box. Instead, they connect to a tiny microchip brick about the size of a standard 2×4. This brick has a variety of settings that control how the lights behave. It's an ingenious system, because with one kit, you can make the lights in the cockpit of your spaceship blink, the lighting outside of your haunted house flash, and the torches on your castle wall glow.

(LEFT) **A close-up of the versatile LifeLites** (BELOW) **A LifeLites product. A microchip is housed in the 2×4 brick, and four LED half pins are attached to it.**

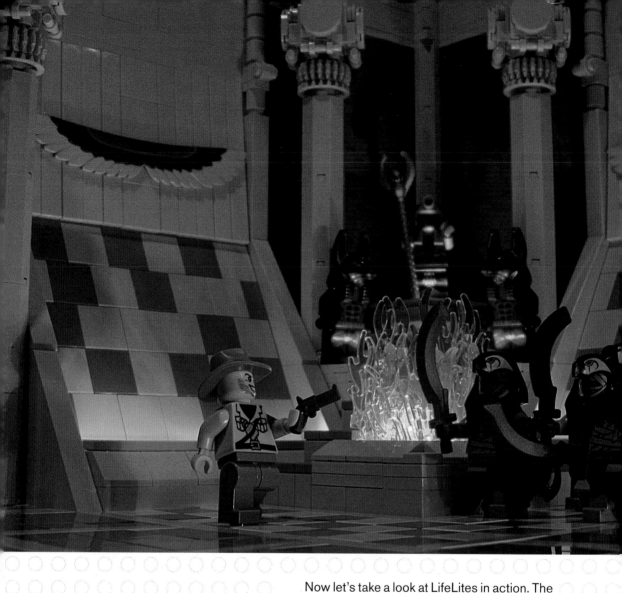

Now let's take a look at LifeLites in action. The lights really set the mood for this Egyptian-themed diorama I built. It's a model of a dark and foreboding ancient crypt, so I decided to use lighting to make it creepier. For example, the lights in the fire pit, which should draw the viewer's eye first, bring the flames to life. Moving up from the fire, some lights you can't directly see cast a spectral blue glow onto the Anubis figures and the high priest, who is summoning the mummies back from the dead. Recessed lights beneath the angled walls provide a subtle finishing touch.

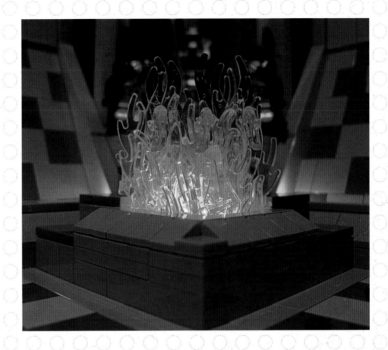

(LEFT) **This diorama, called *Mummies!*, uses LifeLites for illumination. Notice the blue lights in the background under the pharaoh, the raging fire in the middle, and the recessed lighting illuminating the angled walls between the four columns.** (RIGHT) **The light makes these flames look alive.**

Silhouettes

You can manipulate the general outline of a model—its *silhouette*—by playing with its base and overall height.

Here's one approach to consider when designing bases: If your base will represent an artificial surface (like a concrete loading bay for a spaceship model), then a simple rectangular shape might be best. If your model involves an organic surface (like an antique car rolling down an unpaved dirt road), however, then its base could be either free-form *or* rectangular. If you choose the latter, try to add some ornate detailing along the base's edges so the base doesn't look too artificial. Brian M. William's *The Night of the Deadly Bricks*, is a great example of a model with a lavishly detailed rectangular base.

You might also consider using the height of your model as a way to manipulate its silhouette. For example, imagine you're building an old pagoda hidden somewhere deep in a forest. It's surrounded by a grove of trees. Don't just use prefabricated firs—a forest of prefab trees would look fake because trees in a real forest vary in height. Make a few trees really, really tall, and keep some shorter ones, too. You might add a sapling or two somewhere else on the base. This variety will be more pleasing to the eye and will look more natural.

I applied these ideas when building this futuristic diorama, which depicts mechanized forces invading a sacred forest, only to encounter the forest's large, shape-shifting warrior guardian. Notice how, from front to back, the heights of the components in the model increase dramatically. The large white mech is one of the shortest components, and the trees get taller as you move back, ending with one of the tallest elements—the pagoda itself.

(OPPOSITE) **A futuristic diorama with varying heights, built on a long base**

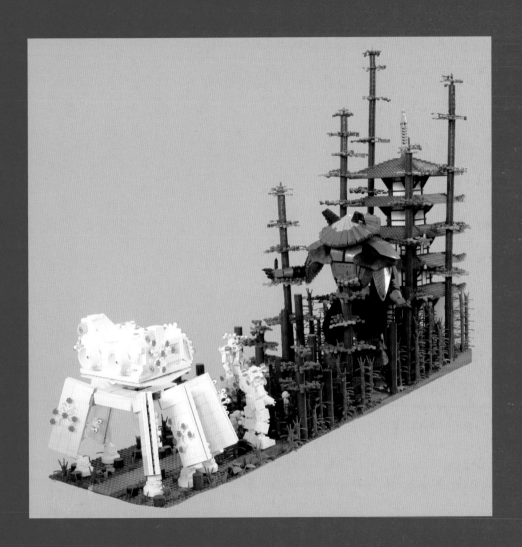

Perspective

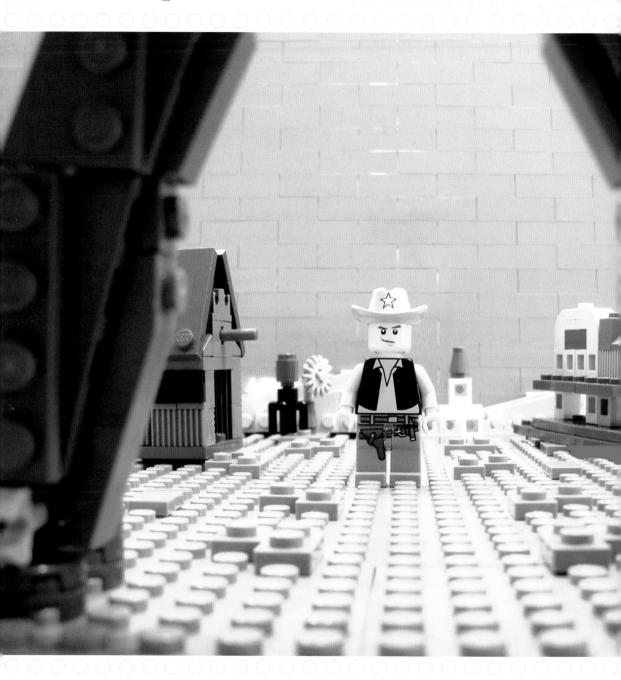

Forced perspective is another composition technique that you can try. This technique works only when the model is shown in a photograph, unless you build some structure to block its inner workings from the viewer.

Normally, forced perspective scenes have tremendous depth. A part of a model that seems laughably puny will often take up several feet of space. The standard format for such models is to build the background at microscale, the middle ground at a slightly larger scale, and the foreground at a normal scale (usually minifigure scale). Few really convincing examples of these models exist, but when the perspective is spot-on, the effect can be very deceiving. Tyler Clites's pair of gunslingers, for example, uses forced perspective—the viewer peers between a gunman's legs at his target. The three sections of the model each use a different scale to create a sense of depth. The foreground contains the first gunman's legs, built at large scale. The middle ground has the second gunman at perfect minifigure scale. The background features some microscale buildings off in the distance, including a church and windmill.

This Town Ain't Big Enough for the Two of Us by Tyler Clites is built at three different scales. The builder edited the original photo to make sure the viewer would see the scene as intended.

Advanced Designs

If you're feeling adventurous, you can manipulate color in more advanced ways. Unusual lighting and tricky color schemes are a couple different techniques to try.

This model by Katie Walker illustrates a clever technique: building with elements that react to black light. The model might look strange under normal lighting conditions, but when exposed to black light, the elements glow. Most transparent elements, particularly the neon-tinted ones available in the space sets from the 1990s, respond to black light.

(OPPOSITE) *We Live On...* by Katie Walker uses many different-toned transparent elements that glow when exposed to black light.

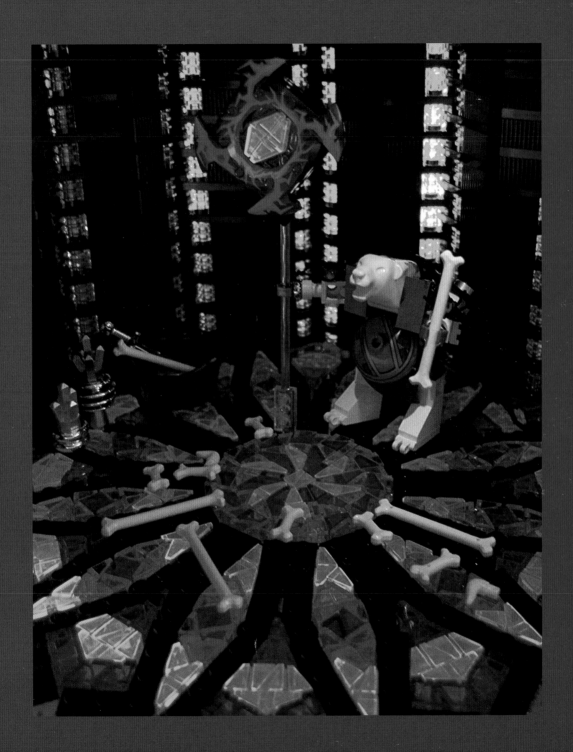

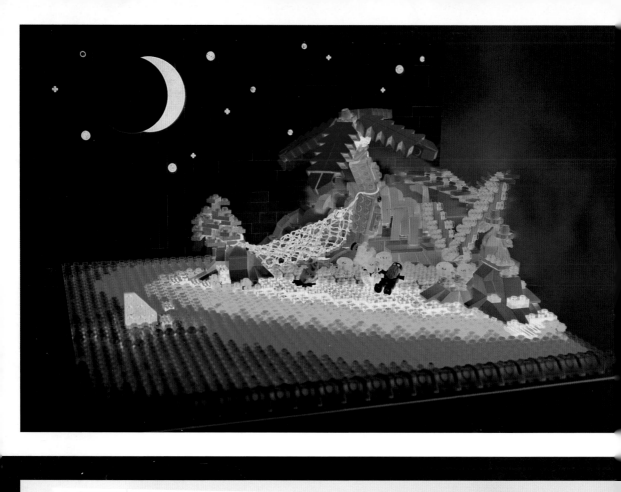
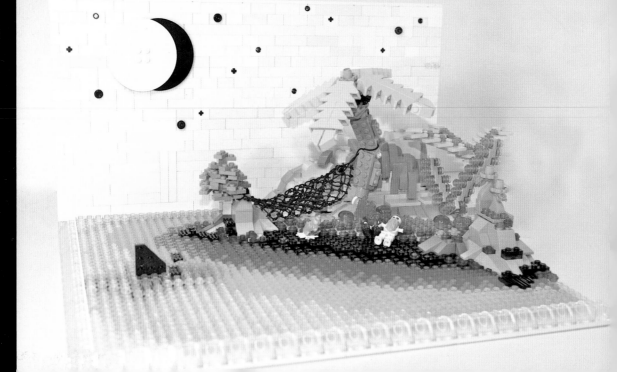

Invert Island, by Sean and Steph Mayo, appears to be a lush tropical island illuminated by moonlight, but it's actually an inverted photograph. Although the night scene was technically achieved through photo manipulation, the builders still had to carefully decide how the final photograph should look and then build the model in those colors' opposites. This was likely a tricky task, given the rare colors they used. The bottom photo shows the untouched model, which is actually made of many pink, blue, white, and orange bricks.

(OPPOSITE TOP) *Invert Island* by **Sean and Steph Mayo. This is the final inverted photograph.** (OPPOSITE BOTTOM) **The model as originally constructed**

Finally, let's look at a vignette of a murder scene I built. Unlike *Invert Island*, there was no photo manipulation done here. Rather than building the scene and converting it to grayscale using photo-editing software, I built it using only black, white, and grey elements. These simple color choices give the model a film noir mood, like an old detective picture.

A vignette of a murder scene built only in black, white, and shades of grey, giving it a film noir look without any postediting

When it comes to color, there is no definitive right and wrong. Experimentation often leads to the best color combinations—combinations that may not be immediately obvious, but create additional texture or convey a certain mood.

8 Wildlife & Foliage

Foliage and creatures are often taken for granted unless they are integral to a model. Many builders view them as enhancements rather than critical components and compromise when building them. Why spend a lot of time on animals or plants that act as mere decoration in a model? It's simple: because every detail counts.

First, we'll look at animals, starting at minifigure scale. We'll discuss adding articulation, choosing a scale, and other topics before moving on to fantastical creatures, like dragons and dinosaurs. Building such creatures is very different from building minifigure-scale models of real-life animals, as you'll soon see. We'll cover plants last, with a focus on how to build realistic trees.

Animals

The very first LEGO animals were built with bricks, like the horses in the 1978 #375 Classic Yellow Castle set. Six years later, the first prefabricated horse was released, and birds, monkeys, and cats soon followed. Today, the LEGO Group produces a vast array of prefab creatures, including ants, cows, dogs, crabs, snakes, spiders, scorpions, goats, and even elephants. The LEGO Friends line also introduced new, stylized critters like puppies and hedgehogs.

A selection of prefabricated creatures, including a hippo-griff, a tiger, and a stingray

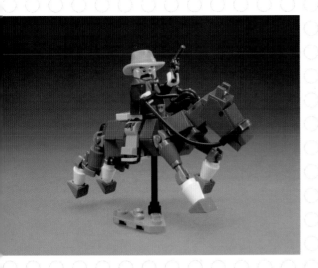

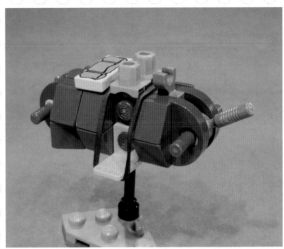

Articulation

Single-piece creatures are cute and classic, but building animals with bricks offers one major advantage: articulation. While most LEGO animals are static, brick-built ones can be posed in any position you like. For example, if you're building a cowboy riding off into the sunset, you would probably pose his horse mid-gallop, as in Brian M. Williams's model of Theodore Roosevelt. As you can see from the photo of the deconstructed model, the minifigure's legs are actually attached to the horse's side to make him look like he's riding.

Being able to pose your animals is key, even if they aren't the main focus of your model. For example, imagine a model of a sty in which every pig is posed in the same way—that would look phony! If you want to include many of the same animal in one model, articulation can make each one distinct.

(LEFT) **This horse by Brian M. Williams has movable joints so you can pose it. Here, the horse's legs are arranged so it looks like the animal is charging.** (RIGHT) **A deconstructed shot that reveals how the Roosevelt minifigure attaches to his horse in a riding position**

Achieving Realism

To build a realistic-looking animal, start by gathering reference photographs of that animal in many poses—sitting, jumping, charging, and so on. At minifigure scale, you won't be able to perfectly duplicate every section of the animal; instead try to re-create the most important shapes and lines accurately so viewers can easily recognize your animal. Anatomical models or illustrations of skeletal and muscular systems can help you choose the most important physical characteristics of the animal to emphasize. Look at my buffalo to see this in action.

At this scale, the key was to include enough identifying features to make the buffalo distinguishable from a bear, a horse, or any other brown animal. Most important is the buffalo's head: He has the signature long face, wide nose, and horns. Moving down his body, note the broad, rounded shoulders, which are an iconic characteristic of this bovine. I used a barrel for the torso because it not only shapes his shoulders well, but also has a furlike texture. Last is his belly, which curves inward due to the use of 3×3 dishes. The smooth surfaces of those dishes indicate much shorter fur compared with the fluffy mane suggested by the barrel, just like on a real buffalo. And voilà: *Bison bison*!

(OPPOSITE) ***Bison bison***, also known as the American buffalo (ABOVE) An orange tiger with black rubber bands for striping

It's not quite that easy, though; building a convincing animal like this is time consuming. With the right reference material as a starting point, however, the process will be a lot smoother.

First and foremost, decide on a scale. I'll stick to minifigure scale here. Then, research and gather elements of the right color in a size corresponding to your scale. When dealing with minifigure scale, your elements will almost always be small. You might make minor exceptions, like the barrel of my buffalo, if such elements will be vital to your model. Keep curved, organic elements, like the palm tree sections used in my bison's legs, on hand. More common elements like dishes, travis bricks, and cheese slopes are also helpful.

Finding the right elements can be tricky if you're building a creature of an usual color—for example, a tiger—because orange elements are hard to find. If you lack the elements to build your critter in one color, try a similar but more common color, or hold off until you can find more of the elements you want. You can also compromise: If you're building a beaver and you don't have enough brown elements, he'll probably look fine in grey or tan, too.

At this stage, don't worry about details like stripes or spots. As you can see in my model of a tiger, you can add patterns in other ways, including elastic bands and stickers.

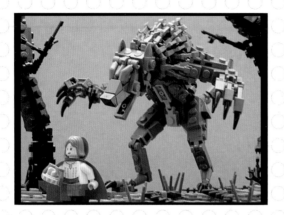

This *Big Bad Wolf* by Tyler Clites has a menacing look. His brow is made primarily from minifigure arms.

The head is the most important and most defining part of the animal. For example, Little Red Riding Hood wouldn't be scared of this wolf if his face were cute instead of fierce.

But the head is also one of the smallest parts of a minifigure-scale creature, which means it's often one of the trickiest to build. That's why, as contradictory as this might sound, I recommend building the body first. This goes only for creatures at minifigure scale or smaller. With the body complete, you should find it easier to scale the head.

If you start with the head, you'll probably want to build it perfectly and capture every subtle detail. You could end up with a head that is too big for the body, which might also result in an animal that's too big for your original scale.

Creating Small Animals

Assembling little critters is much easier than building large ones. For small animals, just choose the most recognizable physical characteristic and make that the focal point of your assembly. Tiny critters take up only a couple of cubic bricks on a LEGO grid, so you can leave out features like arms and legs to keep them to scale.

Squirrels, for example, have big, bushy tails, so give that feature special attention. Rabbits have long, floppy ears, so make sure the assembly does, too. Roosters are known for their beaks and combs, so try making the beak a bright orange and the comb a bright red. By emphasizing the quintessential traits of small animals, you can make them convincing, even if they are missing legs or eyes. This great little bird model with its squawking beak is a perfect example.

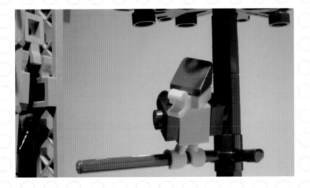

A little bird by Brian M. Williams

Prefabricated Creatures

Of course, you don't have to build your plants and animals from scratch all the time. Prefabricated (prefab) ones can also look good in models when you use them well. Whether you should use them depends entirely on your model. Thankfully, there's a large quantity and variety of prefab critters and plants available, and more are always being added to the mix.

Adding prefab creatures to studless models is a good way to add a subtle LEGO aesthetic. This is especially true for the classic animal and plant elements that have been around for decades. Another time you might choose a prefabricated animal over its brick-built counterpart is if the latter isn't instantly recognizable. At the end of the day, if your animal doesn't look like what it's supposed to be, don't use it. Also, certain prefab critters, like spiders or ants, are so small that there's no realistic way to build a brick assembly at the same scale.

There is no cut-and-dried method for putting together animals at minifigure scale, and it's nearly impossible to build them perfectly the first time. Don't give up, though; achieving realism in these small assemblies is very rewarding.

Prefabricated ants!

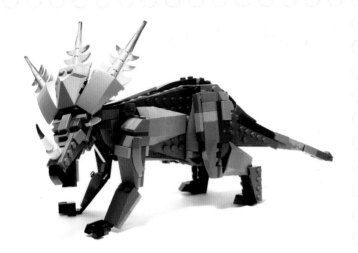

A large styracosaurus

Fantastical Creatures

Building mythological (or otherwise fantastical) creatures is a lot like building real animals, with one major difference: creative control. A kangaroo is only a kangaroo with a little head, thick tail, and long feet. A fire-breathing dragon, however, is a fire-breathing dragon with or without horns, spines, and razor-sharp talons. This type of creative control applies mostly to fictional animals, but it can also apply to models of dinosaurs and other creatures that don't exist in our present world.

I divide creature models into two categories—small and large—because each category requires different procedures. The small category includes centaurs, fauns, griffins, chupacabras, raptors, pterodactyls, and so on. Meanwhile, the large category contains creatures of monstrous sizes, like my styracosaurus, along with dragons, krakens, basilisks, and so on.

Building models of small, fictional creatures is a lot like building realistic animals. Because they are small, you just have to gather elements in the correct sizes and desired colors before you start. You have more creative control, however, which makes them easier to build.

Some of the most interesting small creatures to put together are those that are part human, like centaurs and satyrs. For minifigure-scale versions you have an immediate starting point: the minifigure torso and head. You can build directly from the minifigure, so half of your creature is automatically done, and you have a perfect reference of scale for the rest of it. From there, you just have to build the second half, whether that's a horse's body, goat's legs, or even the branches of a tree.

Large creatures are much more difficult to construct. I recommend avoiding specific prefabricated creature elements (like ones that were available from the 2001 Dinosaurs line). It's not easy to make a seamless model if you combine prefabricated elements with an otherwise brick-built monster. Such combinations usually create glaring texture disparities between the prefabricated elements and brick-built sections. Imagine a giant sculpted dinosaur leg with a little prefab foot at the bottom of it—the two components just wouldn't match in texture or size.

But as shown in Chapter 5, you *can* combine bricks with fabric elements. Another model that makes this combination successfully is my model of Maleficent from Walt Disney's 1959 animated classic, *Sleeping Beauty*. This vicious Marc Davis–animated, black-and-purple beast is one of my favorite Disney characters, and building her for a Disney-themed issue of *BrickJournal* was a no-brainer for me. The spine-based building technique I used here is similar to the flexible hose spine from Chapter 6: I started with Maleficent's spine and built everything else off of it. You could apply the methods behind her construction to any large, fantastical creature.

I began with the most important part of this model, her head, which I consider the focal point. When working on animals of this size, as opposed to those at minifigure scale or other small sizes, it may help to build the head first. For example, I didn't technically build this Maleficent model at perfect minifigure scale because it's impossible to determine what that scale is—dragons aren't real, so you can't check the proportions. In this case, it was fine to build the head before the body because it wasn't important to get the size exactly right.

(BELOW) **My minifigure tree-man, with flexible hosing as branch arms** (OPPOSITE) **Maleficent from Sleeping Beauty (1959)**

I built the long upper jaw with the studs facing outward; finger hinges (described in Chapter 1) helped bring it to a point at the end. Meanwhile, I built the thin lower jaw using many plates and cheese slopes, careful to keep it at the correct thickness. Her eyes are solid yellow minifigure heads with 1×1 cones on top, and I used mudguards, one of my favorite parts, as eyelids. My favorite detail on the entire dragon is the pair of small winglike appendages on her face, which are made from katanas and capes (an unlikely but effective combination). Maleficent's hallmark horns, built using a variety of cones connected to bent Technic tubing, top off the head.

This dragon has a muscular body with lots of curved shapes. How could I build that out of square elements? I began with the purple breast section and black back, which are mirror images of each other. The individual black and purple segments are connected to the others with finger hinges, and a series of internal supports hold the two strands apart.

There were no good wedges to fill in the sides, so I turned to something I could easily fold into the correct shape—capes! I used two capes from the Technic #8010 Darth Vader set—the same ones used in my *Tanuki Samurai* model from Chapter 5. After filling in the sides, I built the tail from bricks.

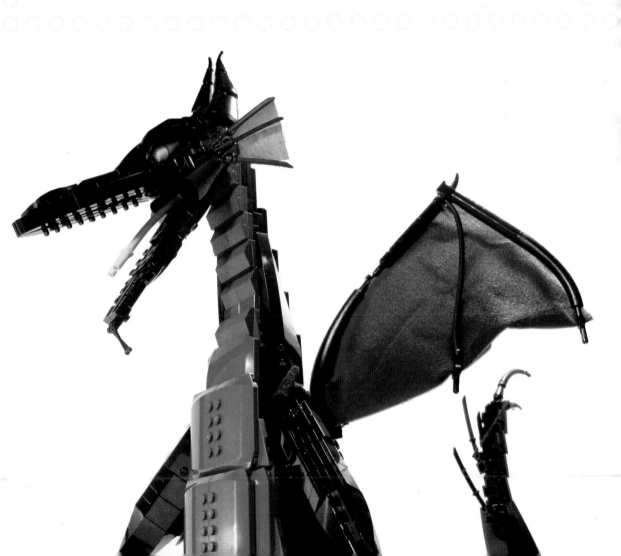

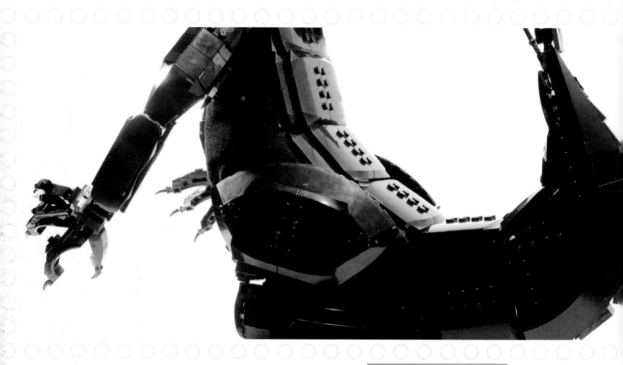

Designing a creature of this size is difficult and time consuming, especially when you're aiming for an organic aesthetic. But there is a silver lining—because the dragon is a beast of fantasy, you have a lot of creative freedom, especially concerning the model's size.

Maleficent's back. Large capes fill in her sides.

Ken Ito on Dinosaurs and Dragons

There are many useful methods for building large, fantastical creatures. You can use nonplastic elements, sculpt sections sideways, build off of a spine (as discussed in Chapter 6), or use any combination of these techniques. LEGO builder Ken "aurore&aube" Ito's dinosaurs illustrate this point well. Anatomically accurate and dynamically posed, his dinosaurs and dragons look ready to come alive.

Your specialty seems to be dinosaurs and other large creatures. How do you choose what to build? Do you have a favorite model?

I would love to build spaceships and robots, but I can't do it well. When I was wondering what I should build, I thought of what I love that others don't build—dinosaurs! Early on, I built simple, small-scale models of dinosaurs. Of course, I wanted them to be realistic, but I thought that was impossible to achieve using square bricks.

When I saw dinosaur sculptures made by professional sculptors in Japan, I realized that I'd made excuses when I built my models. Professional sculptors and illustrators seem eager to adopt the newest techniques, and after they finish, they keep researching. I thought of those professionals as my role models. I wanted to build dinosaurs worthy of being admired by them. I still wanted to build models of dinosaurs with LEGO elements, but I wanted to make them cooler, more realistic, and more scientifically correct. Dragons and creatures in movies and illustrations inspired me.

My favorite model is the *T. rex*, which was the first creation I built in my current style of dinosaur models.

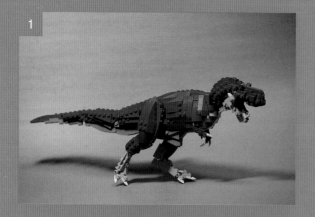

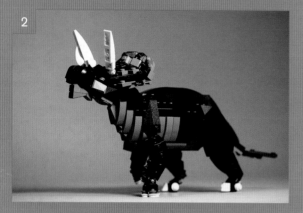

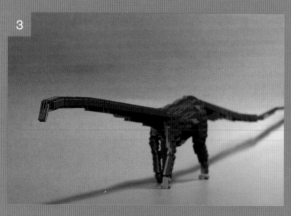

All of your dinosaurs are incredibly realistic—their bodies are beautifully sculpted and look like the real thing. How do you make your models so lifelike?

I think a skeleton is the most important component in building realistic LEGO dinosaurs. At least, I always take care not to forget that! I want to make someone looking at my models think, "This LEGO dinosaur certainly has a skeleton!" I also try to invent skeletons for fictional creatures.

 The next important element is making sure the model isn't static or stiff. For example, in my *Tyrannosaurus*, the right arm is reaching forward while the left arm hangs back. At the same time, the right leg falls backward as the left leg comes forward. I think it looks more realistic to arrange the body in a moving pose than to fix it in a stiff position. Try to catch the moment in action!

How articulated are your models? Is articulation important to you when you're building a creature?

The points of articulation in my models are created from a combination of either parts #4733 (modified 1×1 brick with studs on four sides) and #3176 (modified 3×2 plate with hole), or part #4697b (t-bar) and two #2555 parts (modified 1×1 tile with a clip). These combinations are more useful to me than hinges because they are stronger, and hinges often break the streamlined appearance. Having strong, articulated joints is certainly important to my building. These joints are not for playing with but for posing and for supporting the models' heavy bodies.

Can you explain your building process? Are there certain procedures you always carry out when working on a model, or is it different every time?

I always take a theme from a sculpture, illustration, or movie. Once I have my theme, I build the model in my brain first. If I find a way to complete the model in my head, then I begin to actually build it. During that time, I need reference materials, such as skeletal illustrations, pictorial books, and so on.

The process is a little different for dragons and other fictional creatures. There aren't any images of their skeletons, so I have to imagine how they would look. If you want to build a dragon, how you design it has a huge effect on making it realistic.

I always build the head and face first because it's difficult and troublesome to resize the head to fit the body. I build by trial and error, reworking the model until I'm satisfied. I'll modify it later of course, but I think a certain degree of satisfaction is needed at this stage.

Next, I build the bulk of the body, legs, and tail. If I feel that some part of it is off (in most cases, the body is too long or too short), then I modify that part.

4

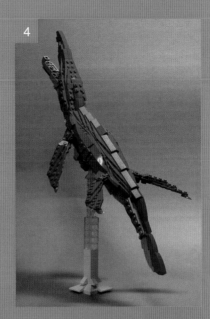

5

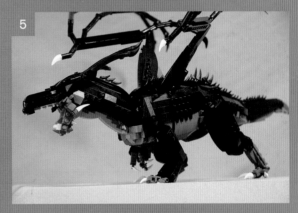

6

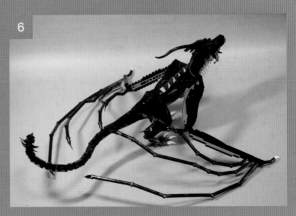

Do you have any tips or hints for building models of dinosaurs, dragons, and other creatures?

For building models of realistic dinosaurs, I think it's most important to observe skeleton and muscle. For dragons or other creatures, I do not like "design for design's sake." Excessive design can spoil the realism in more fanciful creatures. For example, to my modeling scale, I think that part #49668 (modified 1×1 white plate with tooth) is too big to express the real size of an actual creature's tooth. I find other parts to use as teeth instead because that one doesn't fit my scale. In design, subtraction is often more important that addition.

Ken's theories on creature building can also be applied to nonreptilian monsters, as shown in *The Battle of Evermore*

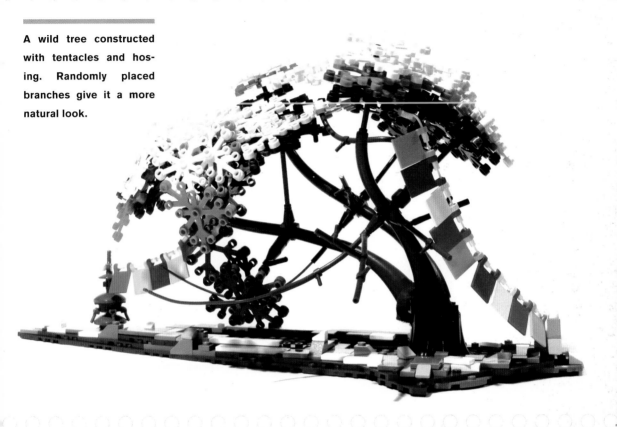

A wild tree constructed with tentacles and hosing. Randomly placed branches give it a more natural look.

Trees and Foliage

Trees and plants come in many colors, shapes, and sizes. Here are some pointers for replicating them with LEGO elements.

You should have several elements handy when building trees: hosing (flexible or stiff), minifigure hands, 318 bars, hinges, arches, and tentacles. Most of these elements can be used as tree limbs.

Always begin at the base of the tree and build your way up. How you design that base depends on the size and shape of the tree you're creating, but you'll probably want an element that's wider than those used for your branches. (Small, thin trees are an exception here; their bases are thin, and that width usually carries through the bulk of the tree.) You could start with a prefab tree stump element to give the base an accurate texture and footprint. A conical element is another good choice for a tree base because one end is wider than the other.

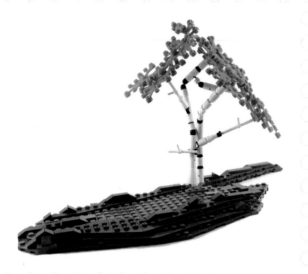

A birch tree made from bars, Technic connectors, and levers. Note the conical element at its base.

Branches are usually tapered, so they often look most convincing when built from tentacles, arches, and hosing. In fact, hosing or other 318-compatible elements make some of the best tree branches. You can even use minifigure hands as clips and add flexible hosing to the hands' stumps for detailed secondary branches.

A tree's leaves are more difficult to build realistically. There aren't many leaf elements in the LEGO spectrum. The ones available include the common two- and five-point leaf elements, along with a few palm counterparts. More recent palm elements make accurate palm trees, but the older, more common leaf elements don't make very detailed foliage. Those leaves do, however, work well in groups—try interlocking them to create lush, leafy structures.

(OPPOSITE TOP) A tree by Katie Walker. Many leaf elements are interlaced together to form the rounded treetop. (OPPOSITE BOTTOM) A pair of leaf elements from Katie Walker's little tree. On a grand scale, connecting leaves this way will create a lush and realistic canopy.

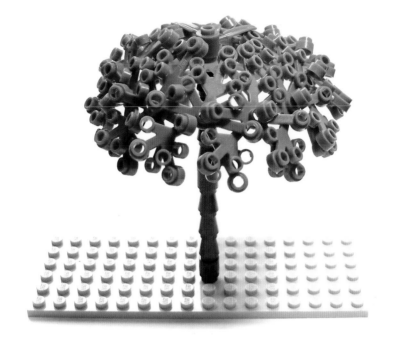

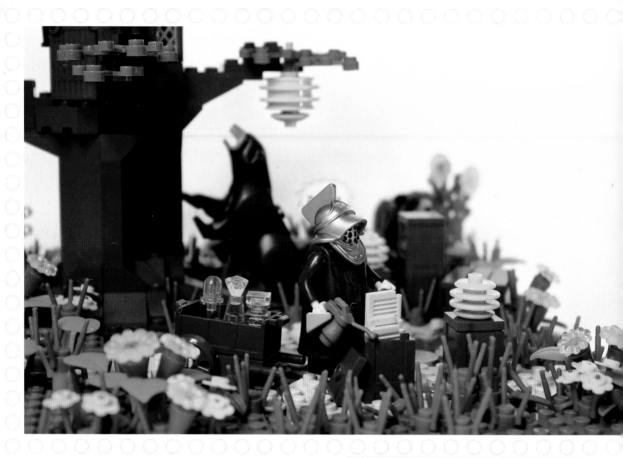

Thankfully, other plants are easier to build than trees. Flowers, for example, look best when they're random and varied. You can combine classic flower tops with others from lines like Scala and Friends to make a beautiful, realistic flower field.

For cattails, try adding brown 1×1 round bricks to the tops of tan poles. Cacti are pretty easy to build, too. Bunching palm elements together will make a big agave, for example. You can use the octagonal pillar elements prevalent in sets from the 1990s, or 2×2 round plates with 1×1 round plates between each level, to make detailed saguaro. Plain green minifigure heads even make great round cacti.

The Honeybee Tree by Sean and Steph Mayo depicts a beekeeper being as busy as a bee. Notice the use of standard System flowers with Clikits flowers. The variety of foliage makes the field look natural and unkempt.

Large-Scale
9 Figures

Models with character stand out from the rest. They tell viewers there's more to see than meets the eye. Character isn't easy to convey, though.

Typically, you'd imbue a model with character through styling, but whether you're creating someone real or fictional, styling isn't the only way. Scale, proportion, articulation, and expression are some other great design components to incorporate into figure building. They can help define your figure's mood, temperament, and attitude. Here are some things to consider in your design.

Scale

Certain types of models lend themselves to a particular scale, but that's not the case for figures—they can be built successfully at many different scales. Often, you'll find yourself choosing a scale after you've already started building. How can that work?

The hardest part of building a figure will almost always be the head, so that's the most natural place to begin. Your scale will depend on the style you're going for and the complexity of the features on the head.

(LEFT) **A Victorian gentleman's head** (RIGHT) **A devil's head, complete with goatee and horns**

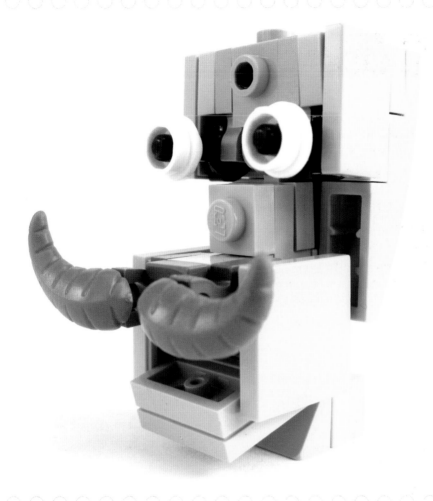

After you finish building the head, use it to scale the rest of the body. If you start with the body, the head you construct afterward might be the wrong size, and it's often easier to scale the body based on the head.

Unless you've already found a scale you're comfortable building at, you may inadvertently build your figures at different scales, and that's fine. This can be irritating if you're creating multiple figures to be used together in a single diorama, but it makes each construction unique. Variety makes the process more engaging but difficult to perfect.

Proportion

After scale comes *proportion*—the relationship between the size of the body parts and the body as a whole. You can approach proportion in two ways. On the one hand, you can build an anatomically correct model. In that case, the proportions of the head and body would need to be as accurate as your LEGO elements allow for, just as with any other medium. On the other hand, if you build a stylized character (perhaps in the Japanese *chibi* style, which features large heads and tiny bodies), you might want anatomically *incorrect* proportions. The second way obviously allows for more creative control.

Proportion in LEGO models isn't about getting every little detail of the body correct; rather, it's about creating a unified sense of accuracy throughout the different parts of your model's body. This Anubis figure is a good example of proportions done well. Its proportions, while not perfect, are an accurate representation of the human body.

Proper proportions are important because they add realism and tie your model together. With this type of organic building, it's impossible to completely avoid the LEGO aesthetic, whether you're stuck with an unusually flat forearm or a couple of studs where there should be none. That forearm won't look so flat when you take into account the perfectly sculpted leg.

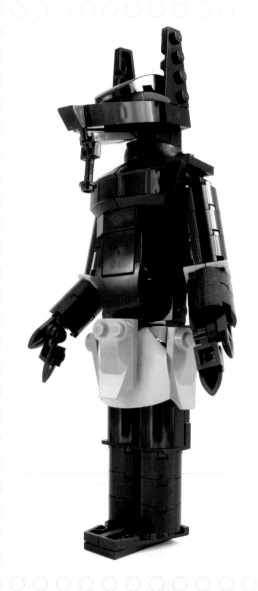

The proportions of this Anubis statue aren't perfect, but the torso is about right compared to the arms, which are about right compared to the head, and so on. Notice some of the shaping elements used to define the muscles in his torso.

My LEGO homage to the Belvedere Torso is an interesting and rare example of proportionality. This model was built at a larger scale than the Anubis model, which allowed me to achieve more detail. I built this model solely to sculpt the muscles in the torso and leg; in this case, accurate muscle-to-muscle proportions were my goal. Notice the pectoral muscles, which can be used as a reference point to compare his abdominal muscles, shoulder muscles, and so on.

(LEFT) **An anatomically accurate sculpture of a male human torso and leg, inspired by the Belvedere Torso. This model was made using many wedges and bows.** (RIGHT) **A back view of the torso. Notice the spine, made from a hose, which runs down the length of his back.**

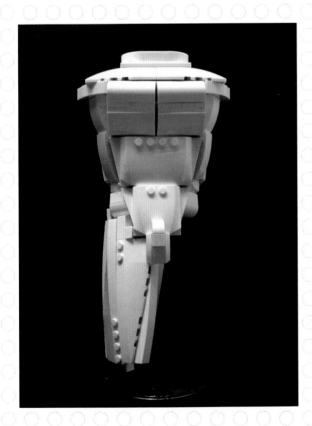

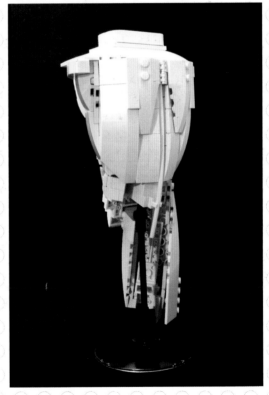

Articulation

It's extremely difficult to build figures with *articulation*, or the ability to be posed. In fact, I recommend avoiding excessive articulation in figures if only for one major reason: It decreases stability. This isn't such a problem in small figures, but for models that stand around six inches and taller, stability can become a serious issue.

You should add articulation points only where necessary. Such points include the shoulders, the neck (to allow the head to swivel), and perhaps the elbows. If you're going to add leg joints to a free-standing model, make sure you build strong ones. The legs have to hold up the rest of the model, so if you're careless, the model could break.

If you plan on having the figure in an action pose, don't worry—there are ways around the instability that joints add. For example, if you want to build a figure of a warrior charging into battle, you'll need to add joints to his hips, knees, and ankles. To make his legs stronger, just build him onto a base. If you connect a figure to a base, its legs won't have to support the rest of its body. The base itself becomes a part of the figure, like giant feet.

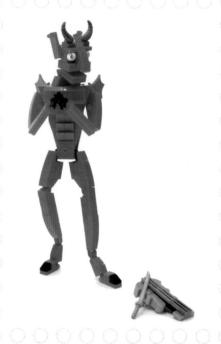

This fully articulated devil laments the loss of his golden fiddle, which lies at his feet.

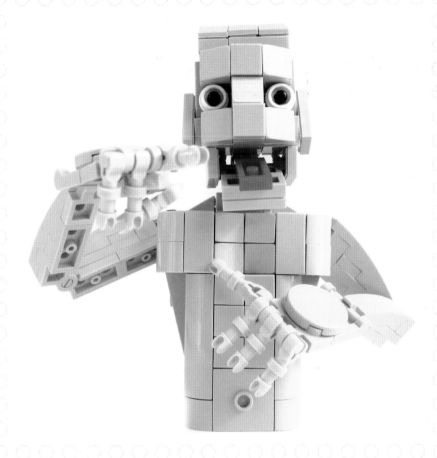

Expression

If articulation is the most difficult feature to build into a character, expression is the most fun. When you're building an expression, you can really stretch elements beyond their textbook uses to create an array of faces—from angry to happy to sad to just plain insane.

But nailing a character's expression isn't nearly as important as getting other design elements right. For most viewers, a well-built character staring blankly ahead is probably as impressive as a more expressive one. What expression will add, however, is another level of realism. It provides a layer of personality and character, and that still counts for a lot.

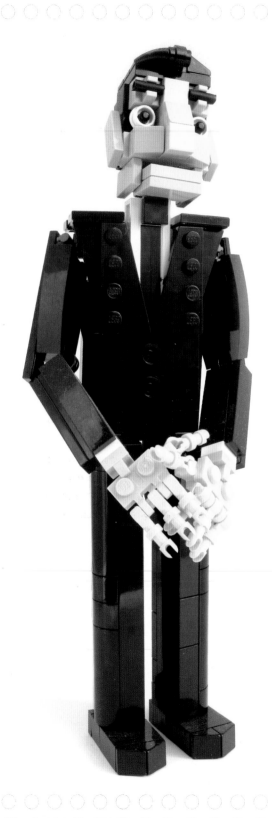

These two figures—one of Rod Serling (host of *The Twilight Zone*) and the other of Bert (Dick Van Dyke's character from *Mary Poppins* [1964])—show how to build a head on a small scale that accurately represents its real-life counterpart.

In both figures, the head takes up three cubic bricks, so I had to focus on their most defining features. For Serling, it was his heavy brow and slick hairdo; for Bert, it was Dick Van Dyke's pronounced chin.

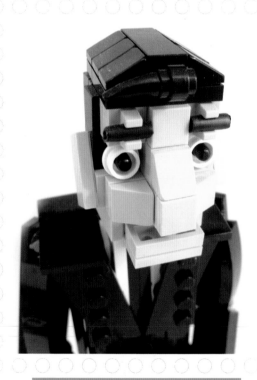

(LEFT) **Rod Serling of *The Twilight Zone***
(ABOVE) **Serling's head. Notice his thick eyebrows and slick hair.**

Crafting the figures' expressions was an interesting task, too. The heads have almost no articulation, so I had to build expressions directly into the faces. Serling's eyebrows are key to his expression: They're thick, straight, and unmoving. He wears the cool stare he always had when delivering one of his signature monologues. Bert, on the other hand, has a happy expression, courtesy of two 1×1 round plates sticking out of the sides of his mouth. They round his cheeks into a bright smile.

You could, of course, build a head that does allow for articulation, in which case you could add expression by, say, opening the figure's mouth.

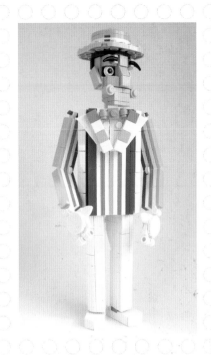

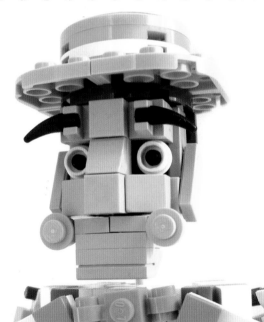

(ABOVE) **Bert from *Mary Poppins* (1964) on a jolly holiday. Remember how I said every detail counts? Notice Bert's baby-blue bow tie and matching socks, just like in the movie.** (LEFT) **Bert's head. Notice his large chin and smiling cheeks.**

Iain Heath on Characters

You build lots of models of famous people and characters. How do you choose which people or characters to build?

Most of my work is inspired by stuff that's going on "right now" in popular culture, such as new movies, current events, and Internet memes. It's my way of adding a little extra twist to the shared experience, especially if I can get my model built and up on the Web while the original is still in the public consciousness. So I guess you could say I just like to cash in on other people's popularity!

I am pretty selective about what I build—there's a lot out there to draw inspiration from, but only so many hours in the day. I need to feel passionate about the subject matter. My models definitely reflect my personal tastes and sense of humor. If you're going to spend a long time working on a model, you really need to be interested in what it's based on.

It's also important to choose subjects that are visually distinctive or memorable in some way so that people will recognize what you're parodying. Often there will be a particular image circulating widely on the Internet, so I'll work from that specific image. I also look out for opportunities to add some humor or a twist. For example, I once built Governor Schwarzenegger holding a press conference as Conan the Barbarian.

When building models of people, fictional or otherwise, it's important that they're instantly recognizable. How do you accomplish that?

It actually doesn't take a lot to make a character model recognizable, even at very small scales, if you choose your subjects wisely and follow a few basic rules.

Some builders, very much like cartoonists, use bold, artistic styles; they exaggerate certain features and are more impressionistic with the bricks. My style is more like sculpture—I want my models to look as much like the originals as possible, because I'm really interested in modeling human anatomy and posture. (I also want to see how scarily lifelike I can make them!) I usually build my models with accurate proportions and set them in realistic positions.

The first and most important phase in a character build is to study the source material closely and figure out two things: pose and detail.

Choosing the right pose will breathe life into the model. You don't want it to just be standing there with its arms at its sides as if it's waiting for a bus. Usually, the original subject matter will determine the best pose. The best poses are often those that capture a freeze-frame sense of motion, such as a superhero mid-punch.

Arnifornia

With detail, the object of the exercise is to figure out what to keep and what to discard. The scale you build at is a factor, obviously. Step way back from the original image, see what features you can still recognize, and focus on those. Drop any small details that don't add much to the model or that would complicate the build in some way. The pose is the most important detail, so it's often worth sacrificing other details, or accuracy, to get it right.

Beyond that, the keys to building a good character model are just technique and willpower. People and creatures involve a lot more curves and unusual angles than you might typically see in vehicles and buildings. It's important to learn techniques like SNOT and one-stud connections. Many of my models these days are 80 percent SNOT, to the point where I've trained myself to completely avoid "studs-up" as the default starting point for any new model.

Getting really high fidelity into your model is simply a matter of referring back to your source material continually and doing a lot of iteration. That's where the willpower comes in. With my model of Bilbo Baggins, I actually spent four hours getting a single arm to look natural.

I research my subjects thoroughly, finding different photos taken from different angles, and tape printouts of those photos to the wall above my work area. At each step, I eyeball my work against the photos, find the next thing that's missing or incorrect, fix it, and iterate.

(ABOVE) *Jay LEGO* (OPPO-SITE) *Finders Keepers!*

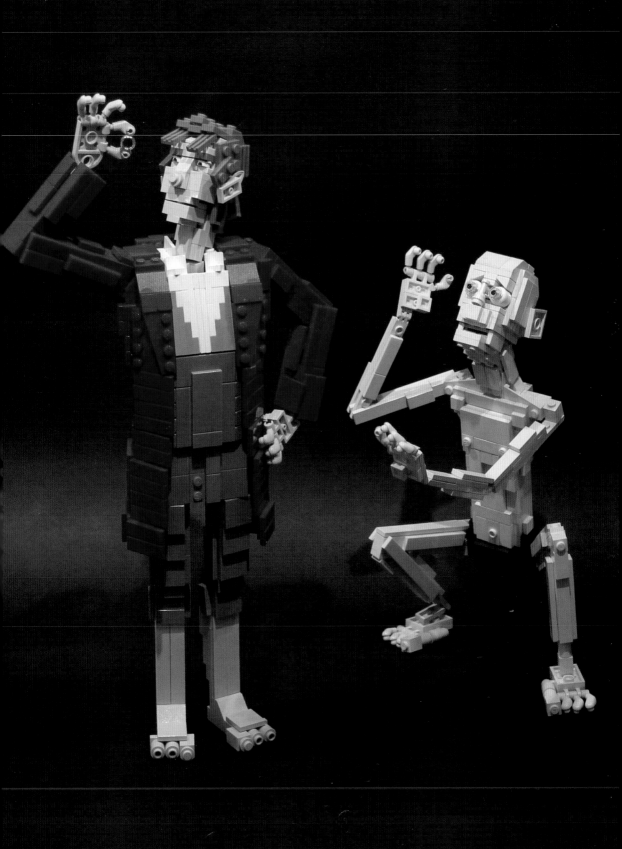

You often build in different scales, where some of your characters are large and some are small. Is there a particular scale you prefer, and if so, why?

Actually, I enjoy both large and small scale equally, but for different reasons.

When I started building characters, I took the obvious path of following Miniland scale (the scale used in LEGO theme parks) because it requires less training and fewer bricks. As I got better, I broke from the strict Miniland pattern so I could add more realism. I'm one of several builders who work at a modified version of this scale, which we have christened *Miniland+*.

The smaller scale is great because a typical build is between two and eight hours of work, so I can get a model of some current meme uploaded very quickly. It's a deliberately less-detailed scale, so you can be more impressionistic. The skill is in finding the "essence" of a character (that is, what makes it recognizable). In the early days, I didn't like the blank faces at this scale, and I developed my own style with elongated, anime-style heads so I could add facial expressions. That's where I got into the habit of drawing in pupils with a Sharpie, so that the character could engage with the audience better. Since then, I've come to appreciate blank heads again, because they are more in proportion with the bodies.

The much larger scale of character models came about because I wanted to challenge myself artistically and technically. I wanted to take my craft to the next level by attempting something closer to real sculpture. I developed my own system based around a 1:6 scale, where a 1-foot model represents a 6-foot person. This scale allows for accurate proportions based on a head that is three studs wide, which is perfect for separating the eyes and adding a lot of interesting facial detail. At that point, someone could actually recognize the subject of the model, based on the head alone.

Of course, this scale is much more challenging to work with than Miniland+. A typical build at this scale represents 40 hours of effort, so I can't react as quickly. That can be tricky when I'm trying to build characters from a movie to coincide with the film's release date. But this scale is very rewarding because, if you can muscle through all the technical obstacles, the results can be spectacular.

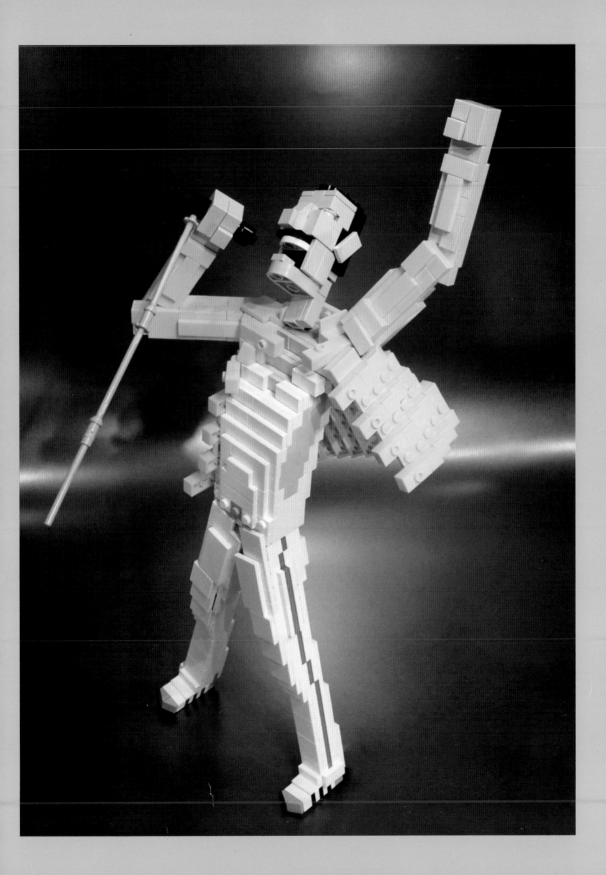

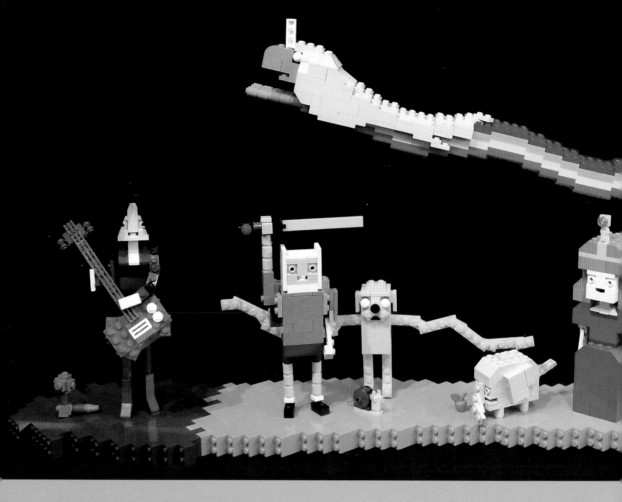

Can you describe your building process? Are there certain procedures you always carry out when working on a model, or is it different every time?

It varies based on the scale, but I have a few common rules. It's best to start a model by building the smallest part and then design the rest of the model to scale around that part. For character models, the smallest part is usually the eyes or the head. If you build the smallest part last, it may end up being disproportionate to the rest of the model.

For small models, I don't have a set process; it's more a collection of tricks and techniques for achieving certain effects (such as fixing limbs at odd angles). I often build the torso studs-sideways using plates, because that makes it easy to create clothing effects, such as a jacket, shirt, and tie combination. At this smaller scale, details like clothing are best modeled by using color variations within a flat surface.

My larger-scale models do follow a general system that I developed. I have some prebuilt "stencils" of different kinds of figures in profile, and I use those as templates to capture the basic skeletal structure and muscle groups. I also tend to sculpt the larger models one dimension at a time. That is, first I figure out the side profile, then I work on the front profile, and then I look down onto the model and sculpt the girth, from head to toe.

At regular intervals, I have to stop adding and removing bricks and build a fresh copy of the model with proper internal strength. Typically, a larger model gets rebuilt about five times like this.

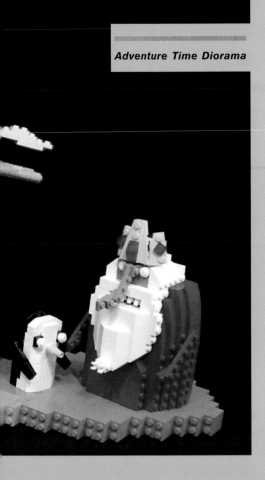

especially if it's in an action pose that gives it an odd center of gravity. The solution is usually to build a flat base for the model and extend one of its legs into the interior of the base.

Do you have any tips or hints for building models of people and characters?

Building character models has its own peculiar challenges to overcome and techniques to learn. As with anything, it requires a lot of hands-on practice to master. But here are some general pointers.

First, continually check your progress against your reference images; just like a painter, break down the scene and figure out how to emulate each part. The human eye is particularly sensitive to the human form, so if your model is "off" in some way (legs that are too short, an arm bent at an impossible angle, and so on), that flaw will stand out. It's worth getting a basic understanding of how the human body hangs together, perhaps by looking more closely at the people you see every-day. Or study yourself. I often strike poses in front of a mirror to figure out angles and proportions.

Also, don't try to put the entire model together in one pass. Start with a crude frame, just to fig-ure out how the model will occupy space. Then start to add bulk (again, crudely at first). Take one or two aspects, and refine them a little; then take some other aspects, refine them further, and repeat the process over and over again. And don't be afraid to backtrack if something isn't working. Character models tend to be spindly and fragile, so it's important to keep the model structurally sound as you progress. Otherwise, it'll come apart every time you try to add more to it. Every so often, you'll need to stop and construct a copy of what you've created so far, figuring out how to make it sturdier, and then continue with the copy.

A particular feature of my larger models is that the poses (limb positions and such) are fixed in place. I don't like using poseable joints to set the pose because they leave horrible gaps and make the figure look like a mannequin. For me, it's important to decide the pose right at the begin-ning. To do this, I build a simple mockup figure with poseable joints, use it to experiment with poses until I find the one I like, and then reference the figure going forward.

There are two particularly nasty challenges at this scale. One is filling in small gaps in the torso, usually around limb connections. It can be tedious to figure out the best combination of small parts to fill each gap, bearing in mind that the neighboring regions may have been built at completely different angles to one another. The other challenge is getting a model to stand up,

At the end of the day, whatever style you adopt, it's your choice of subject matter that counts. Try to find topics that will appeal to your audience and evoke some kind of emotional response. It's also cool if you can add something (humor or a twist) to make your interpretation special. Building character models isn't just about replication—your own ideas can play a large part, too!

Arrietty the Borrower

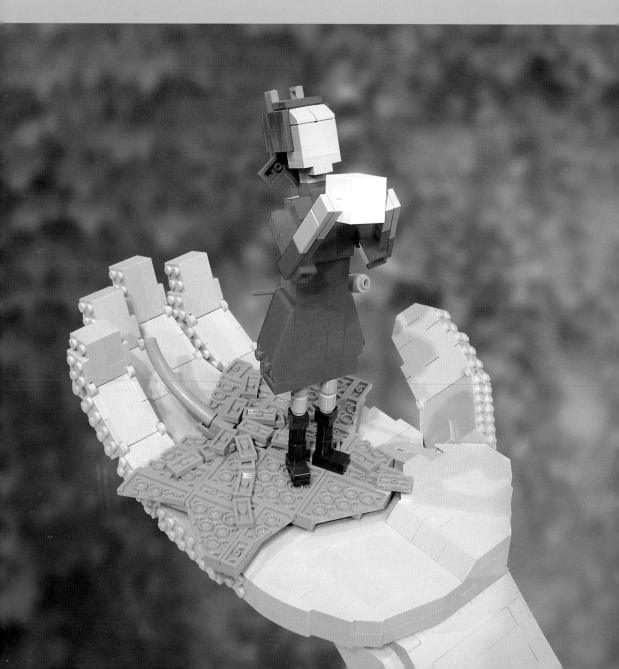

10

Cars, Wagons, & Watercraft

Cars, trains, and other vehicles are popular subjects for LEGO models. Antiquated modes of transportation, like old sailing ships, can be particularly fun to build because we can take them for a spin in a way we otherwise couldn't. This chapter will explore some of the most popular types of vehicles to build with LEGO.

Automobiles

The LEGO Group has produced automobiles and trucks as official sets since its earliest days. In my opinion, cars are the most classic subject to build from LEGO elements.

Many builders consider accuracy even more essential for cars than for other types of models. This can be a challenge when building at minifigure scale because the average car is only five or six studs wide. Adding a few extra pieces may accidentally transform your Barracuda into a Challenger.

So how can you make a perfect LEGO car? If you're going for accuracy, SNOT techniques and knowledge of the available elements are essential because there's little room for error. There are several key steps to the automobile-building process that you should follow, as demonstrated with my early 20th-century motorcar.

A green motorcar from the 1910s or early 1920s. This particular car is six studs wide at minifigure scale.

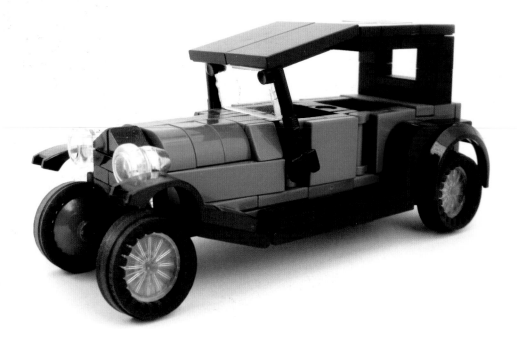

General Advice

The area from the grill up to the windscreen defines many cars. Focus on that section first to make sure the model actually looks like your car of choice, and then work your way back to the trunk. If you don't, you'll have a hard time filling in the middle later.

> The hood curves downward, just as it does on the real car. On either side, a green 1×4 tile angles away from the hood by the height of one plate as it approaches the windshield.

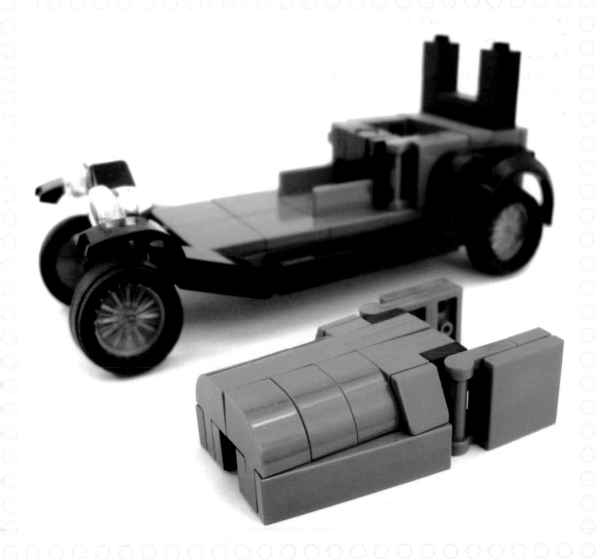

Next, focus on the wheels, which will immediately link your vehicle to its era if you build them correctly. Wheels can be tricky because there are only a handful of ways to build them at minifigure scale. I built this set of wheels from bicycle wheel elements to make them look old-fashioned, like what you'd see on a classic Model T. If you want to build modern wheels, I recommend using 2×2 dishes—chrome ones work especially well for cars from the late 1930s through the 1960s. However you build the wheels, you'll almost always want to use some type of 318 element for the axle.

(ABOVE) **My motorcar has bicycle wheels with inside-out tires wrapped around them. The bicycle wheel spokes look like early 20th-century automobile wheels.**

When you finish the wheels, check them against the rest of your car to ensure that their size matches. It may help to build temporary supports to hold the wheels in place while you build the rest of the car.

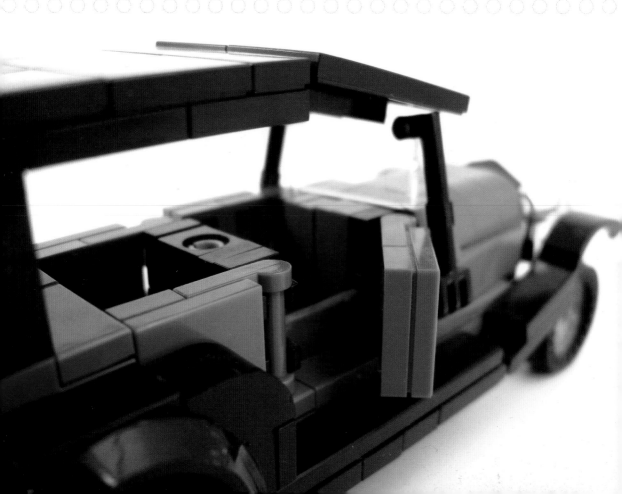

Unfortunately, vehicle doors are often a huge source of frustration, especially if you want them to be functional. Adding hinges to that area is tricky! You may want the doors to open enough that minifigures can get in and out, but it's almost impossible to add that functionality. The best solution is not to get too hung up on building a car with fully functional doors.

As for windows and windscreens, don't limit yourself to prefabricated parts. Many of the best car models use other transparent elements to achieve the same effects in more inventive ways. When it comes to car windscreens, no single, nonprefabricated element works best. The transparent element you choose will depend on how big the area behind the hood of your car is. You could build 20 cars, all with completely different windscreens.

(OPPOSITE BOTTOM) **This vehicle has functioning doors, but it's hard to actually open them because of the way it's built. The sides of the car are built studs-out, so the doors are made from 1×1 clips and modified plates with 2×2 tiles.** (BELOW) **This windscreen is a windowpane normally reserved for prefab house window frames. The pane is wedged between two old-style finger hinge elements.**

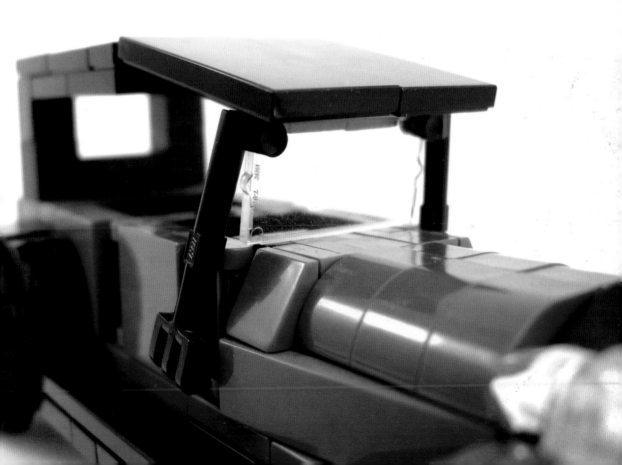

Common Pitfalls

Now that you've seen the basic steps for building cars, you can explore other building possibilities, but keep the following potential pitfalls in mind.

One common fallacy is that it's good to start with a prefabricated chassis. These bulky plates are really just a good way to doom your model to mediocrity. Unless you have no other option, it's better to avoid using a prefab chassis altogether.

The problem with a prefab chassis is that you're restricted to its footprint, and not only when it comes to the body of the vehicle—you're also restricted to its wheel wells. Most prefab chassis have four cutout sections for the wheels; some even boast axles to which you can attach your wheels. If you've built LEGO cars before, you know that the wheels are often one of the most challenging components to work around. If you don't have enough room for the wheels after designing your car on a prefab chassis, you're in big trouble.

Space constraints, like the relationship of wheels to wheel wells, make it difficult to build automobiles, which leads us to another misconception: Contrary to popular belief, a minifigure doesn't have to fit in your car. Although LEGO product designers follow the rule that if a person would fit inside something in real life, a minifigure needs to be able to do so in a model version, I've built only a couple of cars that could fit an entire minifigure. My other cars fit only the upper body or just the head (so that it *looks* like somebody is driving), and that's all you need.

If you try too hard to fit a minifigure in a car, one of two things will happen: The car will look perfect, but it will probably be out of scale, or the exterior will look wrong because of the interior space you had to leave for the figure. If you want your car to look realistic, you'll need to sacrifice some functionality.

You also shouldn't worry about making your car wheels spin. Many who grew up with LEGO compare their models to the official ones and try to include all of the same functions. But official LEGO sets are subjected to so many constraints that you shouldn't consider them a definitive standard for your own models. Don't restrict yourself to that mold!

It is possible, however, to build a realistic set of wheels that spin, if you really want to be able to roll your car. Just build the wheels out of 2×2 dishes, and use a hose nozzle for the axle. Then, you can stick the tip of the nozzle through the two dishes and let the wheels spin freely.

Tires, 2×2 dishes, and hose nozzles—everything you need to make spinning wheels

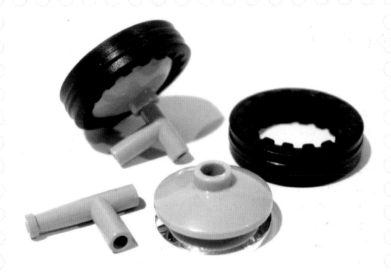

The Garage

Here are some vehicles showcasing the realism you can achieve when building cars at minifigure scale. Each model adheres to the techniques described earlier.

(1) *Nepali Tata Truck*, originally built for an issue of *BrickJournal*. This model uses loud colors and patterns to replicate the intricate details found on the real thing.

1

2

3

(2) **An old black Bentley. Its rear mudguards are made from The Claw elements from a** *Toy Story* **set, and its headlights are made from transparent Clikits beads attached to black battle droid arms.** (3) **A side view of the Bentley** (4) *Sentinel 400,* **a retro-futuristic limousine originally designed by Syd Mead** (5) **An early Rolls-Royce in dark red. This car is exactly five studs wide.** (6) **The Rolls-Royce's detailed undercarriage**

4

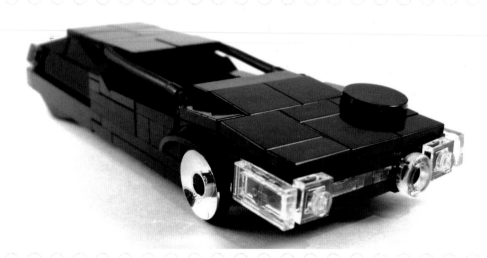

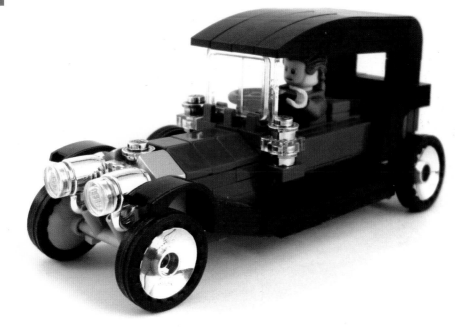

Adam Grabowski on Cars

Builder Adam Grabowski isn't just a LEGO fan responsible for some of the most impressive automobile models on the Internet. He's also a LEGO product designer working in Billund, Denmark, to help create some of the company's most distinctive sets.

How do you decide which automobiles to build?

I tend to build cars from movies, cars that I'd like to own, and cars that have a certain piece in their appearance. That last category means a particular piece is the obvious choice for a mudguard, front end, grille, or something else, and I can build a car around that one element. I actually build movie cars in this way.

What's your favorite model of the ones you've built?

My Warszawa cars are my favorites. I built them on and off over about six years. I usually have some idea of where to begin. I might even have about 50 percent of the model planned, and then I just add the remainder as I go. But I had virtually no idea how to make the Warszawa. I looked at pictures, and I tried out all kinds of combinations before I found something that worked. That said, I constantly rebuild models, so I can't say how long it will stay my favorite, and there are technically better cars in my collection.

Most of your cars are accurate replicas of real automobiles. How do you achieve such realism at minifigure scale?

It's more about the overall *feeling* than perfect realism. My cars just look right, even though they aren't perfect. It's also a situation where you need to say, "Okay, that's enough to decode what that is." Don't try to reproduce every curve and shape you see on the real thing, because you can't. It's just impossible.

Furthermore, a definition of scale is quite important, but real cars are different sizes, so try to go with your gut feeling. LEGO fans seem very strict about this nonexistent minifigure scale, forcing themselves to build within those constraints. Loosen the limitations.

I also know cars, which helps a lot in making models more look like real, functioning machines and not a collection of greebles.

Building in rare colors gets difficult because the LEGO elements are scarce. How do you build in rare colors?

I try to get as far as possible with the given colors. If a 1×4 plate doesn't exist, I don't paint one; I use 1×1 plates instead. But I don't let a $20 price tag on a rare color or lack of a piece in a certain color stop me. Then I'll paint. I could wait for certain bricks, but when I'm in the mood to build, I want stuff now, not in 10 years.

Could you explain your building process? Are there certain procedures you have for building, or is it different every time?

It's always different. Usually I start with a piece that inspires me and then build around it until I'm finished. The only consistent thing is that I always mess up the wheel base. (Every single one of my cars was one stud longer at some point.) I never stop looking for that perfect wheel or wheel arch position. It drives me nuts if I can't position the wheels exactly as intended, and I use all kinds of crazy connections so I can adjust them by a fraction of an inch. I also always get stuck on the windscreens; not a single car I've built has a windscreen that makes me happy.

Do you have any tips or hints for building automobiles?

The most important thing is to know your subject; it helps to have at least a basic understanding of automobiles. Also, *do not hesitate* to copy people's work. I get so tired of those who claim they invented this or that and won't try to replicate solutions. If it works for you, then do it, even if you didn't invent it.

If you do copy something, give credit—not for basic techniques (who knows who first came up with building windscreens out of 2×2 slopes?), but rather for builds. You want my Bug? Build it, but don't claim it's yours. You like how I made this wheel? Please, build it—I don't care for a credit. Techniques are ours. Creations are mine.

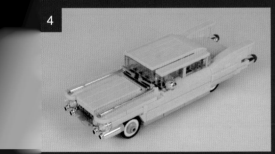

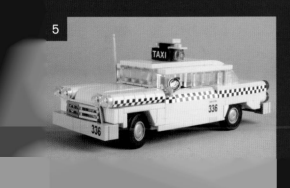

(1) *GAZ-M-20 Pobeda*, a Warszawa car (2) *1958 Edsel Bermuda Wagon* (3) *Ecto-1* from *Ghostbusters* (1984) (4) *Pink 1960 Cadillac Sedan DeVille Series 62*, a gorgeous, heavily painted model (5) *Checker A11*

Wagons

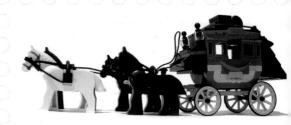

Horse-drawn vehicles (including wagons, stage-coaches, and sleighs) are among the most overlooked subjects in the vehicle category. Usually when you do see one, it's part of a larger display, but a stagecoach can be at least as cool as any car. Building a wagon is similar to building an automobile, with a few additional challenges.

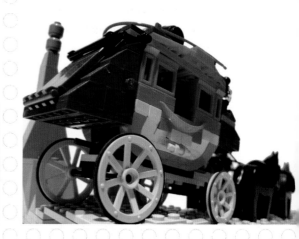

(TOP) **A classic red-and-yellow stagecoach** (MIDDLE) **The bottom of the stagecoach's cabin is built with upside down bows.** (BOTTOM) **This Victorian funeral carriage sports a curved chassis.**

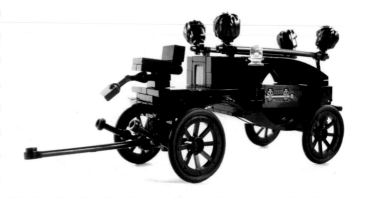

Shaping the Cabin

Depending on the stagecoach, its cabin could be at least as complex as a car. Stagecoaches are often boxier than cars, and they are full of elaborate detailing. Even if the cabin is simple to build, the bottom and chassis will be more complicated. Your LEGO coach cabin needs a space a couple of bricks high between the base and the ground, so you can build the bottom of the coach (a consideration that's not necessary when building cars). Real-life coaches almost always have curved bottoms, like the bottom of my red-and-yellow stagecoach. If you look closely, you'll notice the bottom is built with bows that have been flipped upside down to curve inward—that's a lot more complicated than the bottom of an automobile.

Attaching inverted round bricks is one way to make a curved coach bottom. You could also flip curved elements upside down to create the right shape. Flipping curved elements is easier because more studs-up elements are available than inverted ones: All of the bows and curved slopes will be at your disposal (as in my *Ghost Coach*). You can even use more unusual curved elements, like mudguards, to create subtle patterns on the sides of cabins.

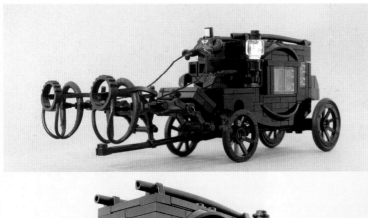

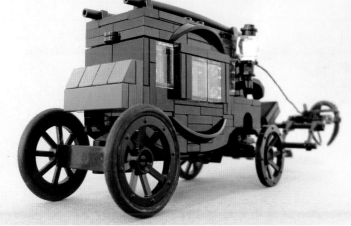

(TOP) **In *Ghost Coach*, a spectral black carriage led by ghost horses, only the horses' bridles are visible to mortals.** (BOTTOM) **This close-up view of the carriage shows off the mudguard detailing.**

Wheels and Horses

It's impossible to build a wagon wheel from scratch at minifigure scale, which means your only solution is to use prefab wheels. These classic elements come in two sizes, and they have been officially released in two colors—black and brown. For minifigure scale, I usually recommend the smaller size, but it all depends on what you're building. If you look at my red-and-yellow stagecoach, you'll see that the front wheels are small and the back ones are large. That happened to be the most accurate wheel configuration for that specific model.

If you don't want black or brown wheels, search aftermarkets like BrickLink, where you'll find them in blue, yellow, red, green, and other colors. These nonproduction versions were made by the LEGO Group, usually as tests, but were never officially released. That makes them expensive, but if one of these striking colors is just what your wagon model needs, it could be worth the money. The yellow ones worked especially well in my red-and-yellow stagecoach.

Even more than the cabin and wheels, horses really define wagon models. You don't have to build your horses from scratch, but you do need to build harnesses and restraints so they can pull your wagon. You'll also need to add bridles because the ones printed onto prefab horses do not look realistic. I recommend the bridle elements from the Friends or Belville themes, but you could also build bridles from scratch using lots of LEGO string or 318 elements. Be sure to couple the horses' restraints with string for a realistic look; the *Ghost Coach*, for example, has very complex bridles because they need to have extra structure built in to give the illusion of levitation.

A prefab wagon wheel in a rare blue color. You can even wrap a small tire around it to add some extra detail.

Watercraft

From dinghies to galleons, watercraft are exhilarating, intimidating subjects. Building a LEGO ship can be intense, but the payoff is an amazing display piece that you can show off proudly. Ships are both classic and classy!

The LEGO Group has produced all sorts of official watercraft sets. The 1978 USS Constellation (#398) was a truly impressive ship model, earning it a rerelease in 2003. The first LEGO pirate ship sets, the Black Seas Barracuda (#6285) and Caribbean Clipper (#6274), were released in 1989. You'll find the prefabricated elements in sets like the Black Seas Barracuda—for example, its hull and masts—invaluable as you build.

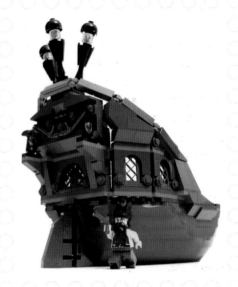

Building the Hull

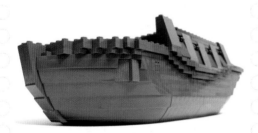

There are a couple of approaches you can take when building a LEGO ship. One is to start with a prefabricated hull and then put your own spin on it by adding slopes and jumper plates to create subtle curves.

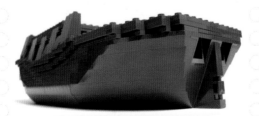

(ABOVE) **The back of a prefab hull** (LEFT) **Even though the base of this hull is prefabricated, the swooping slopes along the outside give it a lot of character.**

Another approach is to construct a hull from scratch. One way is to sculpt the hull studs-up, which works best for ships built at massive scales, like those at LEGOLAND theme parks. It's best to avoid this method unless you want your ship to look really blocky. The alternative is to use other techniques that are not purely studs-up. Look at the work-in-progress photograph of my *Fulton's Revenge* to see other techniques used on a studs-up base. This ship boasts subtly curved panels of tiles that create a drooping shape.

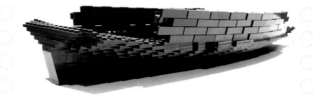

I used a studs-up style to build the base of the hull of *Fulton's Revenge*, but you can also build strictly with outward-facing panels instead, as in the Dutch whaling ship shown below and opposite. That way, the front and bottom of the ship won't have the stepped look shown in *Fulton's Revenge*.

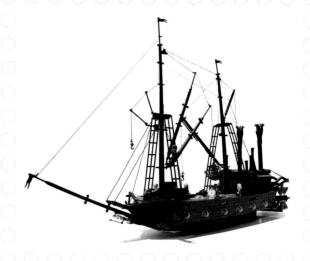

When starting from scratch, you also need to decide whether to build the entire hull or just show the top, as if the ship were resting in water. Think about how you want to display the model. If the ship will be part of a diorama, build a flat hull so the bottom looks submerged. Conversely, you could build the complete hull and construct a stand to perch the ship on, just like most wooden model ships. This is a great way to show off your craftsmanship.

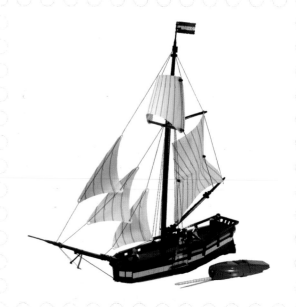

(TOP) **A work-in-progress shot of** *Fulton's Revenge*, **showing the sculpted hull and curved tile panels** (MIDDLE) *Fulton's Revenge*, **a steampunk paddlewheel steamship. The hull was built completely from scratch.** (BOTTOM) **A Dutch whaling ship built with a studs-out hull**

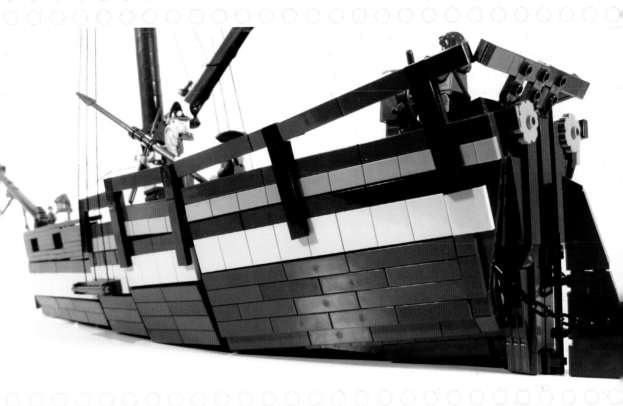

Final Details

The hull is often the toughest part of building a LEGO ship, so once you're done, the sails, rigging, masts, and so on will probably feel like simple decorations. If your model needs these details, save them for last. You can use prefab elements here because they look accurate. Plus, they'll save you lots of work. You can add your own touches to them if you like.

Prefabricated sails come in several shapes, sizes, and colors, but don't let those characteristics restrict you. The sails are fabric, so you can fold them up to get a different shape if you need to, as I did with the sail at the stern of the Dutch whaling ship. If there's no prefab sail that you think fits your model, you can also create your own out of fabric.

You may also want to build your own masts if you don't like the prefab ones. You can use many different elements to construct a mast, but 2×2 round bricks are the most common choice. They work particularly well because they have axle holes running through them. You can stick an axle through the mast to help support it and then anchor it into the hull of the ship. That way, the mast won't tip over.

(ABOVE) **A close-up of the tile panels on the Dutch whaling ship. All of the tiles are flush against the side of the ship because the pieces underneath are facing studs-out.**

Tom Jacobs on Watercraft

Tom "Bonaparte" Jacobs is a long-standing and well-respected member of the European LEGO community. His passion for ships has resulted in some of the most impressive models out there.

How did you end up building so many different ships? Could you describe some of your favorites?

I try to make a collection with a good variety of ships, so I've never made the same type twice. My first decent ship was an English two-deck "ship of the line" based on the *HMS Prince of Wales*, of which only few paintings remain. Based on these paintings and pictures of similar ships, it was possible to reconstruct this lost beauty with LEGO. It took about one year to finish the model, and two years later I spent another few months giving it a full facelift.

It's important to mention that this ship, and most of my other ships, are co-builds with my friend Rick Bewier. We often build them together, with some beers or mojitos, which is much more fun than building alone. And when we have visitors, we let them help with parts of the ships. Several Eurobricks friends have contributed to parts of our ships.

For our next ship, Rick and I wanted something that had never been done before, so we made the galleon called *Nuestra Señora de la Concepción*. It has inspired many others to build LEGO galleons, which is a refreshing change from the abundance of LEGO frigates we've seen over the years.

The rigging and sails on your ships always look great. How do you make them?

We use old bed linen or curtains, which we steep in coffee to make them look worn. Next, we use glue to make them a bit stiffer. Making the sails and attaching them to the ships is a pretty time-consuming process.

Can you explain your building process? Are there certain procedures you always carry out when working on a model, or is it different every time?

We follow several identical steps with every ship. We use prefab LEGO hulls as a base, but the rest is actually hard to explain. Rick builds up the rest of the hull on top of the prefab; it involves using a lot of jumper plates. Only the stern is different each time, and I find that part most challenging.

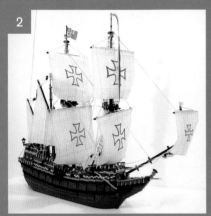

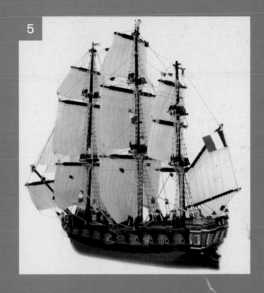

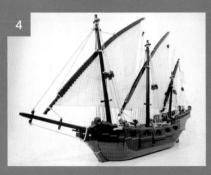

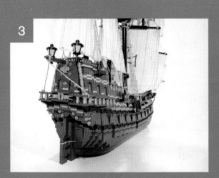

(1) *HMS Prince of Wales* by Tom Jacobs and Rick Bewier (2) *Nuestra Señora de la Concepción* by Tom Jacobs and Rick Bewier (3) Stern view of *Nuestra Señora de la Concepción* (4) *French Navy Xebex* (5) *French Frigate Minerve*

Do you have any tips or hints for building ships?

The best advice I can give is to have a look at our "LEGO Pirates Master Index" in the Classic-Pirates.com discussion forum (*http://classic-pirates.com/forum/*). There, you'll find a complete building tutorial for a sailing ship. You'll also find some visual tutorials for making sails, doing the rigging, and so on. In addition, there are many indexes with stunning LEGO ships, from which you can borrow ideas and techniques.

11 Buildings

From houses to skyscrapers to castles, buildings are an essential part of the LEGO repertoire. The way LEGO bricks connect lends itself well to creating buildings, and the earliest sets encouraged that idea with models of houses featured on the boxes. Even if you aren't familiar with LEGO product history, you can probably imagine what those structures looked like: square houses with triangular roofs. As LEGO created other elements, those basic, brick-stack houses became more advanced and more charming. Builders could use windows, doors, and slopes to make early buildings look more realistic. Over time, the types of buildings were diversified to include castles and even moonbases.

If the first multicolored block houses of the 1950s are at the bottom of the realism scale, then the modular building line, which debuted with the #10182 Café Corner set in 2007, is surely at the top. The modular building line is highly detailed, but fan-made building models have become even more mind-blowingly realistic since the advent of the online LEGO community.

Whether you're building your dream home, a medieval palace, or an underground moon hideout, you'll find several design concepts useful, and we'll explore them here.

A Texture Medley

Detail and texture—key to any LEGO model—are especially important for buildings. When you build an automobile, the front (from the grill to the windscreen) is its defining feature. Buildings, on the other hand, have no single defining feature. Instead, they are full of subtle detailing, and in real life they have hundreds of textures. If you want to construct a realistic building, focus on those unique textures and details. Imagine a grand castle hanging off the edge of a cliff, like the one in *Colonial Outpost*. You might have jagged cliff textures at the bottom, tiny slits for archers in the fortress walls, and so on. Varying textures will make your model more interesting to look at.

While it's easy to stack bricks for walls and use slopes for roofs, doing so will produce an assembly that is unrealistically smooth and shiny. Build these large components out of smaller elements instead, and follow the texturization techniques in Chapter 5 to make them more interesting. This approach will take more time, but building the red brick wall of your townhouse from three hundred 1×2 plates rather than a hundred 1×2 bricks will be more realistic and impressive, so your extra work will pay off. Both *Colonial Outpost* and the model based on "The Legend of Sleepy Hollow" show what a model can look like when built this way.

Some models, like vehicles, work well as freestanding pieces, but most buildings should be built onto bases to give them context. You can use your base to construct a landscape that complements your building. The castle in *Colonial Outpost*, for example, is built onto jagged rock-work, and the Headless Horseman in my model based on "The Legend of Sleepy Hollow" is riding on a rough dirt road as he approaches the bridge. But if your building were a well-maintained mansion instead, surrounding it with trimmed grass built from green tiles would help frame it.

(OPPOSITE TOP) *Colonial Outpost* by **THE BRICK TIME Team (Sven Pätzold and Björn Pätzold). If you look very closely at the fort's walls, you can see they're not built with bricks but with many plates and tiles. Stacking these thin pieces creates tiny lines, making the wall look weathered.**

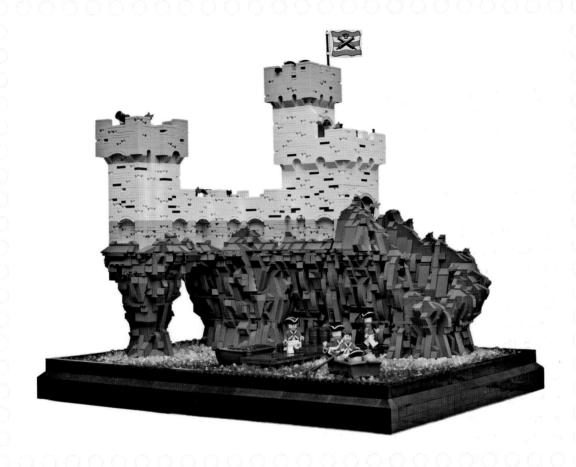

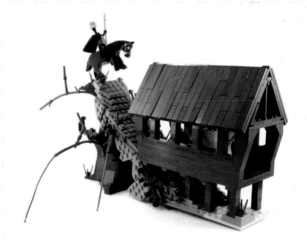

(RIGHT) **This model depicts a covered bridge from "The Legend of Sleepy Hollow." The bridge is made from many brown and reddish-brown plates that create a weathered texture when combined. Several of the tiles that make up the roof are not pressed down all the way, adding to the aged look.**

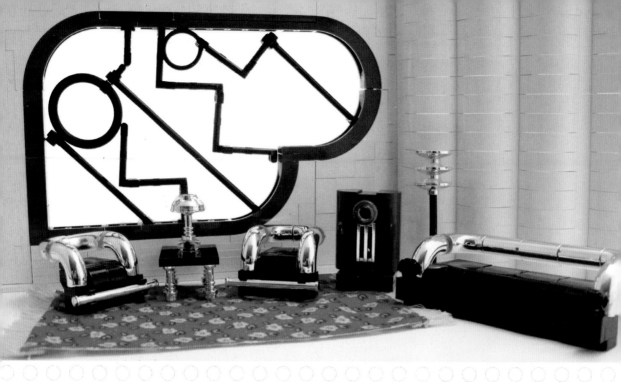

Historical Buildings

This art deco house has a streamlined "Machine Age" aesthetic. The rounded shapes and chrome elements are authentic to late-1930s art deco.

Historical architecture is a popular subject for LEGO fans. Medieval villages and castles, lone Caribbean pirate outposts, and opulent art nouveau hotels have all found their way to LEGO conventions and online LEGO galleries. Whether you're re-creating a famous structure or just building in the style of a particular period, it's important to research both your subject and style thoroughly.

Let's say you're going to build an art deco house. You could build it completely from your imagination, but researching the style will provide invaluable inspiration and information that could make your model more accurate and impressive. For example, you could choose a particular period of art deco: the ornate art deco of the 1920s, the modernist art deco of the 1930s, or the streamlined art deco of the 1940s. If your vision of art deco ends at the 1920s, you'll miss out on a lot of great design elements and motifs. Also, French, American, and even Australian art deco are all different from one another. You should keep these factors in mind when working in any style, from Baroque to Brutalist.

The model shown on this page is a cross section of a Roman gladiator arena. Painstaking efforts were taken to capture the spirit of Roman architecture, and the eight Roman capitals—the tops of the columns—are the highlight of the model.

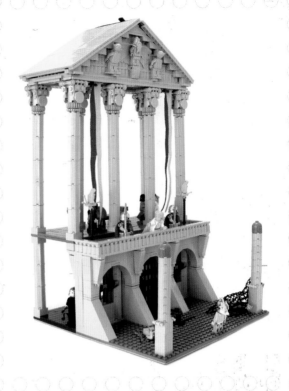

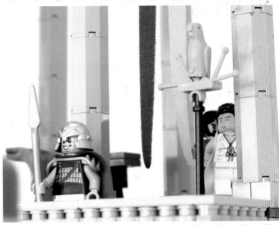

(LEFT) **A Roman column with a capital** (TOP) *Morituri Te Salutant*, **Latin for "those who are about to die salute you"** (BOTTOM) **Little details, like this eagle staff, add more realism and character to your model.**

Luke Hutchinson on Medieval Buildings

Luke "Derfel Cadarn" Hutchinson is one of the most prolific builders of historical buildings in the LEGO community. The detail he achieves in his fantasy and medieval buildings has stunned and inspired scores of fellow builders.

Where do you find inspiration for your original medieval buildings?

My inspiration comes from many sources. I grew up watching Disney, Tim Burton movies, and any medieval fantasy programs that were on. Also, many books I read as a kid had great pictures and scenes that have stuck with me over the years. I sometimes like to find images on the Internet that I then mix and match, picking the best elements from each picture and combining them with my own imagination. I've also built a lot of my models with a particular song in mind. I listen to a lot of heavy rock music, and the songs often inspire me. Recently, I've built a few models based on Warhammer concept art, which suits my particular style well.

How do you design a building?

Once I have an image in my head of what I want, I basically start building the model in my mind, working out various problems and deciding what elements will work best. I then start laying the foundations, which differ depending on whether the focus is on a building or the landscape. If a building is the main focus, I build it separately first to give me more freedom. Once finished, I design and build a landscape (taking into account the dimensions of the completed building), and then place the building on it. If the focus is the landscape, I build that first. Once all the main landscape features are in place, I can just build any extras on top.

Are there certain procedures you always carry out when working on a model, or is it different every time?

I never build without music. It's an essential part of my building procedure, and I now associate many of my builds with whatever rock album I was playing on repeat at the time. Music keeps me motivated and pumped when building, particularly on long projects, which can be tiring.

I also always build display bases for my MOCs because I feel it adds a great finishing touch.

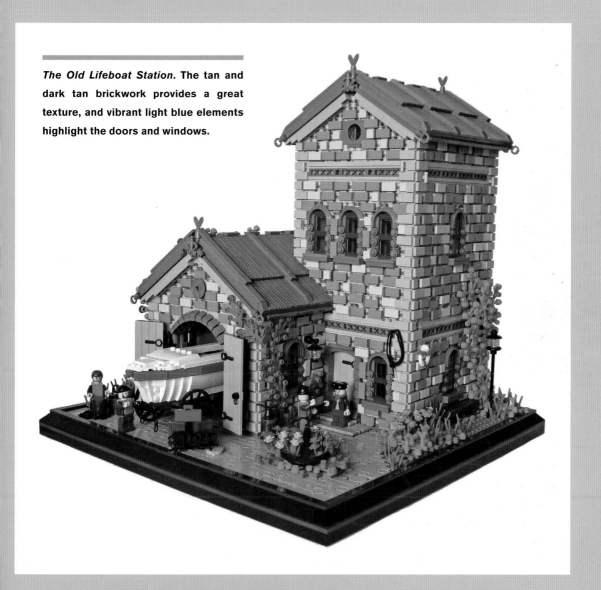

The Old Lifeboat Station. The tan and dark tan brickwork provides a great texture, and vibrant light blue elements highlight the doors and windows.

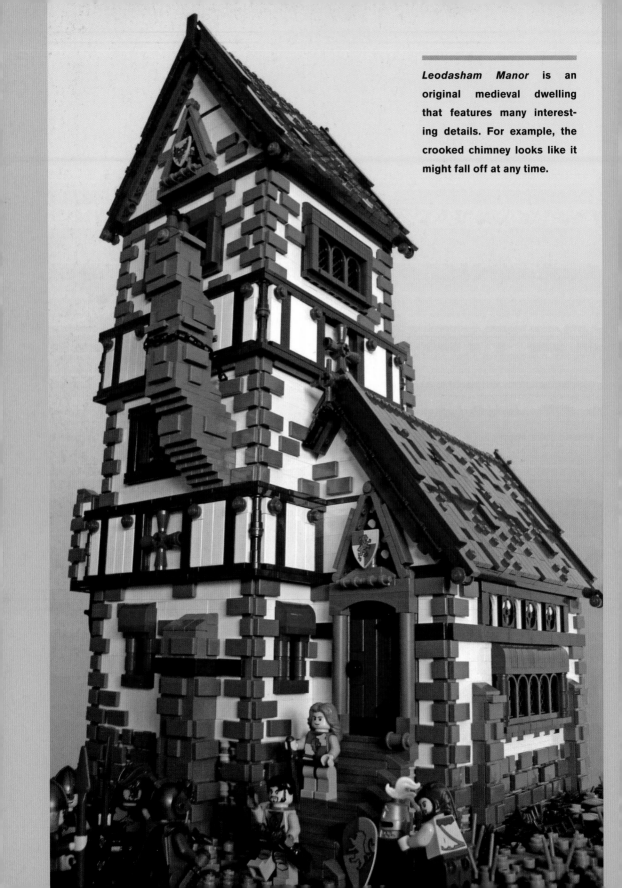

Leodasham Manor is an original medieval dwelling that features many interesting details. For example, the crooked chimney looks like it might fall off at any time.

Do you have any tips or hints for building medieval models?

It's important to know your collection—to know your elements and colors. This always helps when designing a model, because you will immediately know what parts you need and whether they are available in the correct color. It also helps to sit back and take a good long look at your build at various stages along the way. I often find that the smallest changes, like moving a tree a few studs right or left, can make a great difference to a finished model. If you can stand back and look at your model and see that everything flows together, then you are on the right track.

Hangman's Watch. **If you look closely, you'll notice the trees are made of many battle droid arms, which create a spindly shape and a barklike texture.**

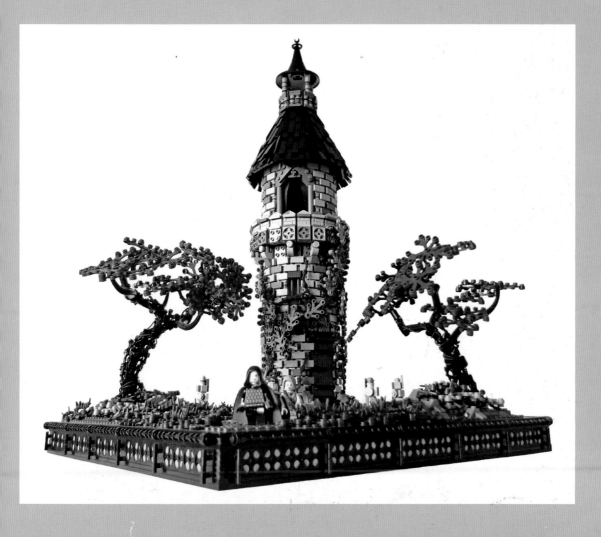

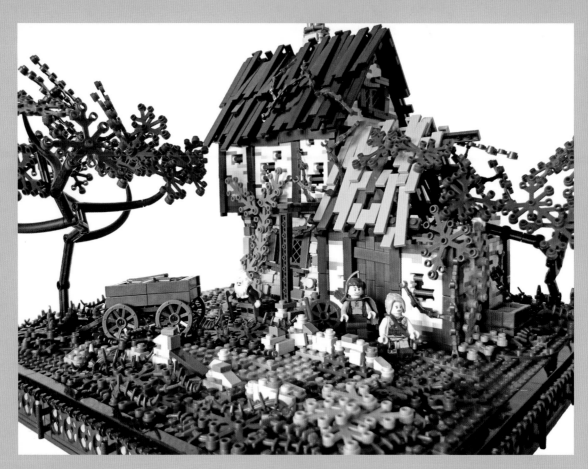
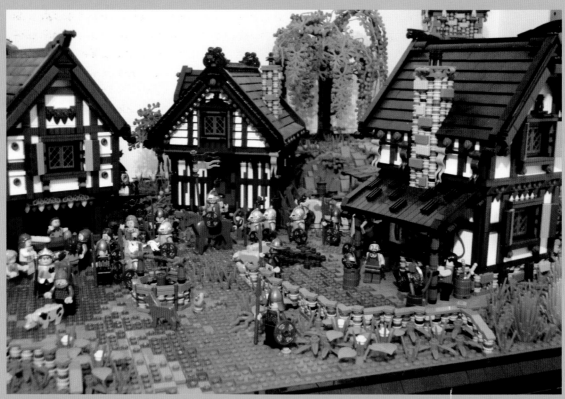

Interiors

A structure's interior is often more detailed than its exterior, especially at minifigure scale. Minifigure-scale detailing primarily consists of small objects, like furniture, which are made of many small elements. To reduce the amount of work, plan ahead as you construct your building so that you can add the level of interior detail that's right for your model.

There are a few different ways to make the interior of your building visible, from adding lights to making sections of it removable.

Lighting

A steampunk factory interior, lit externally to cast many interesting shadows. This is a good example of the dynamism that lighting can add to an already-realistic model.

You could create your building so that the inside is visible only through windows and doors. This method is the least parts intensive, but it has two important implications. The first is that you have to add interior detailing as you go along. It's important to know which interior pieces to add as you build upward because it will be hard to add them after the building is done. The second implication is that the interior won't be visible from the outside unless the inside is lit.

You might be able to see the inside of a real building if natural light hits it just right, but even with opportune natural lighting, the interior of your model will always be pitch black. LEGO windows and doors are just too small to allow much light inside. You'll need to use either official LEGO lights or unofficial lighting solutions like those described in Chapter 7. Luckily, adding lights to closed buildings is pretty easy. You don't need to add lights to each lamp, sconce, and chandelier; you only need to light the inside broadly. In LEGO buildings where the windows don't extend all the way up to the ceiling, you can just snap lights onto the ceiling. Your rooms will be fully lit, and the lights won't be visible from the outside unless someone tries to look at the ceiling through the windows.

Modular Buildings

Another option is to build your structure with a removable roof and floors, as in my saloon model (and sets from LEGO's modular building line). Removable floors will cut the building into horizontal sections, making the interior accessible for decoration and play. If the footprint of your building is the same from the bottom to the top—that is, if all floors share the same dimensions—you'll also be able to add new floors and switch their positions.

This western saloon is built like a modular building set, so the floors can be separated. The back is also open, allowing even more access to the interior. It features a bar on the first floor and a bedroom on the second.

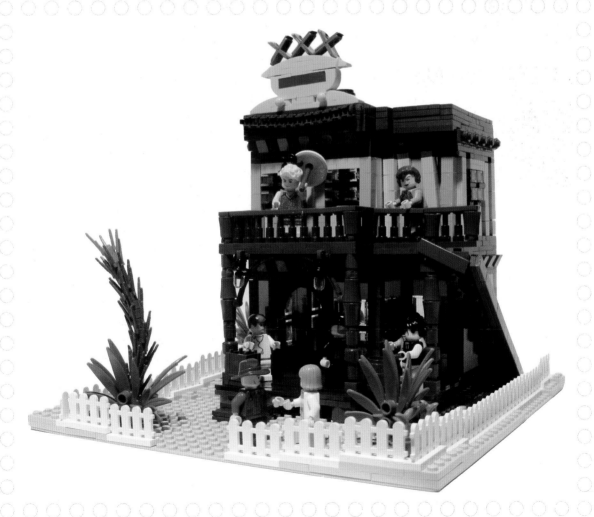

To create a modular building, just make the top-brick level of each floor tiled, with select patches of one- or two-stud plates. That way, the floors will stay attached when on display but can be easily removed for play.

I learned a lot about modular buildings when I helped design set #10232 Palace Cinema (especially after I built 15 different versions of it). The overall concept is simple: Each floor must have the same footprint. The nitty-gritty rules, however, all deal with the interior.

Minifigure accessibility (such as the ability for a minifigure to access all floors) is among the most frustrating aspects of designing a modular building. Staircases are an especially big challenge. If you want your floors to be interchangeable, the stairs must line up no matter which order the floors are in. For example, the Palace Cinema set has stairs in the middle of the auditorium so that you can stack multiple auditoriums on top of one another to make a multiplex. Those stairs let you access the roof from the auditorium, and if you swap the first and second stories, the lobby's staircase also matches up with the door to the rooftop. (If you have the set, try it!) The whole system is quite clever, and you should try building like this yourself. Modular design makes large buildings like skyscrapers much easier to assemble.

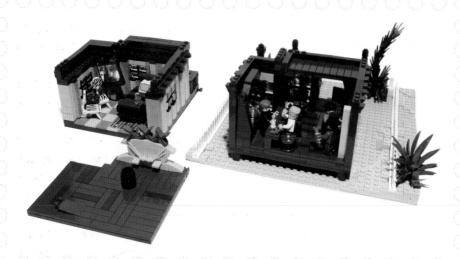

This is what the saloon looks like broken into its three pieces: first floor (right), top floor (upper left), and roof (lower left).

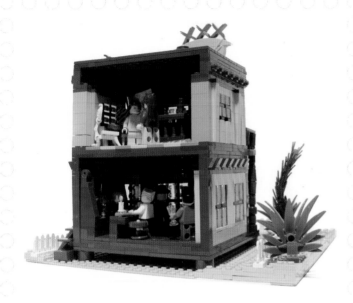

Viewing from the Side

If you don't want removable floors, you can cut the building vertically instead (also shown in the saloon model). That way, the interior will be accessible from the side instead of from above. You can add details to the whole interior, including the walls and ceilings, because viewers will be able to see all of it.

You might also consider splitting the building in half like a dollhouse, with hinges at the seam so you can open and close it. Or you could have the back side of the building cut away permanently so the interior is always visible. These two methods are basically the same, but the second doesn't require a back wall to seal the house shut. Leaving the back open will use fewer parts, and it's especially useful if you're constructing dioramas in the interior.

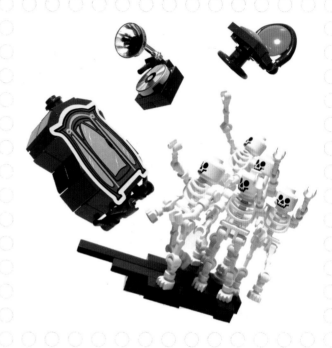

Furniture and Other Details

If you decide to build a full-fledged interior, then you'll most likely want to build furniture and other minifigure-scale details. There's no set process for constructing these small assemblies, and you could easily spend as much time on them as on the building itself. You can find and copy chairs, couches, and beds from official LEGO sets, but these cookie-cutter accessories are usually plain and bulky. You're better off making your own.

It's important to be consistent when you build furniture and other small items, so always be sure to consider the style of every piece. For example, would a mid-century couch look good in your Victorian-era drawing room, or would a fainting sofa be a better fit? The latter definitely makes more sense. Even minuscule details like that sofa are important to your overall model, especially if your goal is realism. Notice the attention to detail in the interiors of *Pariah Parlor* and *Finding Nemo*.

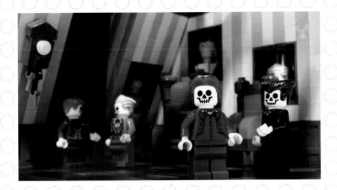

It's easier to explain how to construct LEGO furniture than it is to actually work through the process. First, gather all of your small elements in the colors you need, and then start experimenting with combinations. Stick elements together sideways, upside down, and every other way they're not meant to go. You'll discover the most unusual, yet practical, techniques this way.

Michael Jasper on Furniture

Long-time builder Michael Jasper is one of the best LEGO furniture builders there is. His tiny creations connect elements in fun ways, and they always pack a lot of character.

Even though many of your creations are small, they all look intricate. How long does it usually take you to build one?

The time varies significantly. The more complex and detailed the creation, the longer it will take to build. On the other hand, if my idea of how the final product should look is more concrete, then less construction time is required. It often takes just minutes to design a small model; however, finishing details and improvements may require hours.

How do you figure out the best way to connect elements in your models?

I've gotten into the habit of looking at LEGO elements as what they could be. I favor building at minifigure-scale or even microscale, and I always try to make my creations look as realistic as possible. Common elements like bricks or plates are usually unsuitable for designing small details, so I'm often forced to focus on small and special elements. Of course, a lot of imagination is required.

Could you explain your building process? Are there certain procedures you always carry out when working on a model, or is it different every time?

Creating a new model is always a fresh challenge. It usually starts with either an idea of what to create or how a specific LEGO element could be used in a new way. When re-creating real-life subjects, I often draw on reference photos to match the measurements, shapes, and characteristic features, which I deal with first. Even though I'm quite rarely content with a first result, I never plan things out.

Do you have any tips or hints for building furniture and other small objects?

Basically, meet your own standards. Apart from that, I recommend always building with the minifigure in mind, while still thinking (at least a bit) outside the box. Also, don't clear up your building table too frequently! Seeing the stray pieces might give you some ideas.

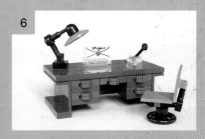

(1) *Grand Piano* (2) *Vincent van Gogh with an Easel* (3) *Ping-Pong Table* (4) *Pinball Machine* (5) *Alfred Nobel with Desks and Scientific Apparatuses* (6) *Desk* (7) *Ceiling Fan*

12 Science Fiction

The classic Space line launched in 1978 and swiftly captured the imagination of LEGO fans. Even now, space themes are fan favorites. But what is it about science fiction that's so enthralling for LEGO builders? For me, it's the fact that it's science *fiction*, and it can encompass nearly anything—especially things that haven't happened or been discovered yet. That gives you a lot of creative control. Many builders craft spaceships and monster-vanquishing mechs, but lush alien planets, icy comets, and astronaut-eating space beasts all fall under this theme as well. What these worlds and creatures look like is entirely up to you!

Robots and Mechs

Who isn't fascinated by robots? They're perhaps the most endearing sci-fi subjects. One of my favorites is Westinghouse's Elektro, a massive metal man who could smoke and talk by way of a 78 rpm record player, from the 1939 New York World's Fair. Then there are bots like B-9, Class M-3 General Utility Non-Theorizing Environmental Control Robot from *Lost in Space* (1965). Of course, we won't own robots like B-9 any time soon, so we'll have to build our own out of LEGO for now.

You can build a LEGO robot for any purpose you can imagine. Do you want it to be bipedal? Go for it! Maybe you want it to roll on treads instead—no problem. How about one that crawls on six spindly legs? Epic! Whether you're building a tiny robo friend or a three-foot-tall city crusher, you'll want to start by choosing a style.

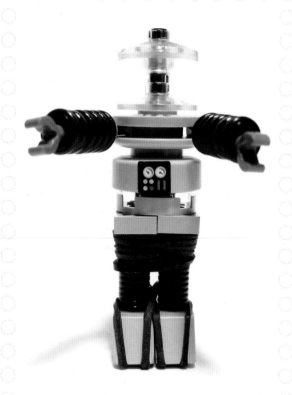

B-9 from *Lost in Space* (1965)

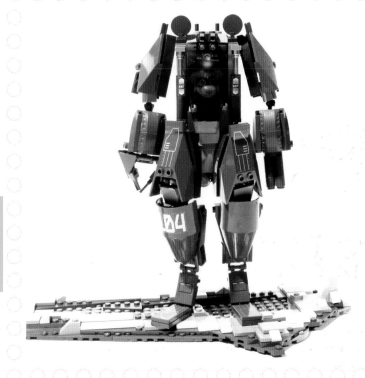

(TOP) *Tanuki Tumbler,* a mech inspired by Japanese science fiction (BOTTOM) A robot inspired by the Victorian era

Style

When you build robot models, you have many styles to consider, and these styles can be broken down by era and region. Each style imposes different vibes, so carefully consider which style will suit your model best.

For example, let's look at the late 19th century. What would a Victorian-era robot look like? How would it function? If you asked a hundred people these questions, everyone would probably come up with similar characteristics: The robot would be cast iron or bronze, have lots of gears and clocklike inner workings, and run on steam. That's an easy example. How about a robot from the 1940s? You might think of World War II and imagine a militarized robot, maybe something resembling a battleship, bearing the insignia of its country.

What about style by region? Robots and mechs found in Japanese pop culture and anime are a good example. My *Tanuki Tumbler* mech is piloted by a FABULAND raccoon and has the angular shapes seen in many Japanese mechs.

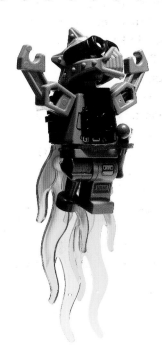

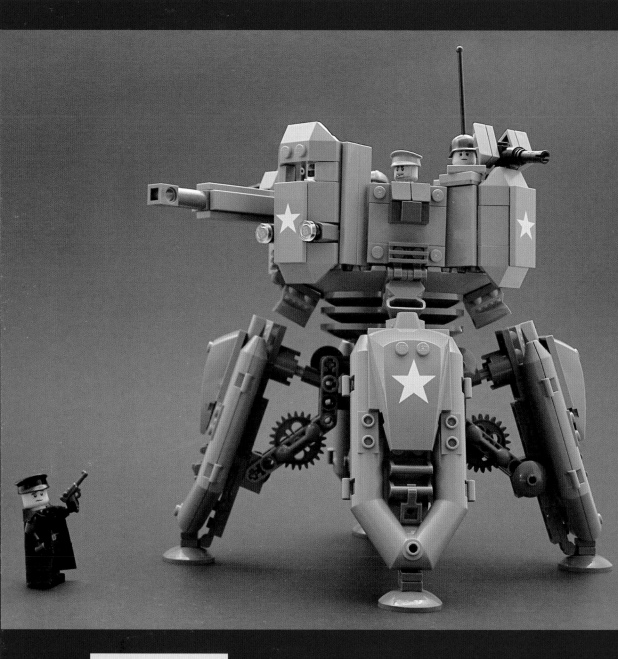

Walking Pillbox by Tyler Clites is a World War II–inspired American mech.

Size

The next step is choosing a size, and as with style, you have tons of options. Consider your bot's purpose—that should help you decide. Let's say you're building a butler bot, perfect for vacuuming living rooms. A minifigure-size robot would make the most sense.

How about a military mech to fight giant monsters? In that case, consider a scale other than minifigure to build in. You might make that robot a couple of feet tall. Be careful not to go too big, though, or your robot may be unable to support its own weight. Or instead you could build a five-inch robot in a microscale city.

A minifigure-size robot with cute, stubby arms

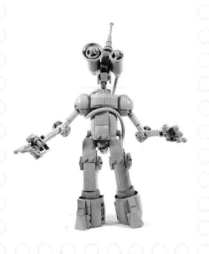

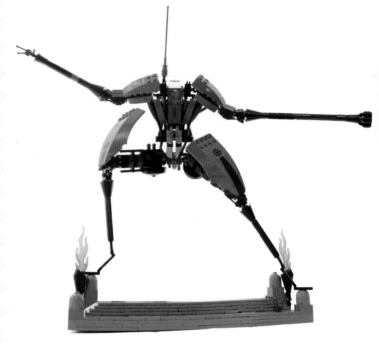

Articulation

It's hard to build models that are both articulated and stable. For example, the 2007 Exo-Force line was something of a debacle in the LEGO community. Its signature mechs buckled under their own weight, making them inconvenient to play with. Designers at LEGO HQ in Billund now make sure that any joints used to build a mech will support its limbs, and you should also follow that principle. If the joints you've chosen aren't sturdy enough, try different joints, or pose the model in a stable position with the knowledge that you probably won't be moving it.

LEGO joints come in several varieties; finger hinges are the least stable, and Technic hinges are the strongest. *Bot-O-Matic* features ball-socket hinges in its shoulders, which make him posable and create a cool shape for his upper torso.

If prefabricated hinges don't do the trick, build your own using any 318 and clip. The most popular mech hinge comprises pneumatic Ts and clips. If you choose a clip with reasonable friction, this joint can be extremely stable despite its small size. Looking at the robot arm I built, you can see pneumatic T hinges used at each joint. The hinges near the shoulder even support the weight of the rest of this heavy, densely built arm. Although I wouldn't recommend using the pneumatic T hinge for critical spots in your mech, like shoulders and hips, it works well nearly everywhere else.

(TOP LEFT) **An articulated robot called *Bot-O-Matic***
(TOP RIGHT) ***Kitsune Killer* is an articulated, fox-piloted mech with multiple joints for versatile posing. Foxes' lean bodies inspired the stylized form, but the outrageously thin limbs make posing it a challenge.**

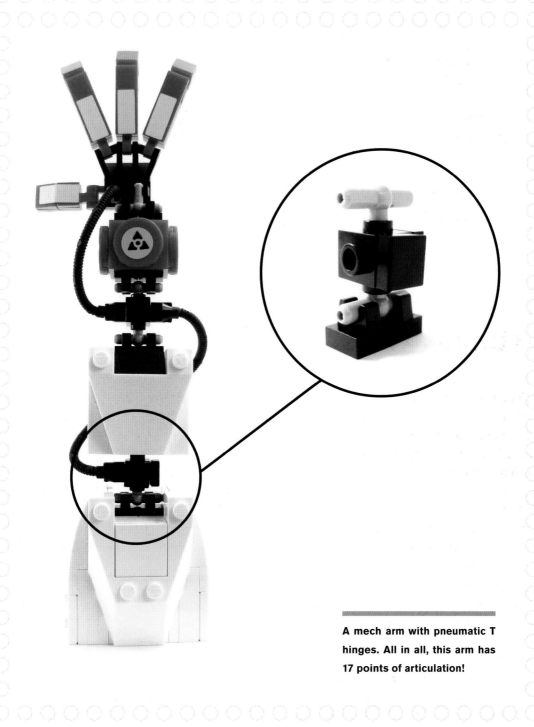

A mech arm with pneumatic T hinges. All in all, this arm has 17 points of articulation!

Brian Kescenovitz on Mechs

Building robots and mechs is challenging; there are builders who dedicate themselves to these subjects because it can take years to master them. Brian "Mondayn00dle" Kescenovitz is one such builder, and his dedication has paid off.

All of your mechs have great style and personality. What's your inspiration?

Inspiration is a funny thing. It's not always there when you're looking for it but often slaps you across the face when you least expect it. When I do need inspiration, I have a large folder on my computer that is stuffed with mech-related concept art, models, movie and video game stills, and so on. Video games and anime in particular feature higher proportions of robots and mechs than other forms of media. I also have a large folder of clippings from video game magazines and other printed media, as well as a sketchbook where I can doodle ideas and quickly flesh them out to see if they work.

Of course, anything with an interesting shape, profile, or feature can spark an idea for a robot or mech. My builds have been inspired by animals, children's toys, kitchen utensils, construction equipment, and architecture. Animal references can be invaluable when designing a mech or robot's legs.

Without a doubt, though, LEGO parts themselves are my primary source of inspiration. I'll see a piece sitting there and think it looks like a toe, a shoulder guard, or something else. Then I'll add a few more pieces to see if it works, and if it looks good, I have the seed for a new build.

Is articulation important to you when you build mechs and robots?

Generally, yes. I try to include as much articulation as the design will allow. Good articulation contributes to a strong shape and stance, and it expands posing options, which can add personality. Hip and ankle joints are particularly important for dynamic posing, and for a humanoid mech or robot, so is the ability to turn and bend at the waist.

Full articulation also adds a sense of realism, even if it's more imagined than anything else. It's the feeling that if you could somehow imbue your creation with a power source, internal mechanisms, gyro-stabilization, and all the other improbable things necessary for a real mech or robot to operate, it could, in theory, function. Silly? Perhaps, but without some serious application of the imagination, the concept of the mech would not exist in the first place.

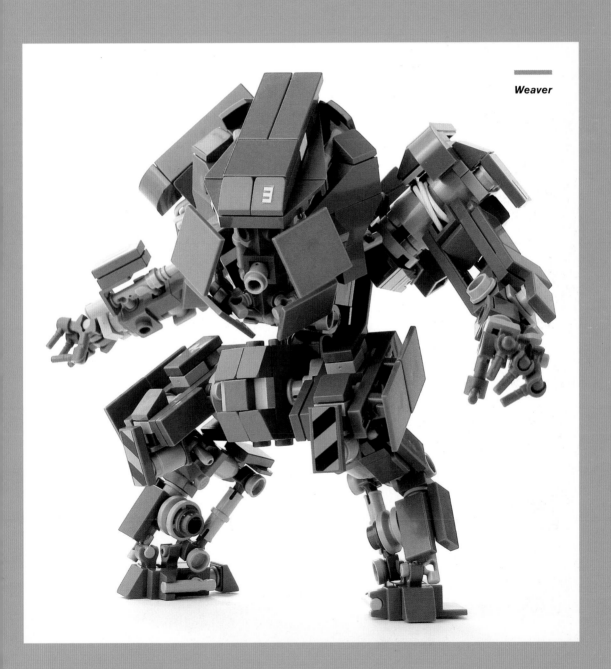

Weaver

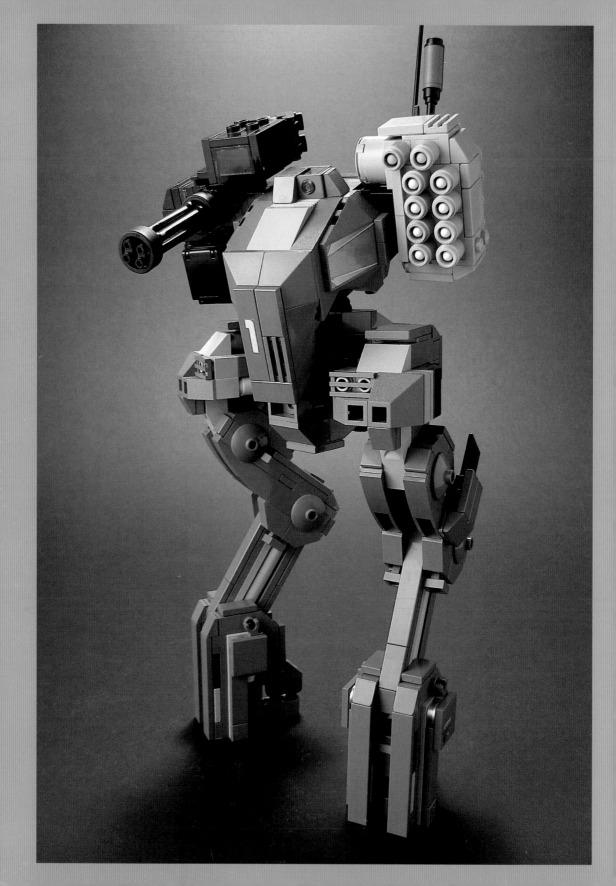

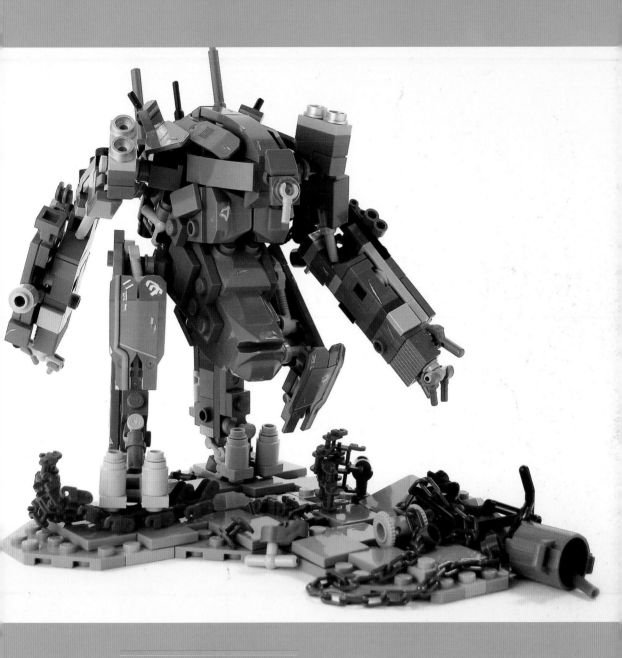

(OPPOSITE) *ICON Class Command Mech* (ABOVE) *District 9 Mecha Suit*

Could you explain your building process? Are there certain procedures you always carry out when working on a mech, or is it different every time?

I almost always start with the legs, even if my original idea involved some other part of the mech. Legs distinguish mechs from other vehicles, so it's important to get them right. Also, from a practical standpoint, the sturdiness of the legs determines how heavy the upper sections of the build can be. It's all too easy to build a massive head or torso section and then be unable to produce visually appealing legs that can also adequately support the body. (Of course, legs aren't required, but I believe the sheer incongruity and wonder of the "walking machine" is what makes mechs so appealing.)

Starting with the legs also helps me better understand the overall form of the build. Form is, in my opinion, the single most important aspect to consider when building a mech or robot. It is often said that form follows function, but a strong form and overall shape can provide that initial "knock your socks off" first impression.

With these things in mind, my building process goes something like this. I start by figuring out at least part of the legs' structure. Next, I address the main body or torso of the build and think about how to attach the legs, keeping in mind how I want the final piece to look and move.

If I'm building a walking tank, this is usually fairly straightforward because those generally have a limited range of motion. In that case, the biggest decision is whether the mech will have a turret that rotates like a tank or legs that will simply attach to a static main body. If I'm building something more humanoid, I will figure out the waist and torso here and decide how much articulation I want the model to have.

At this point, the body and legs are fairly complete, and the model's final shape should be clear. With this (hopefully) stable foundation in place, I can cut loose a bit and experiment with different heads, arms, turrets, weapons, and so on (always keeping in mind the overall form). Once I settle on something, I can finish detailing the build, add some color blocking to set off certain areas, and possibly add a few stickers.

A final step that I'm not always disciplined enough to take is to set the finished product aside for a few days and then come back to it. I often notice areas that need a bit of tweaking or that don't work quite as well as I first thought. After this finishing touch, the build is done.

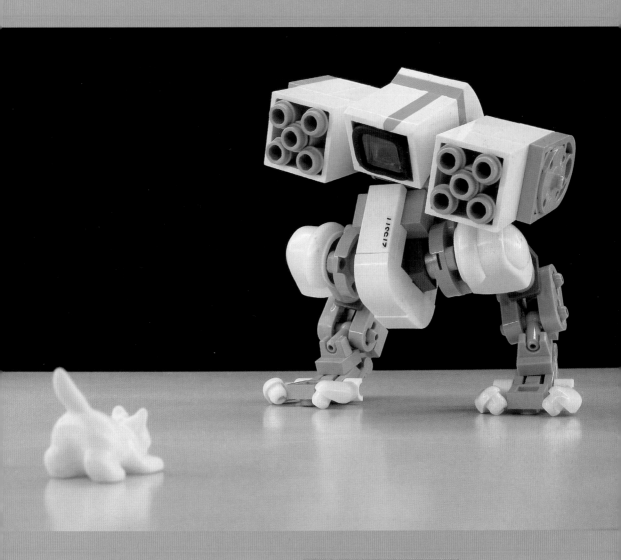

Nine Lives, Ten Rockets . . .
Do the Math

Spacecraft

From the smallest hover car to the largest freighter, spacecraft are a prominent motif in science fiction. As we learn more about space, LEGO fans have a field day dreaming up our future vessels, and they've proven that spacecraft design doesn't have to end at starfighters and rocket ships.

Colani-Class Lancer, **a curvaceous space cruiser inspired by the work of industrial designer Luigi Colani**

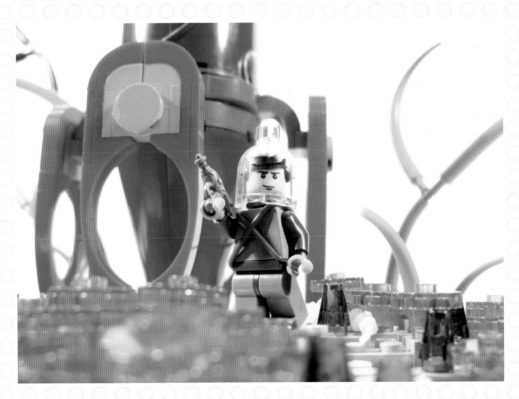

(TOP) *The Bringer of Jollity*, a retro rocket ship that's landed on a strange alien world (BOTTOM) The pilot of *The Bringer of Jollity*, wearing a kitschy spacesuit and carrying a custom BrickArms ray gun

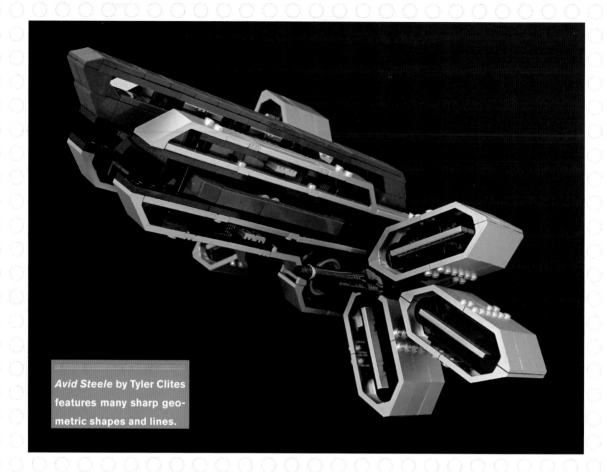

Avid Steele by Tyler Clites features many sharp geometric shapes and lines.

Think of an interesting shape or assembly, then add a cockpit, stick a couple of thrusters on the back, and voilà—an original spaceship! My streamlined *Colani-Class Lancer* model and Tyler Clites's more geometric vessel are examples of two very different styles you could use.

Building a spaceship, however, is a little more complicated than that; don't expect to make a great one by accident. The best ships are deliberately designed to look like they could really work. That means including a plausible propulsion system at a practical spot on the vessel, making sure a minifigure can fit inside, and building the vehicle to look airtight. The key is to add believable components that ground these fantastical vehicles in reality.

(OPPOSITE TOP) *Zip-Class Cruiser*, a retro purple hover car (OPPOSITE BOTTOM) *EX-LF Probe Module* is designed to be viewed from every angle.

Small Vessels

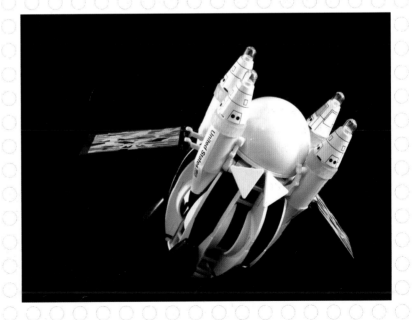

Ships without a lot of internal structure are usually considered "small." To make small, dynamic spacecraft, you'll want to push SNOT techniques to the extreme. Because there's no up or down in space, having elements oriented in every direction also emphasizes the purpose of the ship: to travel on boundless planes. (That's not to say your model shouldn't have a conclusive up and down; most small ships are built with the cockpit on top and landing gear at the bottom.)

If you do want to stress the nature of space in your model, you could build a vessel with no up, down, front, or back, like my *EX-LF Probe Module.* This model looks like it could be a present-day spacecraft.

If you're in the mood to build something kitschier, you can always try a hover car. Futuristic city dioramas usually include these, but they aren't as common as stand-alone models. Hover cars are retro by nature, so you might look at classic sci-fi comics and films and at automobiles from the 1950s and 1960s for inspiration, as I did for my *Zip-Class Cruiser.*

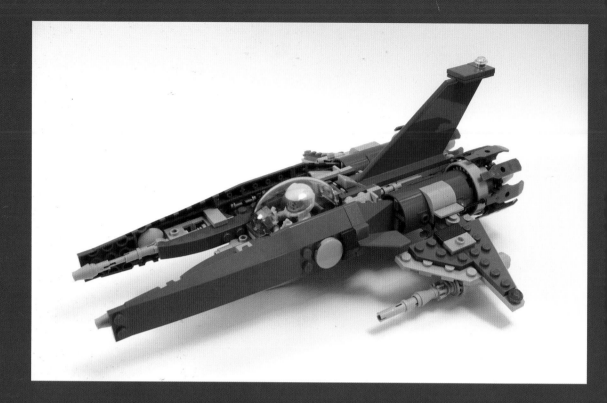

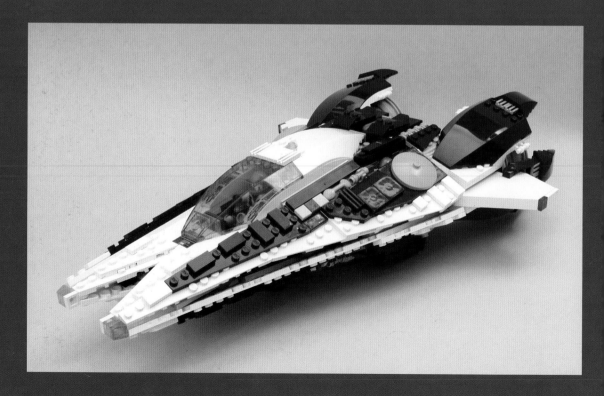

Peter Morris on Starfighters

Starfighters and other external-cockpit vehicles are common LEGO subjects, but that doesn't mean that there aren't innovative designs. LEGO fan Peter Morris is a prolific builder who specializes in starfighters and the like. His eye-catching spacecraft models consistently retain his signature building style.

You build lots of starfighters—what's your inspiration?

My main inspiration comes from various science fiction universes, like *Star Wars*, *Battlestar Galactica*, *Buck Rogers*, *Space Battleship Yamato*, *Robotech/Macross*, *Cowboy Bebop*, and others. I'm also inspired by fond memories of shoot-'em-up video games, mostly from the 8- and 16-bit days. The styling of *Gradius*'s Vic Viper, *R-Type*'s R-series, and the ships from the *Thunderforce* series were unlike anything else when they debuted, and they still look fresh today. I also love concept art. Ralph McQuarrie is at the top of the list, but a lot of the younger guys in works like *BLAST* and blogs like *ConceptShips* do amazing, inspiring work. Some of it even translates well to bricks!

(OPPOSITE TOP) *VV-24 Vagrant*, a Vic Viper–inspired ship (OPPOSITE BOTTOM) *HMSS Music*

How do you design a starfighter?

Sometimes, I see something and I just want to make a LEGO version. My Vic Vipers are good examples; they're meant to look like the art from *Gradius*. That's a challenge, and it's especially rewarding when a finished model looks very close to the original work.

Other times, I just start doodling. Usually, I start with the cockpit and work from there, adding the body, thrusters, and weapons. My sketches are tiny, and I can fit maybe 20 or 30 onto an 8.5-by-11-inch piece of paper. Quite a few of my starfighters are totally original, but if I am working from concept art, I try to better adapt it to the LEGO system or to make it more my own.

You refer to lots of your LEGO spacecraft as "classic space evolved" because they channel the spirit of classic official space sets. Can you elaborate on this concept?

The basic idea is to make a set from the classic space era larger and more detailed, while retaining the original style, play features, and colors. In some of these builds, I incorporate play features that I wish had been in the original set. The key to a "classic space evolved" MOC is that anyone familiar with the official sets should be able to look at it and say, "Oh, it's that one set, but bigger. That's how it always felt to me when I was a kid! And you included the robot!"

How did you develop your building process? Are there certain procedures you always follow?

When I first got back into building in 2003, I had not discovered the Classic-Space Forum (CSF), LUGNET, or Brickshelf. I just started building a couple of fighters that I had been doodling for years (one was based on my very last MOC before I packed up all my LEGO as a kid). It was all trial and error, and it was really slow. After finding Brickshelf and CSF, I wondered how others built spaceships so fast and so well.

I figured they must have a system, so I built a few different types of forward cockpits and canopies, intending to swap out the rear sections to quickly build different ships. I really liked using Technic bricks with holes and pins to mount plates sideways—this let me build visually interesting models, but they were clunky. When I realized I could build flush with the side of the canopy by using 1×2 and 2×2 brackets, I built mostly using that style. The brackets form a tight box around the canopy and allow for fairly sturdy construction while also giving a lot of space to build out sideways from the cockpit.

Sometimes I build outside that general model, but I do use some variation of this bracket cockpit box for the majority of my starfighter builds. It makes it much easier to plan out a model and offers a wide range of possibilities.

Do you have any tips or hints for building starfighters?

I think space is the most creative of all the building themes. There is no right or wrong way to build a spaceship! But sometimes that unlimited freedom can be intimidating. I would say find a style that suits you, and keep evolving that style. Once you get into a groove, it's easier to just keep building. But perhaps the most important thing is to make sure your starfighter has three basic parts: a weapons system, some means of propulsion, and a cockpit for the pilot (even if the pilot is electronic, include some place for a radio or robot).

(LEFT) *Gamma VII Laser Craft,* **Peter Morris's updated take on set #6891 Gamma V Laser Craft** (RIGHT) *Cockpit Box 'n' Canopy*

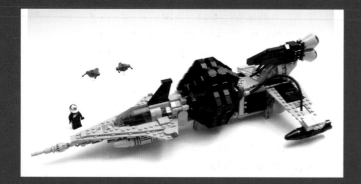

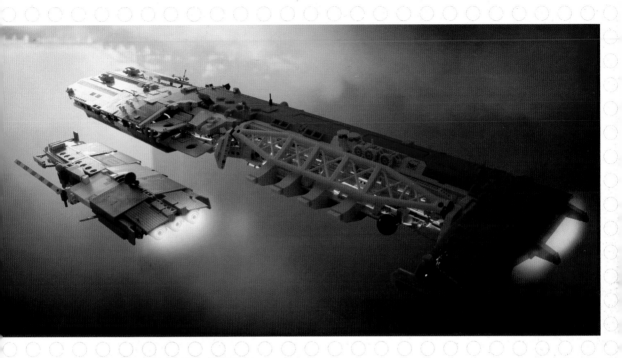

Large Vessels

Large spacecraft are far more difficult to build than small ones. If you undertake such a build, lots of internal structuring will be your key to stability.

You might think many large spacecraft models would have a military purpose, but in fact most are commercial, like shipping vessels. They often have an industrial vibe, with lots of sharp lines and geometric forms—you don't usually see many curves in large LEGO ships. If you're short on parts, try building in microscale; you can achieve a surprising amount of detail.

Pierre E. Fieschi on Freighters

Pierre E. Fieschi has earned a name for himself in the LEGO community with his elaborate microscale spacecraft. Coupled with his amazing postediting, his work makes for some of the best futuristic eye candy out there.

What inspires your sci-fi vehicles?

I'm a big science fiction enthusiast. As a kid, my inspiration came from movies, comics, and even video games. I also draw a lot, and science fiction has always been my favorite theme.

There was, however, a major shift in my designs and drawings when I discovered the video game *Homeworld* and Rob Cunningham's fantastic concept art. The bright colors, asymmetry, and massive scale were a revelation in science fiction aesthetics for me at the time. More recently, I discovered the work of Chris Foss and Peter Elson, which may have inspired the artists working on *Homeworld*. Right now, their rather unique designs are leading me to explore new shapes and color schemes I would have been uncomfortable with before.

I use details from many sci-fi sources in my models. For example, a ship's shape, coloring, and weapons might each come from a different fictional universe. The Borgs call this assimilation, but I'm not a *Star Trek* fan at all!

You work in many different scales. Which is your favorite and why?

I am, without a doubt, a microscale fan. I enjoy building capital ships and giant vehicles, and there isn't really any other scale I could build those in with the space and resources I have available for LEGO right now.

But what I like most about it is going into substud details, which throw off the perception of a scale reference. This doesn't necessarily mean building studless, but rather intentionally using the stud as part of a design. The finished product is usually a lot smaller than it seems!

Microscale is also very diffuse and imprecise. A multikilometer-long dreadnought can be reclassified as a small assault frigate if need be, and a turret design can go from ultra heavy blaster to light pulsar flaks in a heartbeat. That is such an enjoyable freedom.

(OPPOSITE) *Vulture Laser Artillery Frigate*

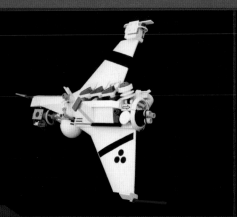

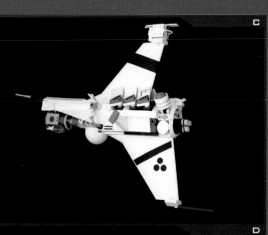

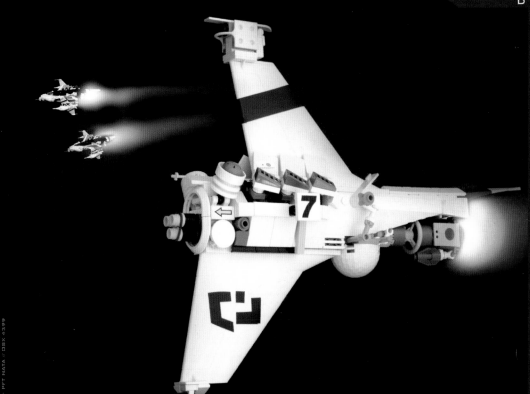

> PFT NATA // DSX 4-399

7

> VULTURE L.A.F.

PIERRE E FIESCHI
12/02/2013

LASER ARTLLERY
FRIGATE

'TRUTHEATER' TRIPLE REPEATING LASER ARTILLERY
'VENOM' DISRUPTION FIELD GENERATOR

'BABIN' DAMAGE CONTROL AI

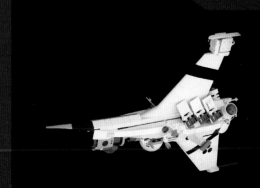

Can you describe your building process? How does it differ between small and large builds?

My building process varies according to the scale of the project, but I do have some constants. Bigger builds take more planning. The structure needs serious thought, which requires time, method, and a good idea of the direction the build is going to take.

Smaller builds, on the other hand, range from tablescrap degeneration to what I call *arborescent design.* Arborescent design starts from using a single brick for a certain purpose. That brick is the root of the build. Design sketches (if I make any) will integrate and work around that detail, and that's how the build takes form. I keep the sketch in mind but always deviate from it, leading to a new sketch, and so on. In the end, the root brick is just a small detail in a big MOC that could have taken a completely different direction.

Do you have any tips or hints for building science fiction vehicles?

I have two. First, don't bother too much with scale conventions. The key to microscale is really the lack of a defined scale. Some people protest that paradox, pretending that *1 stud width = 40 people* and other nonsense. The stud is whatever you want it to be.

My second tip is applicable to more than science fiction vehicles. I'm convinced that the way you sort your LEGO elements influences the way you build, and I suggest sorting by type instead of by color. I think it's much easier to isolate a blue cheese slope from a box of cheese slopes than to isolate a cheese slope from a box of random blue bricks. Sorting by type can also push you into using a color you did not intend to at first, resulting in surprising mixes. Just be careful not to oversort! Grouping some types together is a great compromise because it is much faster, for example, to put together all droid arms than to separate the different types available. This saves time and gives you several options each time you need a certain type of brick. It also feeds the arborescent process, which adds considerable depth to builds.

(OPPOSITE) *Gahnn Construction Journal*, showing the vessel at different phases in the design process

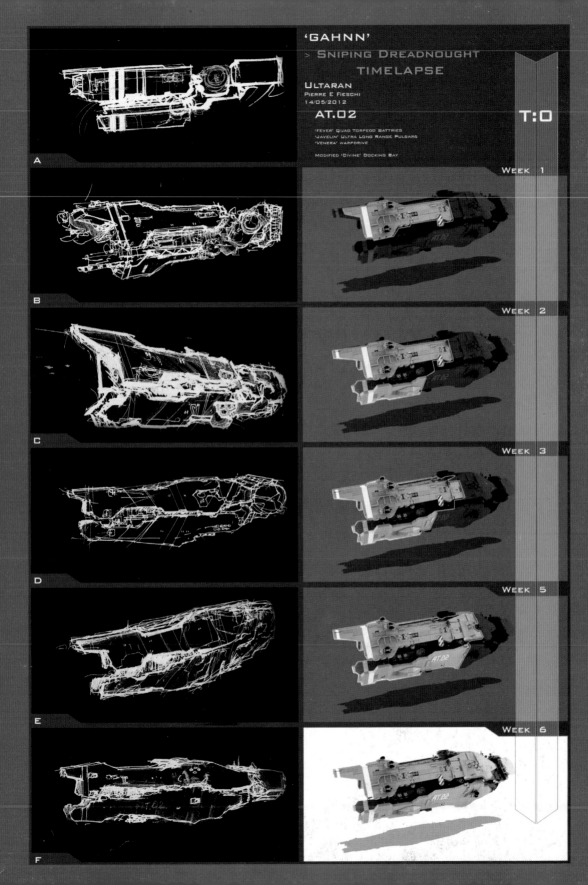

'GAHNN'

> SNIPING DREADNOUGHT
TIMELAPSE

ULTARAN
PIERRE E FIESCHI
14/05/2012

AT.02

'FEVER' QUAD TORPEDO BATTRIES
'JAVELIN' ULTRA LONG RANGE PULSARS
'VENERA' WARPDRIVE

MODIFIED 'CIVINE' DOCKING BAY

T:0

A

WEEK 1

B

WEEK 2

C

WEEK 3

D

WEEK 5

E

WEEK 6

F

A Universe of Possibilities

The science fiction genre doesn't end at robots and spaceships, and neither do the possibilities for sci-fi models! There are many other subjects you could choose to build. For example, the idea of extraterrestrial life has boggled human minds for thousands of years. We really have no idea what aliens might look like, so we can build them to look as fantastical as we can imagine.

For example, look at *The Sheathed Scourger*. A towering heap of tentacles, this strange alien is a feral creature that has been tamed by its planet's dominant species, which is pictured riding it. The creature wears heavy armor and an open-air litter for the rider to sit in.

The alien life-form in my model *Builder of Worlds* is more mechanical in appearance. It is bipedal and has a more humanoid form compared with *The Sheathed Scourger*, which has a free-form design. This one is supposed to be a godlike creature—a "builder of worlds"—and a new planet levitates above his open claw.

You could also build a diorama of a sci-fi building, interior, or space base. Designing futuristic architecture is always an interesting task. *Teleportation Demonstration*, for example, depicts a teleportation chamber, complete with flashing lights and smoke effects via a fog machine.

One of the most fun ways to design a diorama is to draw on existing LEGO space themes. Each LEGO space theme has a specific color scheme, environment, and minifigure style, even more so than the themes in lines like Castle or Pirates. If you build your space model in an existing theme's color scheme, you can create a nod to your favorite Space line.

Take a look at the interstellar prison-breakout diorama *Space Police Escape*, based on the Space Police line. Look past the escaping aliens, and you'll see a lot of heavy greys and a stark white railcar with the Space Police logo. This piece fits into the theme but is unique in its style and construction methods.

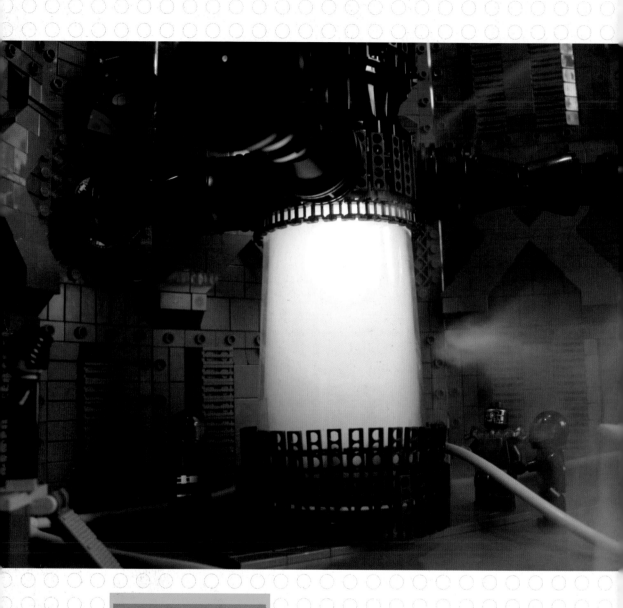

*Teleportation Demonstration,
inspired by Alien Encounter:
The ExtraTERRORestrial, a
defunct theme park attraction
from Walt Disney World*

Keith Goldman on Dioramas

LEGO fan Keith Goldman is best known for constructing massive, sprawling dioramas of futuristic environments. In fact, his dioramas are some of the largest ones constructed by any LEGO builder. What makes them so impressive, aside from their sheer size, is the detail he achieves.

Your sci-fi models are all very original. Is there any specific inspiration behind them?

Although I'm sure every generation says this, I think I was fortunate to grow up in one of the most compelling eras of sci-fi cinema—the early '70s to the mid-'80s. Films like *Logan's Run*, *Escape from New York*, *Brazil*, and *Blade Runner* helped define the way I approach building dioramas with LEGO. Beyond that, sci-fi novel covers from the same era introduced me to artists like Moebius, Michael Whelan, and John Harris. I would also be remiss if I didn't throw in the band Rush, Stephen King, and *Heavy Metal Magazine.*

How do you plan the layout for a massive display before building?

Unfortunately, my drawing or painting abilities tap out at the stick-figure level, so I don't plan my layouts. I usually spend a couple of days or weeks mulling over different ideas, though; there are always more ideas than time.

You seem to build a little of everything— sprawling landscapes, large buildings, spaceships, and so on. What's your favorite subject and why?

Although I may be tempted by other themes like Castle and Town, I'm married to science fiction. First and foremost, it allows me the greatest freedom of expression; nobody can tell me I'm building my giant domed city or robot incorrectly. Real life is fine, but I get enough of that outside my favorite hobby. If you have to ask why sci-fi is cool, you might have to turn in your nerd credentials.

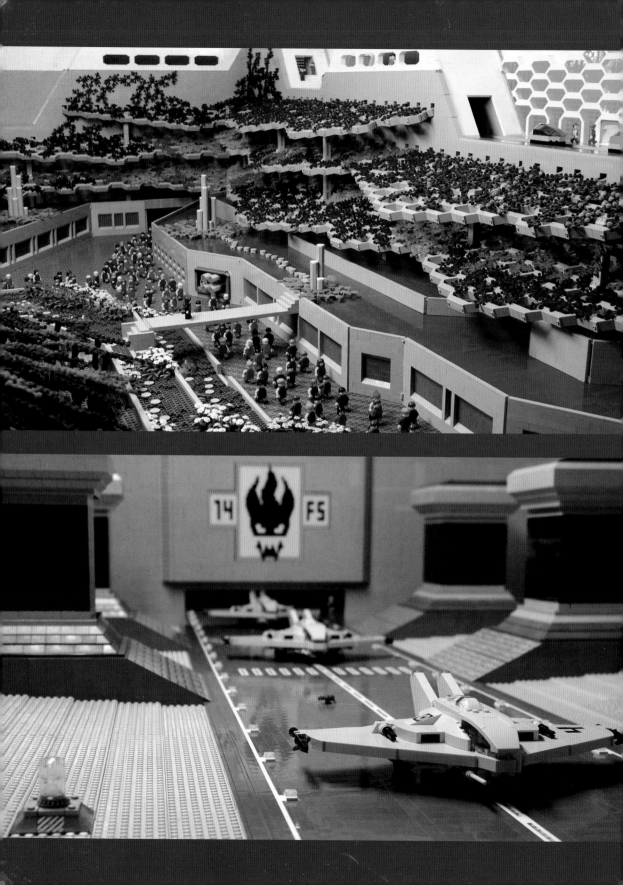

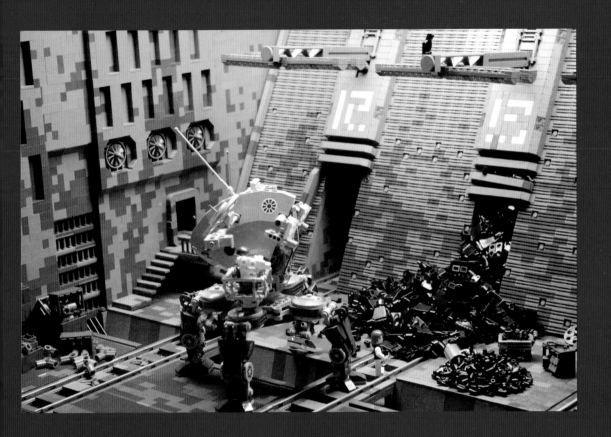

(OPPOSITE TOP) *Logan's Run* (OPPOSITE BOTTOM) *Sand Bats Launch from Thar Air Base, August 2040* (ABOVE) *The Iron Correspondent*

Can you explain your building process? Are there certain procedures you always carry out when working on a model?

It all starts with an idea—usually pulled from something I've seen or read—and then I start to play with the concept to see where I can put my own spin on things.

I decide on the footprint pretty quickly. My table is four feet by eight feet, but only twice have I used the entire space. When I know how big the model will be, I approach it like a house. You lay the foundation, raise the walls, set the roof, and then you're off to the races. One issue I address in the early stages is whether any part of the build will be an eye-block—that is, whether anything will prevent the viewer from seeing part of the model. After the basics are done, I keep adding details until I can't stand the sight of the project any longer. Then I call it finished.

The one other critical step in my design process is getting feedback from a small cadre of trusted associates. Only your real friends will tell you when you're off course on a model. A favorite quote from fellow builder Michael Rutherford is "You're not going to leave it like that, are you?"

When I photograph and edit my finished models, I always try to make sure everything in the scene is LEGO, for maximum immersion. My go-to technique is building up a slanted back wall or using translucent bricks that can provide a nice glow in the photos.

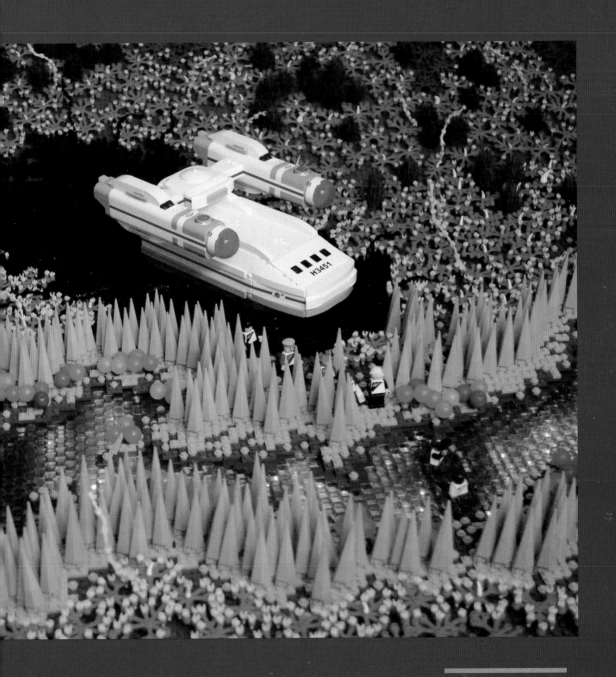

The Paradise Syndrome

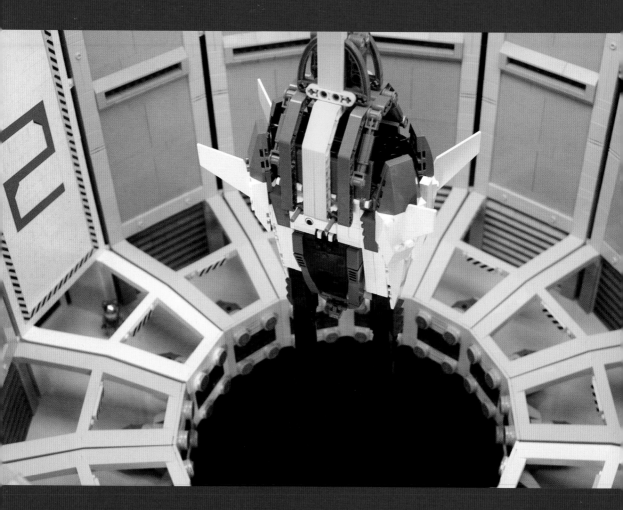

Claw!

Q. Do you have any tips or hints for building sci-fi models?

Treasure your influences, but ultimately, you have to leave them at the door. Although I've built models called *Planet of the Apes* and *Logan's Run*, I took only ideas from the movies; the actual models really look nothing like either film. Don't just build somebody else's vision—make it your own.

13
Final Steps

Completing a model is very satisfying. But now that you've finished building, you want to share your creation with others. How do you do that?

First, you'll need to take some high-quality photos of your model. Looking at a model on a computer screen is different from looking at one in person. Poorly shot photographs can make even the best models look unimpressive. Once you've taken photographs and edited your images, you can post them to an online LEGO community so other builders can admire and critique your work. Receiving criticism is an important part of the creative process and can help you improve your building skills.

Photography

Most LEGO fans who aren't professional photographers agree that taking pictures of a model is a pain in the neck. It can be frustrating to create a whole setup of lights and backdrops just to photograph a model (especially if the model already took a long time to build). If you want high-quality photos, though, it's worth spending some time creating a good setup. A basic lightbox will make the process easier and give you better photographs.

First, you'll need to choose an appropriate-colored backdrop for your model. I always keep white, grey, and black backdrops handy. (You can use other colors, too, but these three are the most neutral.) Remember to choose a backdrop color that makes your model stand out. Poster board or large pieces of construction paper should do the trick, although you could also use cloth from your local craft store or even a sheet or T-shirt. If you do use paper, make sure it isn't stiff or corrugated.

Next, you'll need to build or buy a lightbox. To build a lightbox, cut out large squares from three sides of a cardboard box, and cover the cutouts with white tissue paper. The light you shine through the tissue paper–covered cutouts will illuminate your subject gently. If you don't want to build a lightbox, you can buy a preassembled one instead, like the one shown on the right. Often, they even come with their own auxiliary lights for shining through the sides.

When you have a lightbox, prop up your paper or fabric inside it. Make sure the backdrop touches both the back and the bottom of the lightbox. The paper should curve where it meets the bottom of the lightbox; don't create a crease or that will show up in your photo. Then place your model in the center of the box, and you're ready to snap some pictures!

I use a preassembled lightbox that cost only $20.

Postediting

After taking the photos, you can use your favorite image-editing software to enhance them. No matter how flawless your raw photos look, they can be improved with adjusted color levels, brightness, contrast, and so on. Auto-adjustments will usually do the trick, but if you're familiar with the software, extra editing won't hurt. If you compare the photos of my *P-51 Mustang* before and after editing, you can see that the postedited version looks more vibrant.

(ABOVE) **My *P-51 Mustang* photographed in a lightbox** (OPPOSITE) **My *P-51 Mustang* with postediting**

Sharing Your Work

Once your photos are complete, you can post them online. Here are some websites to consider.

The staple LEGO gallery is Brickshelf (*http://www.brickshelf.com/*), one of the oldest dedicated LEGO galleries on the Web. The site doesn't allow for commenting, so it's not the best place to receive feedback. If you want feedback, try MOCPages (*http://www.mocpages.com/*), which, like Brickshelf, is a dedicated LEGO site, but it allows users to comment and even rate each other's models. There's also Yahoo!'s popular photo-sharing site, Flickr (*http://www .flickr.com/*). Flickr isn't LEGO specific, but it is the number one website for sharing models. You can comment on models, mark them as favorites, and add them to groups. LEGO fans on Flickr have created groups specific to nearly every LEGO theme and concept, which makes it easy to share specialized information about the hobby.

Of all sites, I prefer Flickr because nearly every LEGO fan who's online and building models has an account there. If you're new to the community and want to choose only one website to post on, Flickr is your best option. Post your models to your photostream, add them to groups, and start interacting with other fans. Many models that get featured on various blogs inevitably link back to Flickr, so it's also a good place to get noticed.

Critiques

LEGO model building is a creative hobby, so expect criticism, whether you want it or not. Constructive criticism is a good thing because it will help you develop your skill as a builder; best of all, it's free. Even so, I've never taken feedback—from seasoned builders or otherwise—and *rebuilt* a model based on it. If you're like me, you probably have too many subjects on your to-build list to rebuild everything. Just remember the feedback you receive, and put it to use for similar builds in the future.

Closing Thoughts

Now that you've seen the design processes that experienced builders use to create their models, take what you've learned and use it to your advantage. Some of this information defies traditional building advice, but it's time for more outside-the-box thinking. That said, the LEGO Group is constantly developing and improving the LEGO system, and official designers and fans are always dreaming up new techniques.

Condensed as they are in this book, these theories may sound pretty simple, but in reality, they take time to perfect. That's the irony of LEGO building: It takes as much work and creativity as any other art form, but at the end of the day, models are often seen only as toys. Maybe that's a good thing. Although it's nice to be respected for something we put so much time into, LEGO should still be a playful hobby. Enjoy it!

We should all be proud of our creations, but I've learned over the years that taking LEGO *too* seriously takes a lot of the fun out of the fan experience. A model can still be amazing and inspiring even if it isn't a masterpiece in the classical sense. I actually consider every well-built model a piece of pop art because LEGO products themselves are a major part of popular culture.

LEGO building is, however, still just developing as an art form. The fan community, which was the catalyst for the increase in model quality we see today, didn't emerge until around 1999. How can we expect all of our models to be artful when we've had so little time to mold the building experience into something definitive? If we can build the things we're building now, imagine what models will look like in 10, 20, or even 50 years. Those are some exciting prospects!

Index

Note: Italicized page numbers refer to illustrations

Photograph Credits

All photographs courtesy of Jordan Schwartz, except for those listed below.

Cover: Ryan Byarlay **xii:** Kevin Hinkle **xiv:** Kevin Hinkle **5:** Sean and Steph Mayo **13:** (bottom right) Michael Jasper **40:** (bottom) Ralph Savelsberg (*http://www .flickr.com/photos/madphysicist/*) **42:** Ralph Savelsberg (*http://www.flickr.com/ photos/madphysicist/*) **43:** Mark Kelso **44:** Tyler Clites **45:** THE BRICK TIME Team (Sven Pätzold and Björn Pätzold; *http://www.thebricktime.de*) **48:** THE BRICK TIME Team (Sven Pätzold and Björn Pätzold; *http://www.thebricktime.de*) **50:** Mark Kelso **55–56:** Katie Walker **58:** Katie Walker **59:** (bottom) Katie Walker **60:** Katie Walker **62–63:** Katie Walker **65:** Katie Walker **66–67:** Katie Walker **71–74:** Katie Walker **95:** Ryan Rubino **102–103:** Bruce Lowell **107–110:** Tyler Clites **122:** Brian M. Williams **126–127:** Tyler Clites **128:** Nick Vás **131:** Keith Goldman **133:** Katie Walker **134:** Sean and Steph Mayo **139:** Brian M. Williams **142:** Tyler Clites **143:** Brian M. Williams **150–152:** Ken Ito **155:** Katie Walker **156:** Sean and Steph Mayo **167–174:** Iain Heath **187:** Adam Grabowski **195:** Tom Jacobs, (1) & (2) with Nick Bewier **199:** (top) THE BRICK TIME Team (Sven Pätzold and Björn Pätzold; *http://www.thebricktime.de*) **203–206:** Luke Hutchinson **213:** (bottom) Bruce Lowell **215:** Michael Jasper **220:** Tyler Clites **225–227:** Brian Kescenovitz **229:** Brian Kescenovitz **232:** Tyler Clites **234:** Peter Morris **236:** Peter Morris **237:** Pierre E. Fieschi **239:** Pierre E. Fieschi **241:** Pierre E. Fieschi **246–250:** Keith Goldman

The Art of LEGO Design is set in Akzidenz-Grotesk. The book was printed and bound by Everbest Printing Co., Ltd. in Guangzhou, China. The paper is 115gsm Goldeast matte.

Updates

Visit *http://nostarch.com/legodesign/* for updates, errata, and other information.

More no-nonsense books from **no starch press**

THE LEGO® ADVENTURE BOOK, VOL. 1: CARS, CASTLES, DINOSAURS & MORE!
by MEGAN H. ROTHROCK
NOV 2012, 200 PP., $24.95
ISBN 978-1-59327-442-9
hardcover, full color
Volume 2 also available.

THE LEGO® BUILD-IT BOOK, VOL. 1: AMAZING VEHICLES
by NATHANAËL KUIPERS *and* MATTIA ZAMBONI
JUL 2013, 136 PP., $19.95
ISBN 978-1-59327-503-7
full color
Volume 2 also available.

LEGO® SPACE
Building the Future
by PETER REID *and* TIM GODDARD
NOV 2013, 216 PP., $24.95
ISBN 978-1-59327-521-1
hardcover, full color

BEAUTIFUL LEGO®
by MIKE DOYLE
OCT 2013, 280 PP., $29.95
ISBN 978-1-59327-508-2
full color

THE UNOFFICIAL LEGO® BUILDER'S GUIDE, 2ND EDITION
by ALLAN BEDFORD
NOV 2012, 240 PP., $24.95
ISBN 978-1-59327-441-2
full color

THE CULT OF LEGO®
by JOHN BAICHTAL *and* JOE MENO
NOV 2011, 304 PP., $39.95
ISBN 978-1-59327-391-0
hardcover, full color

Visit *http://nostarch.com/catalog/lego/* for a full list of titles.

phone: 800.420.7240 or 415.863.9900 | sales@nostarch.com | www.nostarch.com